CHICAGO'S

SOUTH SHORE LINE

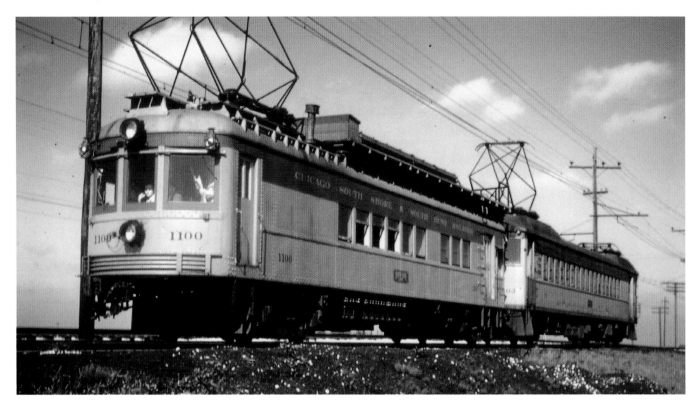

Chicago South Shore & South Bend Railroad (CSS&SBR) line car No. 1100 (built in 1926 as Indiana Service Corporation parlor car No. 376, sold to Indiana Railroad in 1932 and rebuilt as a combination passenger/railway post office car in 1935, and sold to CSS&SBR in 1941 where it was used as an express car and converted to a line car in 1947) and multiple unit coach/baggage car No. 103 (one of ten cars Nos. 100–109 built in 1926 by Pullman Car & Manufacturing Company) are in Indiana on a June 8, 1947 rail excursion. Car No. 103 was lengthened from 60 feet to 77.5 feet in 1943. (*Clifford R. Scholes collection*)

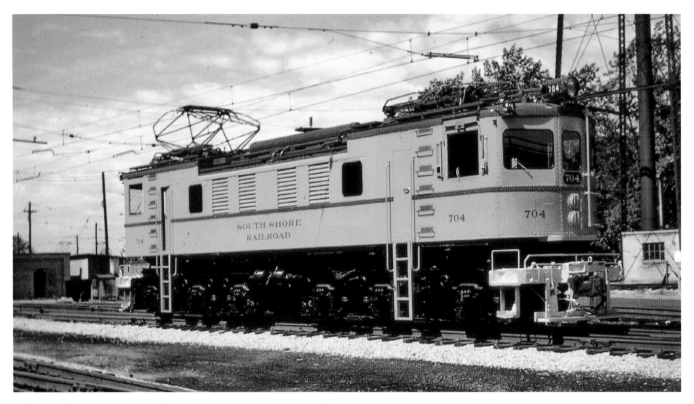

Newly repainted CSS&SBR electric locomotive No. 704 is ready for duty at the Michigan City yard on September 16, 1946. This was originally New York Central Railroad class R-2 electric locomotive No. 1243, built by Alco-General Electric in June 1931. It was renumbered No. 343 in August 1936, sold in 1955 to CSS&SBR, where it was rebuilt and renumbered as No. 704 in 1956, and scrapped in April 1956. (*Clifford R. Scholes collection*)

CHICAGO'S
SOUTH SHORE LINE

KENNETH C. SPRINGIRTH

AMERICA
THROUGH TIME®
ADDING COLOR TO AMERICAN HISTORY

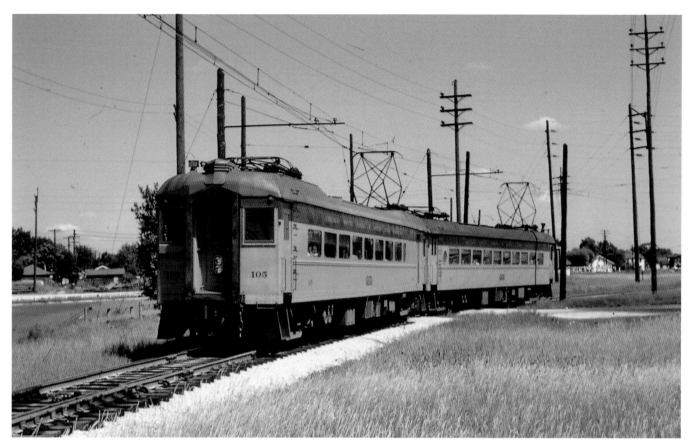

Under the sunny skies of August 8, 1950, CSS&SBR combination multiple unit coach/baggage car No. 105 is part of a two car train at the Bendix, Indiana, siding. This car, built by Pullman Car & Manufacturing Company in 1926, had four Westinghouse type 567-C11 motors. It was lengthened from 60 feet to 77.5 feet in 1944, and in 1950, it was rebuilt with wide picture windows and received air conditioning. (*Pat Carmody photograph—Clifford R. Scholes collection*)

On the top portion of cover: CSS&SBR multiple unit coach No. 38 is part of a two car train at the 11th Street Station in Michigan City, Indiana, in 1974. This was one of four coaches, Nos. 36–39, built by Standard Steel Car Company in 1929. Powered by four Westinghouse type 567-C11 motors, each 61-foot-long coach seated forty-eight passengers, rode on Baldwin 84-60 AA trucks, and weighed 129,600 pounds. (*Clifford R. Scholes collection*)

On the bottom portion of cover: In July 1971, CSS&SBR electric locomotive No. 803 is waiting for the next assignment at the Michigan City yard. This locomotive was one of twenty built by the General Electric Company in 1946 for export to the Union of Soviet Socialist Republics (Russia). However, deteriorating relations between the United States and Russia prevented delivery of those locomotives. The CSS&SBR purchased three of these locomotives and modified them to operate on the railroad's 1,500-volt DC catenary. (*Clifford R. Scholes collection*)

Back cover: On a sunny April 8, 2017, Chicago South Shore (CSS) four-axle 2,000-horsepower type GP38-2 diesel electric locomotives Nos. 2003 and 2009 (two of ten, Nos. 2000–2009, built by the Electro-Motive Division of General Motors Corporation (EMD) in 1981) are waiting for the Northern Indiana Commuter Transportation District (NICTD) train to clear the Michigan City Carroll Avenue station. To the right of the locomotive, NICTD single-level electric, multiple-unit car No. 104 was one of ten cars, Nos. 101–110, built by Nippon Sharyo USA in 2001.

America Through Time is an imprint of Fonthill Media LLC

First published 2018

Copyright © Kenneth C. Springirth 2018

ISBN 978-1-63499-057-8

Typeset in Utopia Std

Published by Arcadia Publishing by arrangement with Fonthill Media LLC

For all general information, please contact Arcadia Publishing:

Telephone: 843-853-2070
Fax: 843-853-0044
E-mail: sales@arcadiapublishing.com
For customer service and orders:
Toll-Free 1-888-313-2665

Visit us on the internet at www.arcadiapublishing.com

Contents

Acknowledgments

Thanks to the Erie County (Pennsylvania) Public Library system for their excellent staff and inter-library loan system. Most of the pictures were purchased from Clifford R. Scholes. Books and magazines that served as excellent reference sources were *Chicago South Shore & South Bend Railroad: How the Medal Was Won* Bulletin 124 of the Central Electric Railfans' Association Editor Norman Carlson; *South Shore: The last Interurban* by William D. Middleton; *South Shore Line Electric Locomotives & Interurban Cars* by Robert A. Liljestrand and David R. Sweetland; Electric Railroaders Association *Headlights* November 1956, October 1959, March 1964, September 1966, June 1967, and February–March 1970 issues; *Michigan City News Dispatch* newspaper October 21, 1982 and November 19, 1982; *Michigan City Dispatch* newspaper March 31, 2017; *Commuter Rail Transit Ridership Report Fourth Quarter 2016, 2015, 2014, 2013, 2012, 2011, 2010, 2009, 2008, 2007, 2006, 2005, 2004, 2003, 2002, 2001, 2000, 1999, 1998, 1997, and 1996* American Public Transportation Association; *Environmental Assessment and Section 4(f) Evaluation NICTD Double Track NWI (DT-NWI) Gary to Michigan City, IN* September 18, 2017, which will be abbreviated as EAS 4(f) Evaluation NICTD Double Track NWI Milepost (MP) 58.8 to MP 32.2 September 18, 2017, which is available on the website www.doubletract-NWI.com and click on DOCS and on the left side scroll down and click on Section 4(f) Evaluation. Thanks to the rail museums across the United States that have preserved electric rail equipment. For example, the Illinois Railway Museum at 7000 Olson Road, Union, Illinois 60180 has Chicago South Shore locomotive No. 803 plus cars Nos. 8, 19, 28, 34, 37, and 40. The East Troy Electric Railway Museum 2002 Church Street, East Troy, Wisconsin 53120 has Chicago South Shore cars Nos. 6, 9, 13, 23, 24, 25, 30, 33, 107, and 203. The Seashore Trolley Museum 195 Log Cabin Road, Kennebunkport, Maine 04046 has Chicago South Shore car No. 32. The year 2018 marks the 110th anniversary of the railroad's first run on June 30, 1908 from South Bend to Michigan City. Public support has kept this railroad in operation.

This book is dedicated to Dr. Phyllis Parise, who has been a tremendous help to our daughter, Kathleen Ruggio, being with her in the hospital for cancer treatment that included chemotherapy, radiation, and blood transfusions, plus she has driven countless miles to get her to medical appointments with a unique ability to provide laughter whatever the challenge.

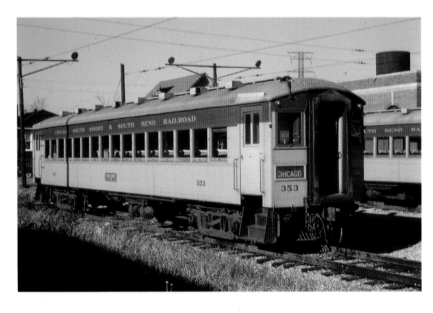

On November 6, 1949, CSS&SBR parlor car No. 353 is at the Gary, Indiana, storage yard. This was one of two parlor trailer cars, Nos. 353 and 354 (riding on Baldwin type 84-60AA trucks), built by Standard Steel Car Company in 1929. Each car seated twenty-six in plush arm chairs, and in 1938, both were rebuilt into a fifty-six-passenger coach. (*Pat Carmody photograph—Clifford R. Scholes collection*)

Introduction

The 4-foot, 8.5-inch standard gauge South Shore Line had its beginning with the incorporation of the Chicago & Indiana Air Line Railway on December 2, 1901, which completed and opened a 3.4-mile streetcar line, connecting East Chicago with Indiana Harbor, Indiana, in September 1903. Planning to connect Chicago, Illinois, with South Bend, Indiana, by railroad, the company became known as the Chicago, Lake Shore & South Bend Railway (CLS&SBR) in 1904. Surveys and plans for the section of the line from South Bend to Hammond were completed by the end of July 1906. The line was planned for a 75-mph maximum speed, with a maximum gradient of 2 percent. A 6,600-volt single phase AC power system was chosen, which reduced construction costs because only two substations were required for the 76-mile line. Construction of the line was underway before the end of 1906 and twenty-four interurban multiple unit passenger cars—each powered by four Westinghouse type 148 motors, with a maximum speed of 75 mph—were ordered in 1907 from Niles Car & Manufacturing Company. These 57.167-foot-long wooden cars featured 6-inch steel "I" beam underframes and weighed 55 tons. Each car interior had polished dark mahogany woodwork, dome ceiling lights, leather seats, and a lavatory. Ten passenger trailer cars, weighing 28 tons and seating fifty-two passengers, were ordered from the G. C. Kuhlman Car Company. On June 30, 1908, the first car completed the 32-mile trip from South Bend to Michigan City in seventy-five minutes. Regular service began the next day between South Bend and Michigan City.

On September 6, 1908, passenger service opened between South Bend and Hammond. The Lake Shore & Michigan Southern Railroad provided a steam railroad connection from Calumet to Chicago. Meanwhile, the Illinois Central Railroad (ICR) was constructing the Kensington & Eastern Railroad (K&ER) between the Indiana–Illinois state line at Hammond and the ICR line at Pullman, Illinois. The K&ER was leased to the CLS&SBR, and starting April 4, 1909, the CLS&SBR began operating to Pullman where the ICR was used to reach the ICR's downtown Chicago's Van Buren Street and Randolph Street stations. Higher than anticipated construction costs contributed to a $52,000 operating deficit by July 1, 1909. The Warren Bicknell Company took over managing the company in October 1909. Even with a $208,000 operating deficit in

1910, double tracking of the line between Hammond and Gary was completed before the end of October 1910. Beginning June 2, 1912, through service was operated between Gary, Indiana, and Chicago's Randolph Street Station on seven daily trains in both directions. However, the electric CLS&SBR multiple unit trains required ICR steam power between Kensington and Randolph Street Station.

The railroad had secured a fine right of way between cities and was built to steam railroad standards. However, in South Bend, Michigan City, and East Chicago, it operated on city streets. The right of way through those cities was designed to be free of sharp curves, which permitted the operation of railroad freight and passenger cars through those urban areas.

With the purchase of two box cab electric locomotives and twenty steel freight cars in 1916, carload freight service began in 1916. Although passenger traffic peaked at over 4 million in 1917 during World War I, by 1924, with increased automobile ownership and expansion of paved highways, only 1.8 million passengers were carried and the CLS&SBR had accumulated a net deficit exceeding $1.7 million. The Cleveland Trust Company foreclosed on the CLS&SBR, and by 1925, it was looking for a way to save its investment. Samuel Insull, who headed the Commonwealth Edison Company, which provided Chicago's electricity, was noted for purchasing utilities and railroads using holding companies. A holding company is a company that owns another company's stock. Based on a survey trip on the CLS&SBR conducted by a small group, including his son, Samuel Insull, Jr., and Britton I. Budd, who was in charge of Insull's railroad operations, it was concluded that the railroad was a good investment. Agreement was reached with the Cleveland Trust Company to form the Chicago South Shore & South Bend Railroad (CSS&SBR). Insull's Midland Utilities Company provided $4.5 million to rehabilitate the railroad and received 60 percent of the controlling interest in the new corporation's common stock, and Cleveland Trust Company received 40 percent. To prevent any claims against the Chicago Lake Shore & South Bend Railroad, it went into receivership on February 28, 1925. The new CSS&SBR was incorporated on June 23, 1925. The bankrupt CLS&SBR was sold at public auction on June 28, 1925 for $6,474,843 to the new CSS&SBR.

On July 15, 1925, Samuel Insull was now in control and plans for rebuilding would soon be underway.

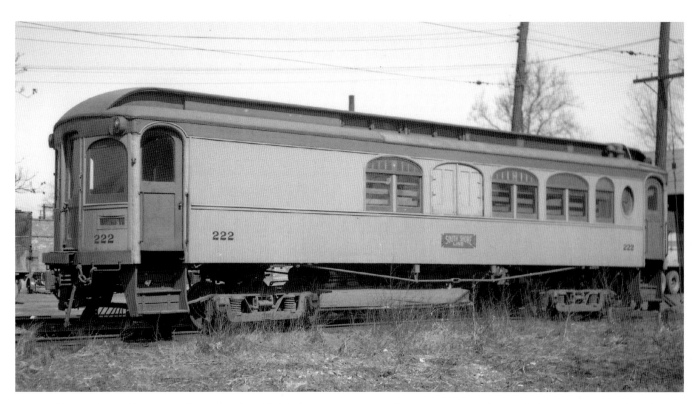

In 1940, Chicago South Shore & South Bend Railroad (CSS&SBR) newspaper trailer car No. 222 is at the Randolph Street Terminal in Chicago, Illinois. This wood baggage car (originally a 100 series trailer built by G. C. Kuhlman Car Company, rebuilt in 1926 at the company's shops into a passenger trailer and later retired from passenger service) was used until the early 1940s to haul Sunday newspapers to various locations on Saturday night. (*Clifford R. Scholes collection*)

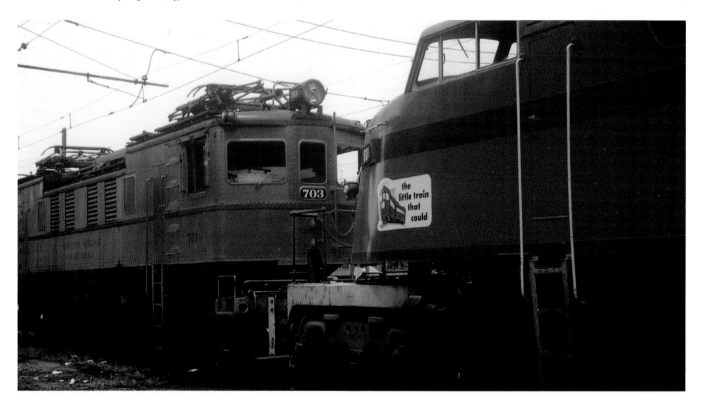

The Michigan City yard is the location of CSS&SBR electric freight locomotives Nos. 703 and 803 on July 25, 1974. Locomotive No. 803 has the slogan "the little train that could," which was applied to cars and locomotives in the 1970s because the railroad operated through tough times. The railroad had petitioned to abandon passenger service that led to the formation of the Northern Indiana Commuter Transportation District. (*Kenneth C. Springirth—photograph*)

1

Chicago South Shore & South Bend Railroad

Under Samuel Insull, Briton I. Budd became president of the Chicago South Shore & South Bend Railroad (CSS&SBR) and a massive rebuilding of the railroad began with 10 miles of the double track section between Kensington, Illinois, and Hammond, Indiana, refurbished with 100-pound rail replacing 70–80-pound rail before the end of 1925. Passenger cars were refurbished and repainted in a new orange and mahogany paint scheme. South Bend, Indiana, received a new station, and Gary and Tremont stations were rebuilt. Michigan City station was refurbished, and all stops received a standardized shelter.

Insull had close ties with the Illinois Central Railroad (ICR), and before Insull took over the railroad, an agreement had been reached that granted CSS&SBR track rights for through operation into ICR's Randolph Street Station. ICR was required by the City of Chicago to electrify its suburban service by 1927. With the ICR using a 1,500-volt direct current (DC) system, it was necessary for CSS&SBR to convert to the ICR DC operation. The entire catenary system was replaced using the existing excellent wooden poles. Eight new substations were constructed by the Insull-controlled Northern Indiana Public Service Company at South Bend, New Carlisle, Tee Lake, Michigan City, Tremont, Ogden Dunes, Gary, and Hammond.

In June 1926, the first of the twenty-five new steel passenger cars ordered from Pullman Car & Manufacturing Company arrived. These were the first interurban cars ever equipped with standard railroad-type vestibules to allow a fully enclosed way for passengers and crew between cars. On July 13, 1926, the overhead wire system was switched over to the 1,500-volt DC system between South Bend and Michigan City, and the new cars went into service on that portion of the line. Alternating current (AC) operation continued with the older cars west of Michigan City. Michigan City to Gary was switched over to DC operation on July 20, 1926. The entire line was switched over to DC operation on July 28, 1926. With the ICR electrification not yet completed, CSS&SBR cars were pulled to ICR's Randolph Street Station by ICR steam locomotives. On August 29, 1926, the ICR electrification project was completed, and CSS&SBR now provided direct passenger service from South Bend to downtown Chicago. While the September 26, 1926 timetable showed hourly limited service between Chicago's Randolph Station and South Bend, local trains mainly to Gary originated and terminated

at Kensington. On May 28, 1927, all CSS&SBR trains operated to Randolph Station. That direct service resulted in passenger revenues increasing 25 percent and freight revenues increasing 30 percent in one year.

CSS&SBR established a bus subsidiary, Shore Line Motor Coach Company (SLMCC), which began bus service on August 29, 1926 from Chicago to Benton Harbor and Grand Rapids, Michigan. By the end of 1926, SLMCC operated twenty-six bus routes in eastern Illinois, south-west Michigan, and north-west Indiana. Although commuter and short haul traffic provided the majority of the company's business, the railroad provided through ticketing arrangements for railroad and Pullman tickets for passengers originating on the CSS&SBR. In later years, the CSS&SBR began selling through rail-air tickets via CSS&SBR and several Chicago-based airlines.

By 1927, the CSS&SBR replaced 70-pound rail with 100-pound rail on 30 miles of track. The siding at Wilson, Indiana (which is between Gary and Michigan City), was lengthened to 2.5 miles. Improvements were made to a number of siding switches to permit higher train speeds. The railroad's semaphore block system, which had been rehabilitated in 1925, was replaced by a new color light block signal system in 1927. On May 21, 1927, the CSS&SBR opened a new $200,000 rail-bus station in Michigan City, which featured a large waiting room for train and bus passengers. CSS&SBR management applied in July 1927 to the American Electric Railway Association for the Fifth Annual Award of the Charles A. Coffin Foundation, which was given to the United States electric railway company that has made the greatest contribution for increasing the advantage of electric transportation for the public and industry. The winning company received a medal and $1,000 for the company's employees' benefit fund. This award had been established by the General Electric Company to honor its first president, Charles A. Coffin. The 1927 award went to the Grand Rapids Railway; however, the CSS&SBR gained a lot of newsworthy publicity for submitting its application.

The South Bend station, which was barely two years old, was enlarged to accommodate the increase in ridership and reopened on January 1, 1928. Before the through service, the fastest train from Chicago to South Bend required two hours and fifty-five minutes in 1926. By 1928, the standard Chicago to South Bend limited train required two hours and twenty minutes, with some faster trains requiring two hours and five

minutes. During 1928, street trackage through Michigan City and South Bend was renewed.

In 1929, the CSS&SBR won the Charles A. Coffin medal because the new management took over an insolvent property in 1925 and, with a $13 million investment, turned large losses into a profitable operation. The 2,787,190 revenue passengers carried in 1928 was 24 percent higher than in 1924. Freight car miles reached 2,992,162 in 1928, which was 150 percent over 1927. Operating freight revenue in 1928 was $3,060,540, which was a 257 percent increase over 1924. The new management increased the number of daily trains from eighteen to seventy-eight. The 90-mile Chicago to South Bend trip was reduced from two hours and fifty-five minutes in 1924 to two hours and five minutes in October 1928, with one train making the trip in one hour and fifty-nine minutes by the end of 1928. Even with that speed increase, the on-time performance increased from 75 percent in 1924 to 93.68 percent in 1928. Operating expenses decreased from 37.1 cents per car mile in 1927 to 34.2 cents per car mile in 1928.

The Great Depression caused a decline in ridership and dining cars were removed in April 1931. Parlor cars were removed in April 1932, and passenger ridership declined to less than 1.5 million in 1932. On September 30, 1933, the CSS&SBR declared bankruptcy and entered receivership. While there were discussions of abandonment, General Manager Charles M. Jones convinced the trustees that the line could survive with a broad base of freight revenues. In 1938, a reorganization plan had been completed, and the CSS&SBR bankruptcy ended with Chicago consulting engineer Jay Samuel Hartt becoming president. The railroad strengthened its freight solicitation efforts and in 1937 began interline passenger ticketing with steam railroad lines. By 1941, freight revenues exceeded $1.8 million, and passenger ridership rebounded to 2.25 million. On the single track west of Michigan City, a new 3,500-foot-long siding was installed in 1941 at Birchim to provide more flexibility in handling the increased freight traffic.

With the outbreak of World War II, yearly freight revenues exceeded $2 million by 1942 and the 1945 CSS&SBR passenger ridership exceeded 6 million. Four used electric locomotives were purchased from the Illinois Central Railroad in 1942 to help handle the increased freight business. To handle the increased wartime passenger ridership, passenger cars were lengthened by 17.5 feet, with the first two lengthened cars completed in 1942. By the end of 1946, there were twenty-three lengthened passenger cars in service.

On November 18, 1948, the CSS&SBR received licenses from the Federal Communications Commission for the frequencies on which the railroad operated their new Very High Frequency (VHF) radio system. The CSS&SBR was the first United States railroad to install a VHF radio communication system. In a June 1949 booklet titled *America's First*

Installation of System Wide Radio Communication by the Chicago South Shore and South Bend Railroad, it was noted that "The Shore Line system was planned and developed by South Shore Engineers in cooperation with the Bendix Radio Division of Bendix Aviation Corporation." Two relay stations were installed. One relay station was positioned at Olive Siding, 3 miles east of New Carlisle, Indiana. The other relay station was located at East Chicago, Indiana. Both stations received and transmitted messages automatically without the use of land wires. Michigan City, where the central operating office was located, was midway between the relay stations. According to the booklet, "This office and mobile units within a 15 to 20 mile radius can talk to each other without the use of a relay station. At greater distances, the relay station automatically picks up the message and relays it." This system enabled the central operating office to talk to the crew while the train was on the move, and the dispatcher was seconds away when the crew needed instruction or help. As passenger cars were remodeled, they were radio-equipped.

After the war, passenger traffic rapidly declined to between 4 million and 4.5 million for the next several years beyond 1950. In contrast to the decline in passenger revenues, freight revenues increased to almost $3.5 million by 1950.

The original CSS&SBR Railroad line had double tracks located on about 2 miles of street running on Chicago Avenue, the principal street in East Chicago. Initially, Chicago Avenue had a small amount of vehicular traffic. However, with the repaving of Chicago Avenue in 1936 and including it as part of the state highway system, more businesses and industries located along the avenue resulting in an increase in motor vehicle traffic congestion, which slowed down passenger and freight train operation. Passenger and freight trains obeyed traffic lights just like the motor vehicle traffic. Since the Indiana Toll Road Commission needed land for their new turnpike, and since the CSS&SBR had the land, the two organizations came together for a joint right of way. Parallel bridges and parallel grading were done by the same contractor. The new elevated line at its highest point was 33 feet above ground level near Columbia Avenue. Eastbound grade approaching the elevated line averaged 1.5 percent while the westbound grade averaged 1.25 percent. For a short distance, the maximum grade was 2.8 percent. The curves were super elevated for 60-mph operation. Former Indiana Railroad line car No. 1100 was used to string the wire either under its own power or by former 600-horsepower Buffalo Creek diesel locomotive No. 42, which later became No. 601. To facilitate installation of the catenary system, CSS&SBR purchased an Evans Auto-Railer rail bus from the Arcade & Attica Railroad that was not rail bound and was used to hang insulators for the catenary ahead of the track. Trucks were used to distribute ties and track fittings for one track, and the materials for the second track were transported by rail. In 1956, the CSS&SBR set up a temporary rail welding plant,

which completed forty-two pressure rail welds daily. The new 5-mile welded rail relocated line extending from Cline Avenue in Gary to Columbia Avenue in Hammond was built at a cost of $2.5 million and opened for revenue service on September 16, 1956. It was 660 feet longer than the old line; however, it eliminated twenty-seven railroad crossings and twenty-eight street crossings. A new station (replacing stops at Cudahy, Calumet, and White Oak Avenue) was built at 5615 Indianapolis Boulevard in East Chicago, Indiana, with a large parking lot.

With gross revenues fairly steady, the operating expenses were increasing, resulting in the net income before taxes of $560,000 in 1956 changing to a deficit of $175,000 in 1960. In 1961, William P. Coliton became president and general manager with a goal of reducing expenses. Maintenance of way costs were reduced by increased mechanization, and there was an internal reorganization that reduced payroll costs. The railroad's bus service between Michigan City and Benton Harbor, which lost $33,000 in 1961, was sold in 1963. With the completion of the Indiana Toll Road in November 1956 and Dan Ryan Expressway on December 16, 1962, passenger ridership that was fairly stable dropped from about 4,440,000 in 1955 to 3,135,000 in 1965. On February 2, 1964, weekday passenger trains were cut from sixty-six to fifty-one, Saturday trains from forty-six to thirty-five, and Sunday trains from thirty-seven to thirty-three. Most of the service cuts were non-rush-hour trains and trains beyond Michigan City.

With most of the decline in CSS&SBR passenger traffic east of Michigan City, the passenger station on LaSalle Avenue at Michigan Street in downtown South Bend was relocated on July 7, 1969 to the western end of the city, close to the main plant of the Bendix Corporation, eliminating 2.3 miles of street-running passenger service. It also meant the closure of the passenger coach yard about a tenth of a mile east on LaSalle Avenue at Sycamore Street. Even though the South Bend Public Service Corporation bus service was through routed to the new station, the direct rail service to downtown South Bend was lost. The 95-foot-long by 31-foot-wide concrete block station included a waiting room, ticket office, vending machines, rest rooms, yard office, and a freight agent's office. Within a few days, the overhead wire was removed, and by the end of the month, the rail was removed.

In 1966, the Chesapeake & Ohio Railway (C&O) and Chicago, Indianapolis & Louisville Railway (Monon) reached agreement ending their battle for control of the CSS&SBR. Both railroads were interested in controlling the CSS&SBR because of its access to the industrial areas of northern Indiana. Under the agreement allowing the C&O to acquire the CSS&SBR, the C&O agreed to give the Monon certain

trackage rights over the CSS&SBR to access certain industrial facilities. On January 3, 1967, the Interstate Commerce Commission approved C&O taking over the CSS&SBR.

During the severe 1969–1970 winter, breakdowns of the CSS&SBR passenger car fleet occurred with as many as seventeen to thirty-four cars out of service. With the schedule requiring fifty-seven of the line's sixty-four cars, the result was cancelled trains and a reduction in the number of cars assigned to the trains that operated. Six multiple unit cars were leased from the Illinois Central Railroad to alleviate some of the problems.

With the C&O controlling the railroad, its freight business prospered. However, by the beginning of the 1970s, the passenger debt increased to $2 million annually. The railroad was anxious to end passenger service, but settled for a major reduction in passenger service authorized by the Interstate Commerce Commission in May 1972. The passenger deficit reached $2.6 million in 1975. In addition, it was difficult to get replacement parts for the railroad's fifty-year-old passenger cars. An evaluation by an engineering consulting firm revealed that the cars were worn out and should be removed from service as soon as possible. The railroad began an effort in the late 1960s to request financial support for its passenger service under provisions of the United States Urban Mass Transportation Act of 1964, but the political complications of the two-state, five-county service territory made it difficult to form a local agency through which public funds could be applied to support the railroad's passenger service. In 1973, the Illinois Department of Transportation provided $273,705 to help some of the railroad's losses in Illinois. That support continued the next year under the newly formed Regional Transit Authority, which only met a small part of the loss. In March 1976, the railroad put $1 million for interim equipment repairs to buy time for a public agency to come up with a new car program. In six months, if there was no program, the railroad would seek to end all passenger service. Although efforts were made, nothing happened. Before the end of 1976, the railroad petitioned the Interstate Commerce Commission (ICC) to end all passenger service. The ICC told the railroad in April 1977 to operate passenger service for ten more months to give the State of Indiana time to save the service. The ICC order stated: "If this does not occur, we think it likely that there is no future for the South Shore's passenger operations." In April 1977, the Indiana General Assembly passed legislation to enable the four Indiana counties through which the railroad served: Lake, Porter, LaPorte, and St. Joseph to form the Northern Indiana Commuter Transportation District to maintain and improve the passenger service.

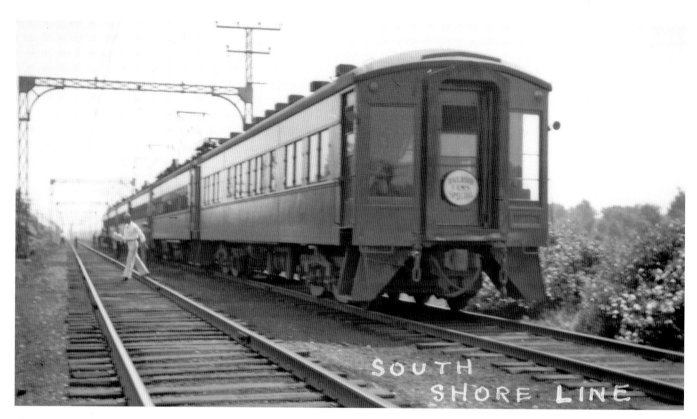

The Wagner, Indiana, siding is the location of this photo stop on a 1939 Central Electric Railfan's Association (CERA) rail excursion in 1939. Double-end solarium parlor trailer car No. 352 was one of two cars, Nos. 351–352, built by Pullman Car & Manufacturing Company in 1927 riding on Commonwealth six-wheel trucks and seating twenty-four. (*Clifford R. Scholes collection*)

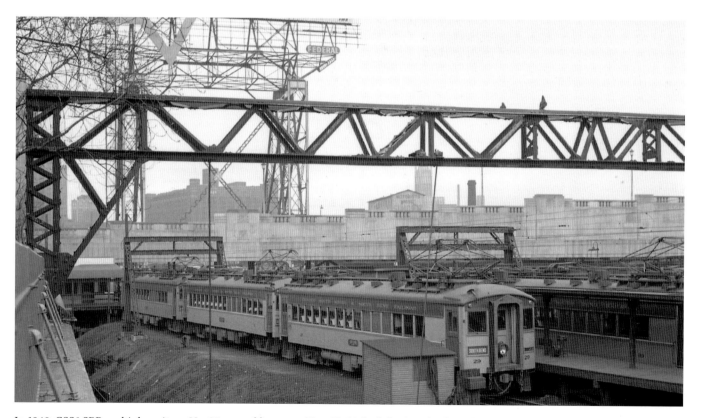

In 1940, CSS&SBR multiple unit car No. 29, one of fourteen, Nos. 26–39, built by Standard Steel Car Company in 1929, with each powered by four Westinghouse type W567-C11 motors, is heading a train at the Randolph Street Station in Chicago. These 61-foot-long cars seated forty-eight passengers and weighed 129,600 pounds. (*Clifford R. Scholes collection*)

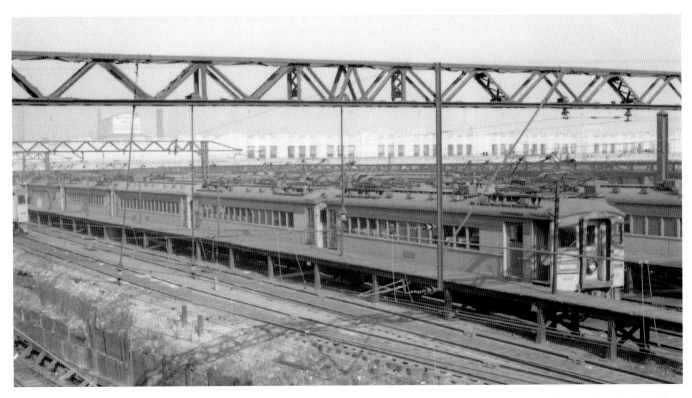

A CSS&SBR three-car train is headed by baggage/coach No. 109 in 1940 at the Randolph Street Station in Chicago. Seating forty-four passengers, this was one of ten cars, Nos. 100–109, built by Pullman Car & Manufacturing Company in 1926. Each car, equipped with a smoking section and two toilet rooms, was powered by four Westinghouse type 567-C11 motors. This car was lengthened from 60 feet to 77.5 feet in 1944. (*Clifford R. Scholes collection*)

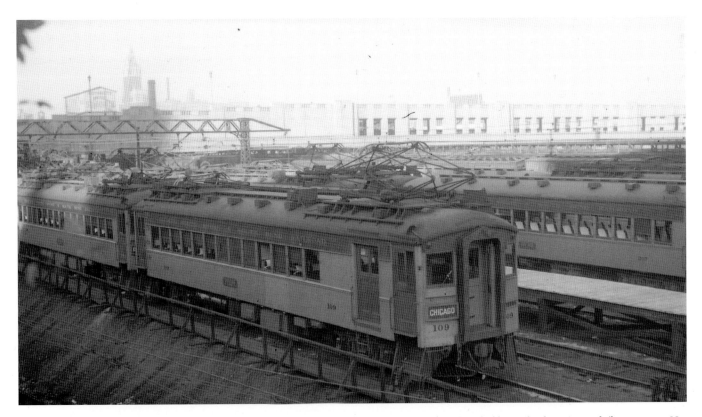

Near Chicago's Randolph Street Station in 1942, this CSS&SBR five car commuter train was headed by multiple unit coach/baggage car No. 102. This car was lengthened from 60 feet to 77.5 feet in 1944. (*Bob Crockett photograph—Clifford R. Scholes collection*)

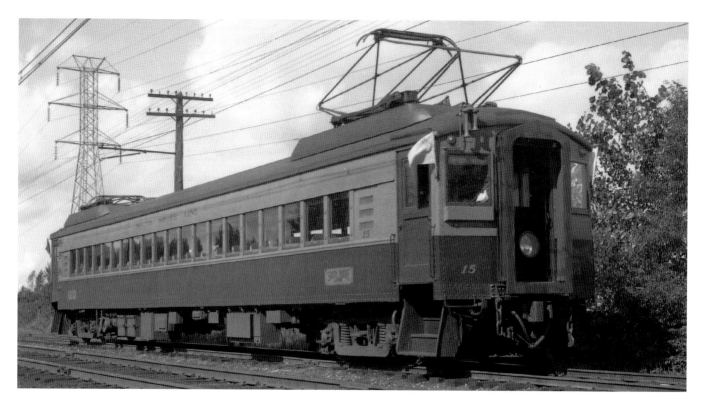

The east end of the Michigan City Shops in September 1942 is the location of CSS&SBR coach No. 15 (built in 1926 by Pullman Car & Manufacturing Company). This was the first car to be lengthened by adding a 17.5-feet center section to the car body, increasing the seating capacity from fifty-six to eighty passengers to handle the increased riding during World War II. The lengthened 147,860-pound car received fluorescent lighting plus a lowered ceiling with a forced ventilation system and electric heaters. The exterior painting of the car was a reversal of the normal orange and maroon color scheme. (*Bob Crockett photograph—Clifford R. Scholes collection*)

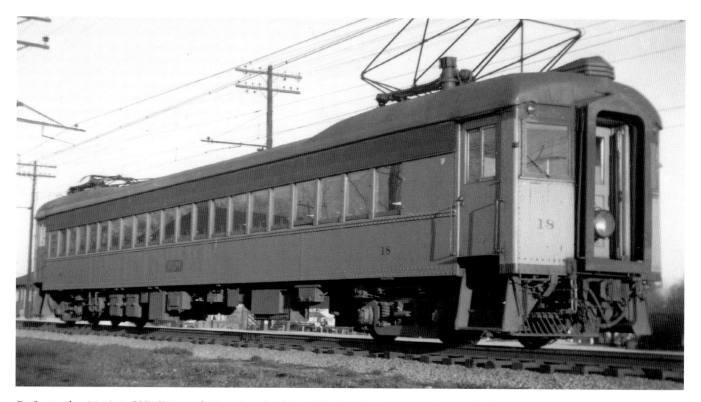

On September 20, 1942, CSS&SBR coach No. 18 is at South Bend, Indiana. This was one of ten multiple unit cars, Nos. 16–25, built by Pullman Car & Manufacturing Company in 1927. Each of these 61-foot-long cars weighed 133,490 pounds and was powered by four Westinghouse type 567-C11 motors. Beginning in 1942, cars Nos. 11–28, 100–111, and 201–206 were lengthened by 17.5 feet. (*Clifford R. Scholes collection*)

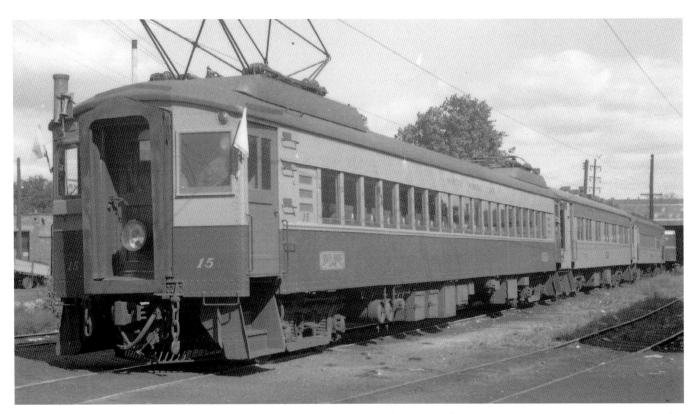

The South Bend yard is the location from left to right of CSS&SBR coach No. 15 (built by Pullman Car & Manufacturing Company in 1926), solarium car No. 353 (built by Standard Steel Car Company in 1929), and baggage car No. 503 (built by St. Louis Car Company in 1926 for the Indiana Railroad as No. 375) in September 1942. (*Clifford R. Scholes collection*)

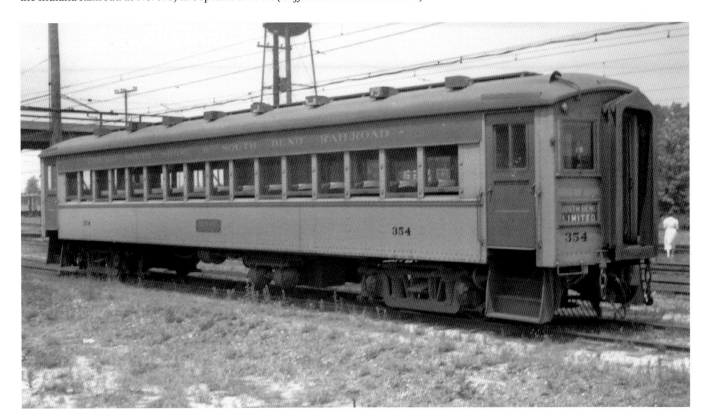

In 1942, CSS&SBR coach trailer No. 354 is at the Michigan City yard waiting for the next assignment. Riding on Baldwin type 84-60AA four-wheel trucks, this car was one of two parlor cars, Nos. 353–354, built by Standard Steel Car Company in 1929, and both were later converted to coach trailer cars after parlor car service ended. (*Bob Crockett photograph—Clifford R. Scholes collection*)

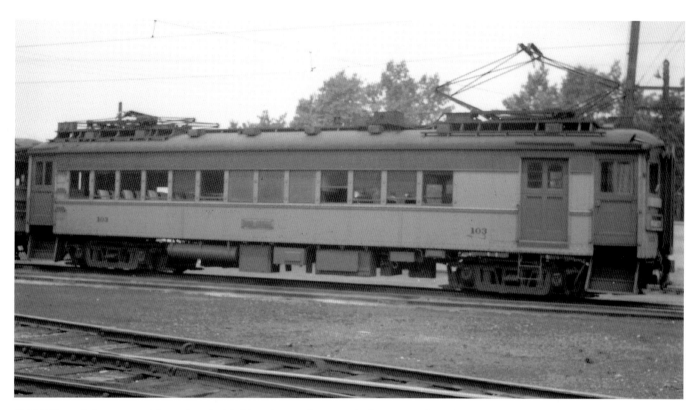

CSS&SBR coach/baggage car No. 103 is at the Michigan City yard in 1942. The first twenty-five all-steel cars, Nos. 1–15 and Nos. 100–109, were built in 1926 at a cost slightly over $1 million by Pullman Car & Manufacturing Company. (*Bob Crockett photograph—Clifford R. Scholes collection*)

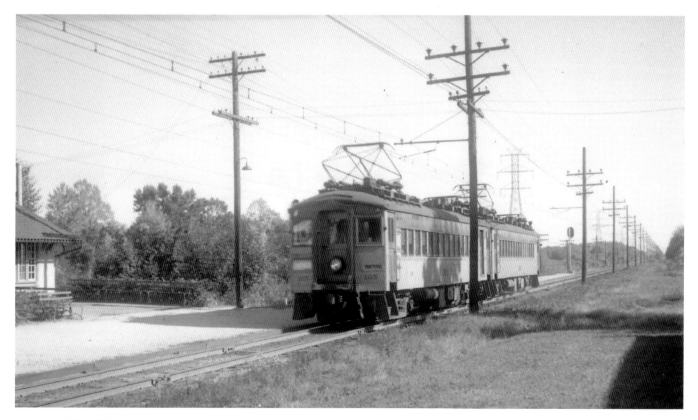

A two-car CSS&SBR train in 1943, with car No. 105 at one end of the train, is at the Beverly Shores, Indiana, station located at United States Highway 12 and Broadway Street. This Mediterranean Revival station characterized by stuccoed walls and tiled roof was designed by commercial artist Arthur U. Gerber, who designed a number of transit stations in the Chicago area. (*Clifford R. Scholes collection*)

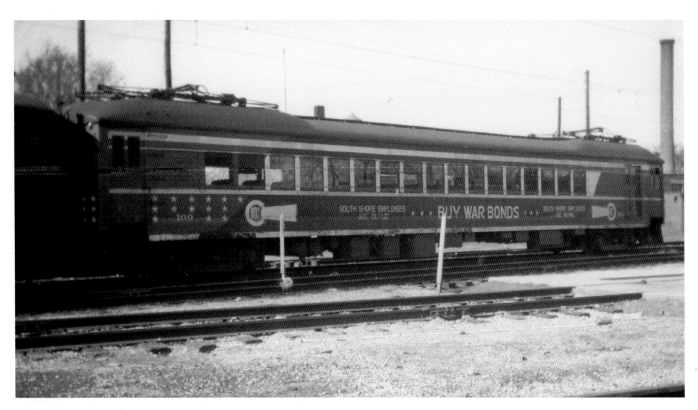

CSS&SBR multiple unit coach/baggage car No. 100 is at the Michigan City shops in 1946 with a special red, white, and blue paint scheme, highlighting the fact that the South Shore employees are buying war bonds during World War II. This was the first coach/baggage car to be lengthened from 60 feet to 77.5 feet. (*Clifford R. Scholes collection*)

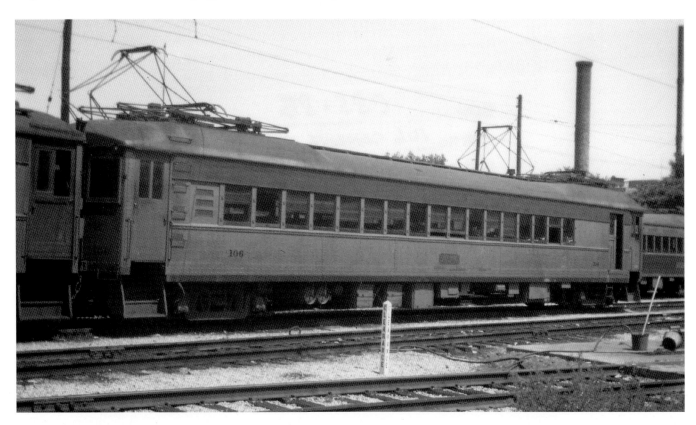

In 1946, CSS&SBR multiple coach/baggage car No. 106 is in the lineup of cars at the Michigan City yard. In 1943, this car was lengthened from 60 feet to 77.5 feet at the Michigan City shop. (*Clifford R. Scholes collection*)

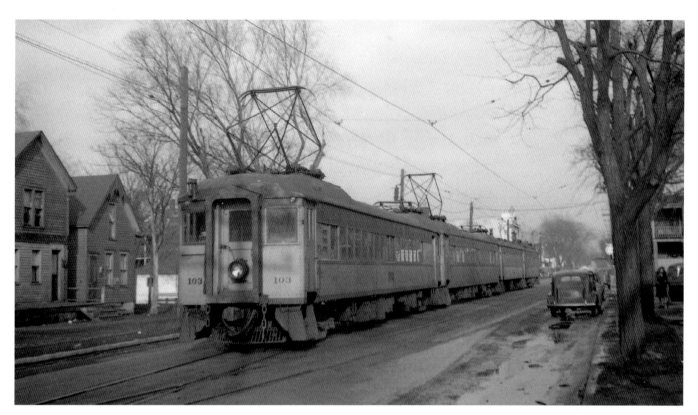

On February 14, 1947, CSS&SBR train No. 26 consisting of coach/baggage car No. 103 (built by Pullman Car & Manufacturing Company in 1926), coach No. 17 (built by Pullman Car & Manufacturing Company in 1927), coach trailer No. 212 (built by Standard Steel Car Company in 1929), and coach No. 36 (built by Standard Steel Car Company in 1929) is on 11th Street at Washington Street in Michigan City. (*Clifford R. Scholes collection*)

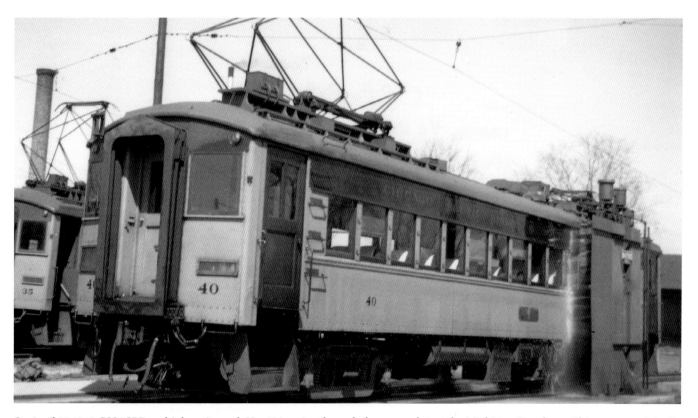

On April 27, 1947, CSS&SBR multiple unit coach No. 40 is going through the car washer at the Michigan City shops. This car was originally No. 213 built by Standard Steel Car Company in 1929 and was rebuilt in 1938 at the company's shops into coach No. 40. The car is now preserved at the Illinois Railway Museum. (*Clifford R. Scholes collection*)

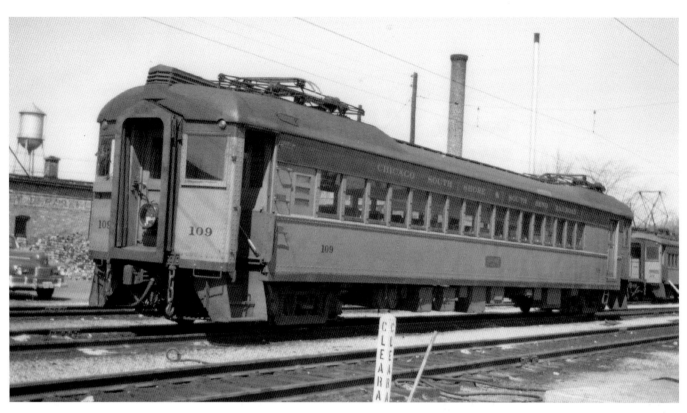

The South Bend yard is the location of CSS&SBR multiple unit coach/baggage car No. 109 on April 27, 1947. (*Clifford R. Scholes collection*)

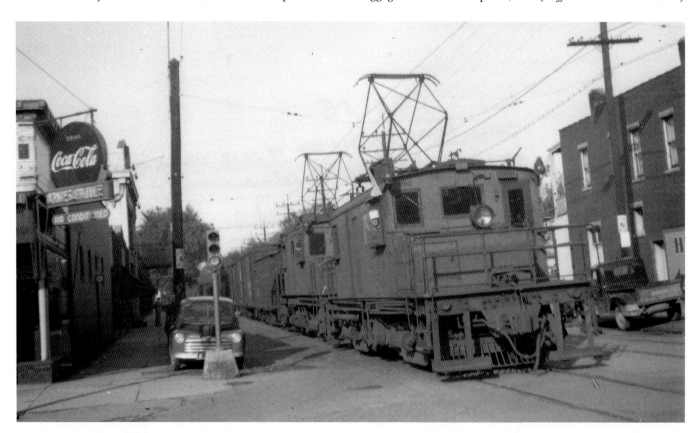

On June 2, 1947, CSS&SBR steeple cab electric locomotives Nos. 1002 (80-ton built by Baldwin Westinghouse in 1926) and 1013 (85-ton built by Baldwin-General Electric in 1930) are powering a westbound freight train on 11th Street at Franklin Street in downtown Michigan City. Freight service began in 1916, and freight houses were constructed at various points along the line with freight revenues reaching $100,000 by 1918. (*Clifford R. Scholes collection*)

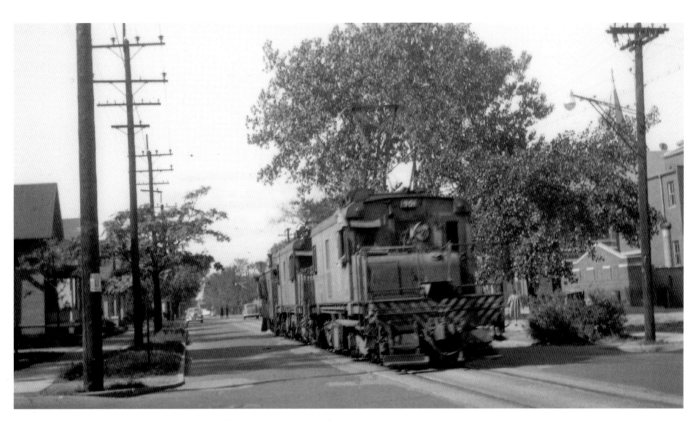

CSS&SBR 97-ton steeple cab locomotives Nos. 901 and 902 are on 11th Street in Michigan City on October 5, 1947. These were two of four electric locomotives, Nos. 901–904, purchased from the Illinois Central Railroad in 1941. They were originally built by Baldwin-Westinghouse in 1929. (*Clifford R. Scholes collection*)

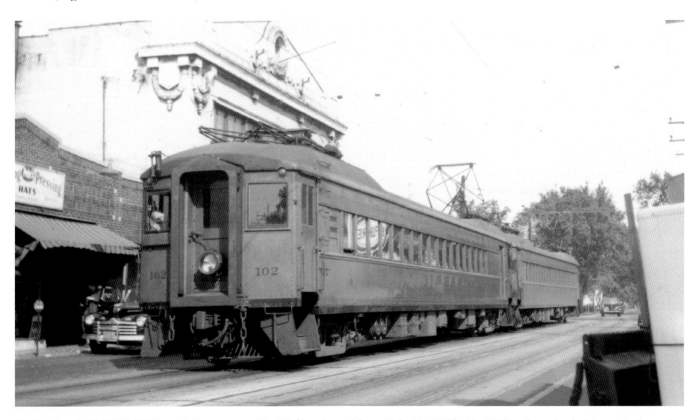

On October 8, 1947, CSS&SBR coach/baggage car No. 102 (lengthened from 60 feet to 77.5 feet in 1943 and received picture windows plus air conditioned by 1950) and coach No. 12 (lengthened from 60 feet to 77.5 feet in 1945) are at the Michigan City station on 11th Street. (*Clifford R. Scholes collection*)

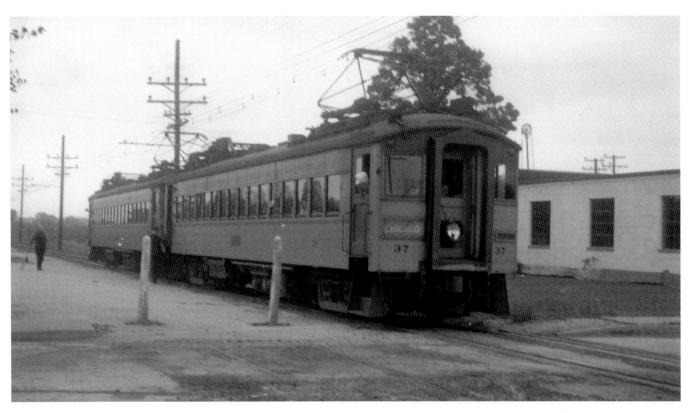

CSS&SBR coach No. 37 and smoker coach No. 22 are at the Dune Acres, Indiana, station in 1948. This flag stop opened around 1910 and closed after parking was expanded at Dune Park station on July 5, 1994. (*Clifford R. Scholes collection*)

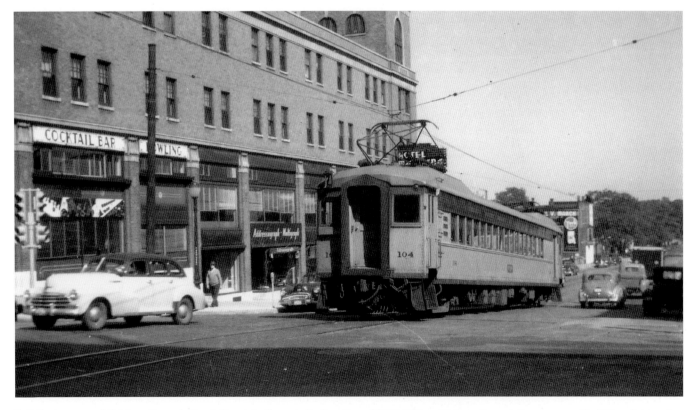

LaSalle Avenue at Michigan Street in South Bend, Indiana, is the location of CSS&SBR multiple unit coach/baggage car No. 104 on September 16, 1949. (*Bob Crockett photograph—Clifford R. Scholes collection*)

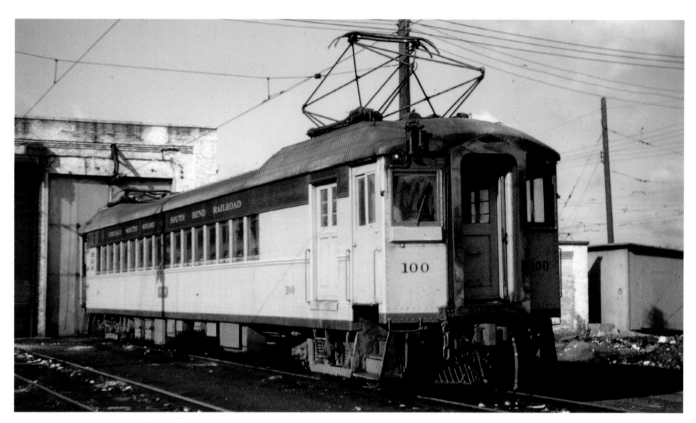

On November 20, 1948, CSS&SBR coach/baggage car No. 100 (lengthened from 60 feet to 77.5 feet in 1943) is parked outside the Michigan City shop. This was the first passenger/baggage car to be lengthened. (*Pat Carmody photograph—Clifford R. Scholes collection*)

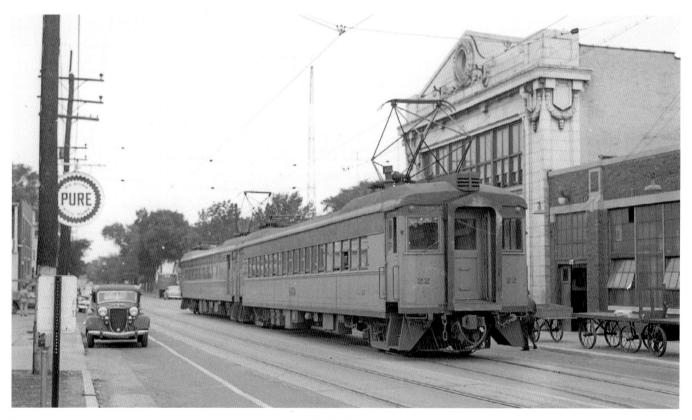

The Michigan City 11th Street station in 1949 is the location of CSS&SBR coach No. 22, plus a combination coach/baggage car. This was a major passenger station for the railroad plus from its opening on May 21, 1927 until the railroad's Shore Line Motor Coach bus subsidiary was sold in 1963 was a bus-train transfer point. (*Clifford R. Scholes collection*)

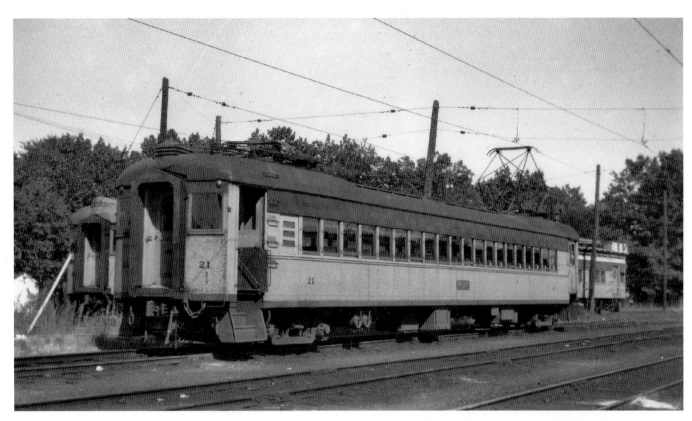

On September 16, 1949, CSS&SBR coach No. 21 and, in the rear on an adjacent track line, car No. 1100 (on the right side of the picture) are waiting in the Michigan City yard for the next assignment. (*Bob Crockett photograph—Clifford R. Scholes collection*)

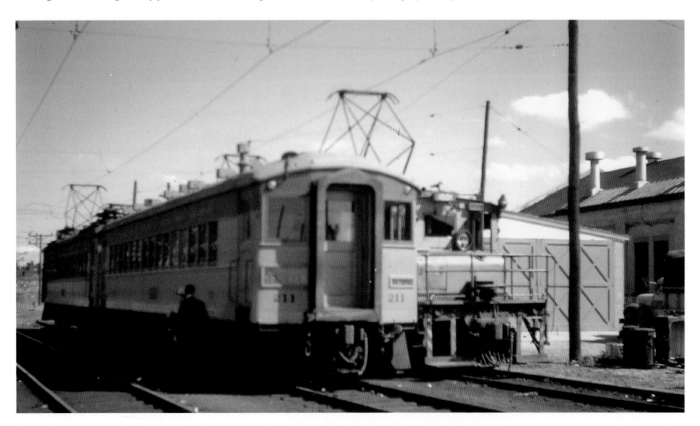

CSS&SBR trailer coach/smoking car No. 211 is at the Michigan City yard on September 20, 1949. This was one of three trailer cars, Nos. 211–213, built by Standard Steel Car Company in 1929. (*Clifford R. Scholes collection*)

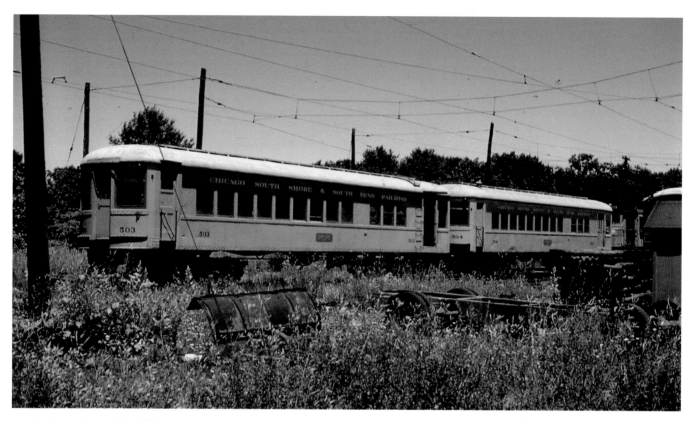

On October 1, 1949, CSS&SBR baggage cars Nos. 503 (rebuilt in 1941 from Indiana Railroad car No. 375) and 504 (rebuilt in 1942 from Indiana Railroad car No. 377) are at the Michigan City yard. (*Pat Carmody photograph—Clifford R. Scholes collection*)

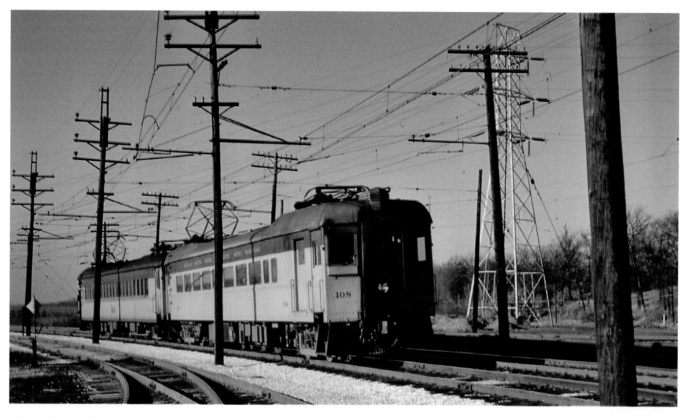

CSS&SBR coach/baggage car No. 108 with another car are west of Michigan City on October 10, 1949. This car was lengthened from 60 feet to 77.5 feet in 1943. (*Pat Carmody photograph—Clifford R. Scholes collection*)

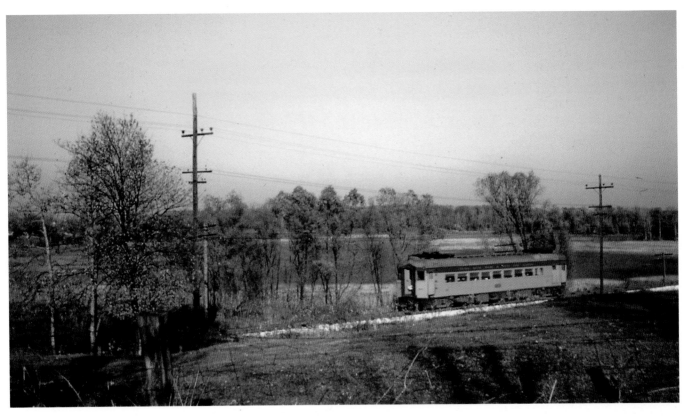

On November 6, 1949, CSS&SBR coach/baggage car No. 107 is gliding by Hudson Lake, Indiana. This car was lengthened from 60 feet to 77.5 feet in 1944 and received wide windows plus air conditioning in 1949. (*Pat Carmody photograph—Clifford R. Scholes collection*)

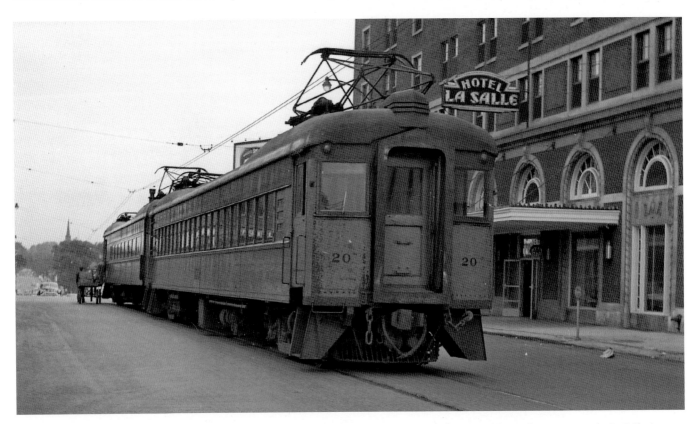

In 1950, CSS&SBR multiple unit coach No. 20 (lengthened from 61 feet to 78.5 feet in 1946) along with another car are at the LaSalle Avenue and Michigan Street station in downtown South Bend in front of the Hotel LaSalle. This was one of ten cars, Nos. 16–25, built by the Pullman Car & Manufacturing Company in 1927. (*Clifford R. Scholes collection*)

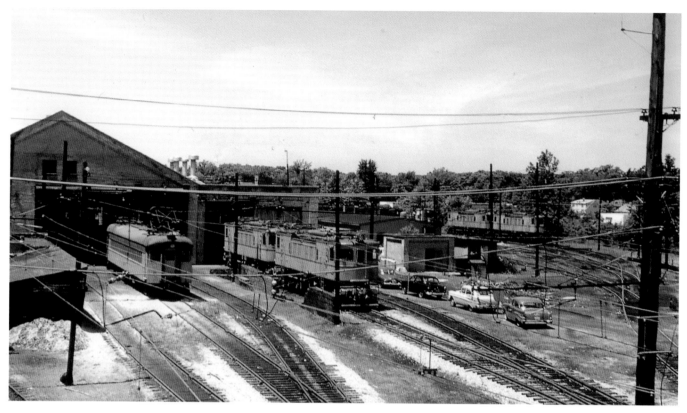

An overall view of the Michigan City yards taken on June 15, 1959 from the Roeske Avenue bridge shows CSS&SBR coach No. 21 (lengthened from 61 feet to 78.5 feet in 1946) on the left and electric freight locomotive No. 706 (originally New York Central Railroad No. 341, built by American Locomotive-General Electric) in the center at the Michigan City yard and shops. (*C. Able photograph—Clifford R. Scholes collection*)

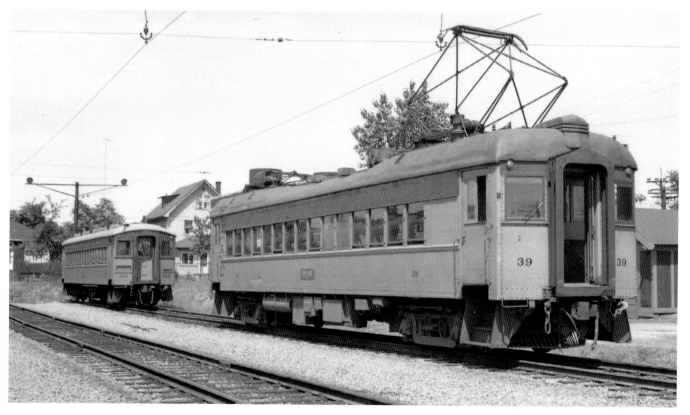

The Gary, Indiana, station storage track is the location of CSS&SBR multiple unit coach No. 39 and, to the left of it, double-end solarium parlor car No. 353 on July 8, 1950. Both of these cars were built by Standard Steel Car Company in 1929. (*Clifford R. Scholes collection*)

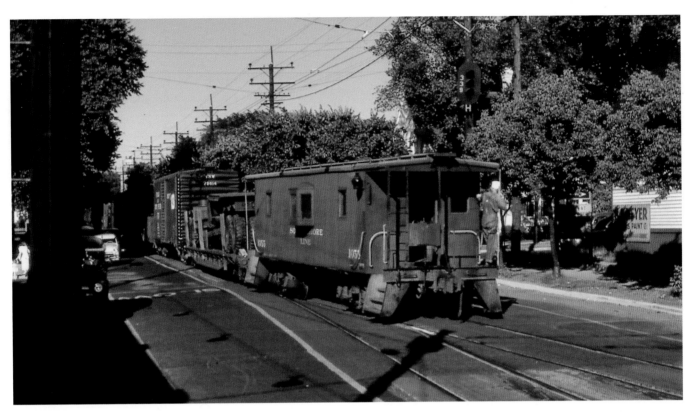

On August 18, 1950, CSS&SBR steel bay window caboose No. 1055 is at the end of a freight train on 11th Street in Michigan City. This was one of four cabooses, Nos. 1054–1057, built by American Car and Foundry in January 1928. (*Pat Carmody photograph—Clifford R. Scholes collection*)

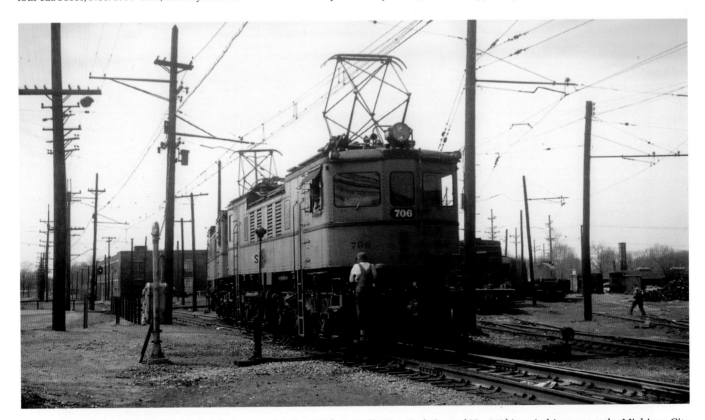

On April 12, 1968, CSS&SBR electric freight locomotive No. 706 (originally New York Central No. 341) is switching cars at the Michigan City yard. This was one of seven class R-2 electric locomotives, Nos. 701–707, built by American Locomotive/General Electric in 1930–1931 for the New York Central Railroad. The CSS&SBR rebuilt Nos. 701–706 during 1955–1956 and No. 707 was rebuilt in 1968. Weighing 280,000 pounds, each 3,000-horsepower locomotive was powered by six General Electric type 286B motors. (*Kenneth C. Springirth photograph*)

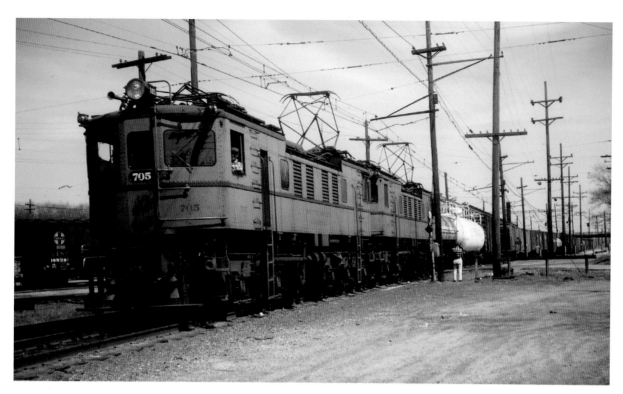

CSS&SBR electric freight locomotives Nos. 705 (former New York Central No. 340) and 706 (former New York Central No. 341) are handling a freight train at the Michigan City Shops on April 12, 1968. Each of these locomotives was built by American Locomotive-General Electric and had a length over couplers of 54 feet. (*Kenneth C. Springirth photograph*)

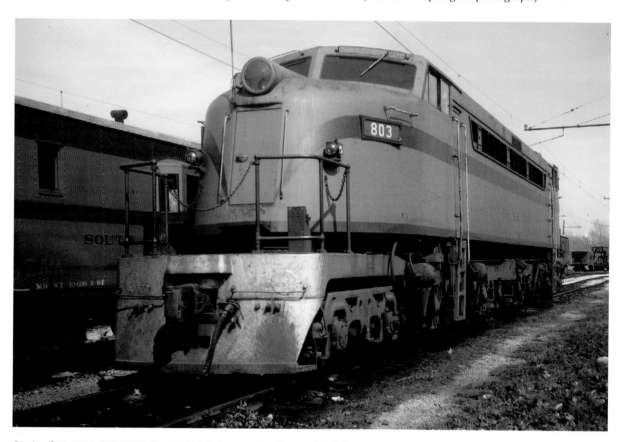

On April 12, 1968, CSS&SBR electric freight locomotive No. 803 (built by General Electric Company originally for Russia, but the Cold War resulted in the purchase of three of these locomotives by the CSS&SBR) is at the Michigan City yard parallel to a bay window caboose, both waiting for the next assignment. (*Kenneth C. Springirth photograph*)

Electric Passenger Service

Following the formation of the Chicago South Bend & South Shore Railroad (CSS&SBR), Samuel Insull's new management team began the work of rehabilitating the railroad. On August 1, 1925, Pullman Car & Manufacturing Company received an order to build fifteen coaches, Nos. 1–15, and ten combination cars, Nos. 100–109. In December 1925, two dining cars, Nos. 301–302, and two parlor-observation cars, Nos. 351–352, were ordered. The dining cars were equipped with large kitchens so passengers could receive quick service. Parlor-observation cars featured large luxurious soft-cushioned chairs. In the book *Chicago South Shore & South Bend Railroad: How the Medal Was Won* Bulletin 124 of Central Electric Railfans Association, page 68, it was reported that three dining and two parlor car trips each way began February 20, 1927, noting, "Parlor car rates were 50 cents between any two stations on the South Shore. A steak dinner was available for $1.25. At this time a one-way ticket to South Bend was $3.01. For $4.76, one could enjoy a very nice trip to South Bend."

To accommodate increased ridership, ten motor cars, Nos. 16–25, and ten trailer cars, Nos. 201–210, were ordered from Pullman Car & Manufacturing Company in January 1927. An additional twenty more cars were ordered and received from Standard Car Company in 1929 as follows: fourteen motor cars (Nos. 26–39), replacement car No. 10 (replacing the original car that was destroyed in a collision), three coach trailers (Nos. 211–213), and two parlor cars (Nos. 353–354). On January 1, 1929, one train began a two-hour schedule between Chicago and South Bend. That resulted in the CSS&SBR winning the Electric Traction's speed trophy in 1929. While the Great Depression resulted in shorter trains by 1930, the CSS&SBR cut its fastest Chicago–South Bend run to one hour and fifty-eight minutes and retained the Electric Traction speed trophy. To meet the increase in ridership during World War II, the Michigan City shops of the CSS&SBR lengthened their 60- and 61-foot-long passengers by 17.5 feet to increase seating capacity by twenty-four to thirty seats per car. Two lengthened passenger cars were completed in 1942, and before the end of 1946, there were twenty-three lengthened passenger cars in service. After 1946, the lengthening program continued with many of the lengthened cars air conditioned and receiving lengthened picture windows. During 1949–1950, some of the earlier lengthened cars received air conditioning and picture windows.

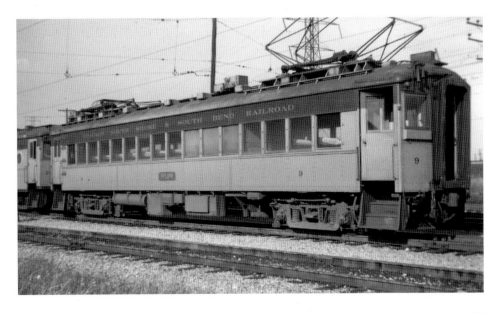

On November 18, 1949, CSS&SBR multiple unit coach No. 9, powered by four Westinghouse type 567-C11 motors (one of fifteen coaches, Nos. 1–15, built by the Pullman Car & Manufacturing Company in 1926), and trailer No. 202 (one of ten trailers, Nos. 201–210, built by the Pullman Car & Manufacturing Company in 1927) are at the Gary, Indiana, station. Trailers Nos. 202–204 were lengthened from 61 feet to 78.5 feet, seating eighty passengers in 1947, followed by the lengthening to 78.5 feet of trailers Nos. 205 and 206 in 1948. (*Clifford R. Scholes collection*)

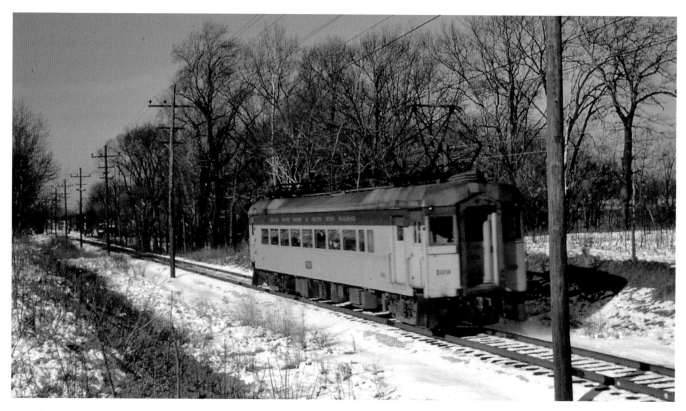

East of Michigan City in rural Indiana, CSS&SBR coach/baggage car No. 109 amid the snow-covered landscape has a very interurban look in this December 8, 1949 scene. This combination passenger/baggage car seated forty-four passengers, had separate smoking compartments, and two toilet compartments. (*Pat Carmody photograph—Clifford R. Scholes collection*)

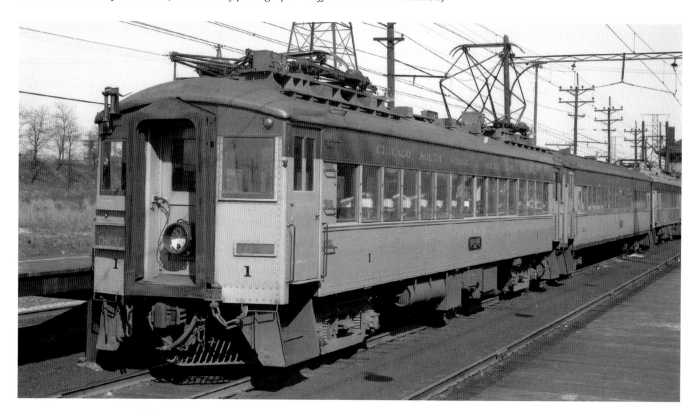

In April 1950, CSS&SBR coach No. 1 is at the Gary, Indiana, station. The car has a well-maintained look after twenty-four years of service since it was built in 1926 by Pullman Car & Manufacturing Company. This car interior was finished with brown mahogany woodwork, interior fittings were statuary bronze, and there were large dome lights. (*Clifford R. Scholes collection*)

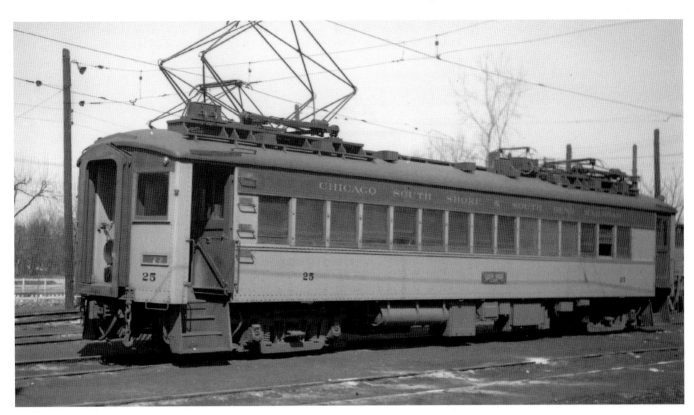

Car No. 25 is waiting for the next assignment at the South Bend yard in July 1938. Delivered in the summer of 1927, this 61-foot-long car, built by Pullman Car & Manufacturing Company, weighed 133,400 pounds and had rotating bucket seats. An enclosed smoking section seating eight was located at one end of the car. (*Bob Crockett photograph—Clifford R. Scholes collection*)

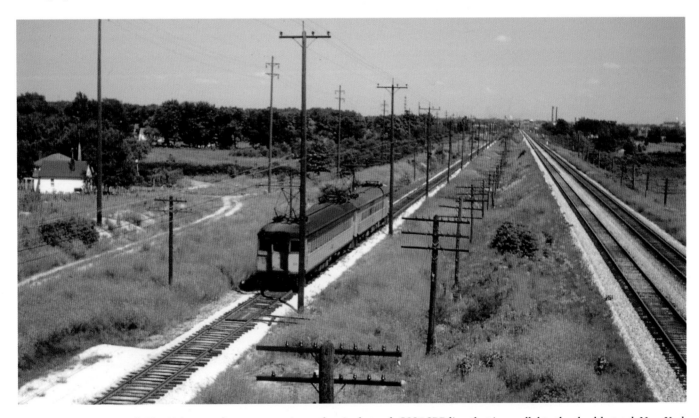

On August 5, 1980, coach No. 12 is part of a two-car train on the single track CSS&SBR line that is parallel to the double track New York Central Railroad near Portage, Indiana. This scene is an example of the excellent right of way that the railroad had secured between cities. (*Pat Carmody photograph—Clifford R. Scholes collection*)

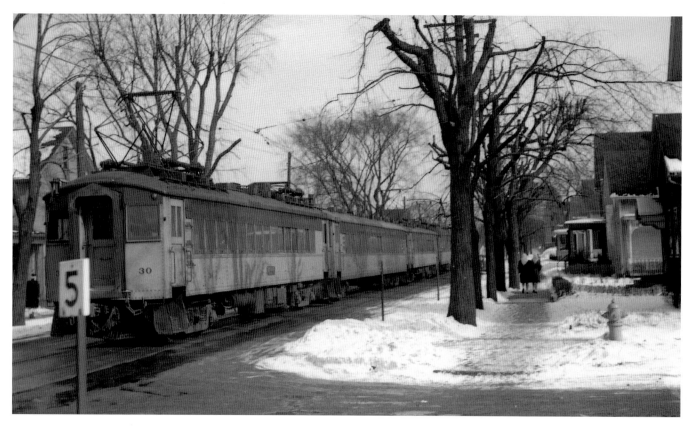

In this 1950 snow-covered scene, CSS&SBR coach No. 30 (in a four-car train) is on 11th Street in Michigan City, near Sheridan siding. This car was acquired by the East Troy Electric Railway Museum in 1983. (*Clifford R. Scholes collection*)

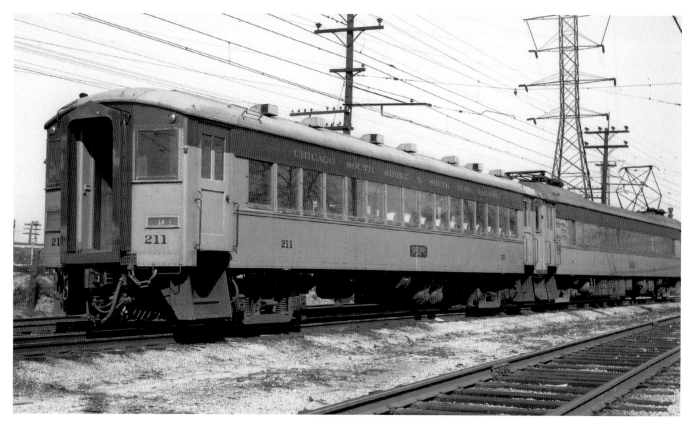

Gary, Indiana, is the location in April 1950 of CSS&SBR trailer car No. 211 (one of three trailers, Nos. 211–213, built by Standard Steel Car Company in 1929) and coach No. 18 (one of ten, Nos. 16–25, built by Pullman Car & Manufacturing Company in 1927). (*Clifford R. Scholes collection*)

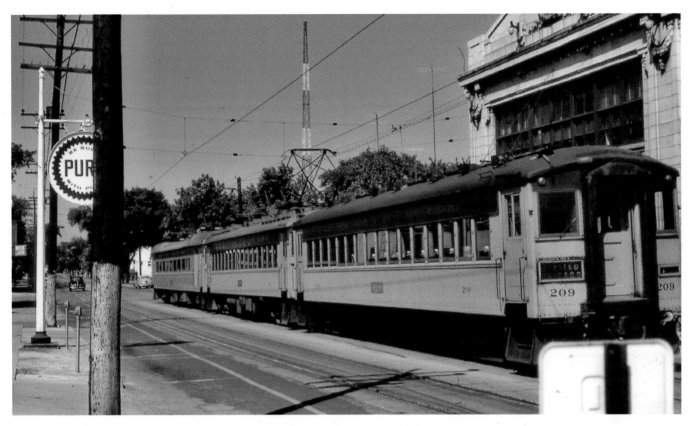

Trailer coach No. 209 is at the end of a three-car CSS&SBR train on 11th Street just west of Pine Street in front of the Michigan City train station on August 8, 1950. (*Pat Carmody photograph—Clifford R. Scholes collection*)

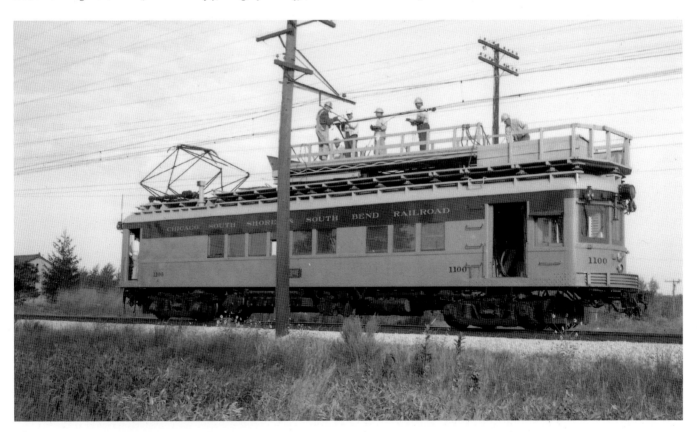

In 1952, Beverly Shores is the location of CSS&SBR line car No. 1100 (former Indiana Railroad interurban car powered by four Westinghouse type 567 motors). (*Clifford R. Scholes collection*)

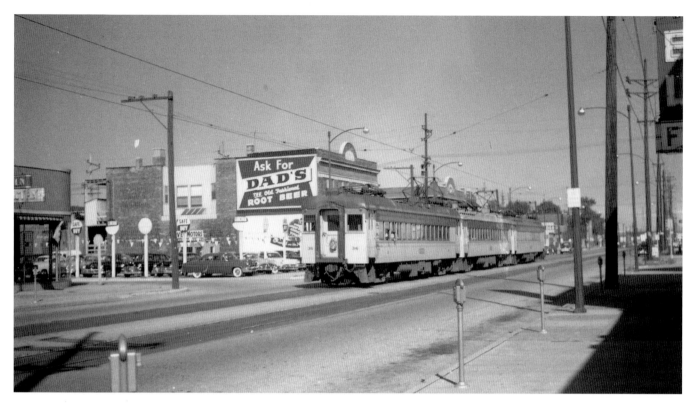

CSS&SBR coach No. 36 is part of a three-car train on Chicago Avenue at Tod Avenue in the city of East Chicago in Lake County, Indiana, on September 3, 1954. In just a little over two years, the Chicago Avenue street trackage was replaced by a relocated line extending from Cline Avenue in Gary to Columbia Avenue in Hammond, which opened for revenue service on September 16, 1956. (*Clifford R. Scholes photograph*)

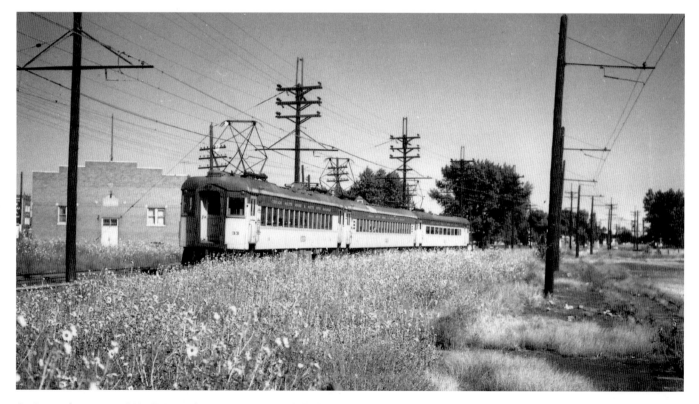

On September 3, 1954, CSS&SBR coach No. 33 is at one end of a three-car train, gliding through the town of New Carlisle in St. Joseph County, Indiana. On July 5, 1994, the flag stop at Arch and Zigler Streets in New Carlisle was eliminated, and the closest stop was at Hudson Lake. Other flag stops that were eliminated that day were Kemil Road, Willard Avenue in Michigan City, LaLumiere on Wilhelm Road, Rolling Prairie on County Road, and Ambridge on Bridge Street in the Ambridge Mann neighborhood of Gary. (*Clifford R. Scholes photograph*)

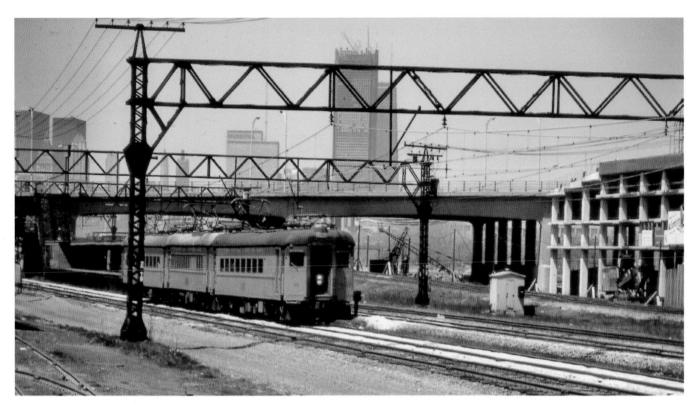

In 1956, CSS&SBR coach/baggage car No. 111 is south of downtown Chicago, passing 24th Street. During 1951, coach No. 29 received large picture windows, lengthened from 61 feet to 78.5 feet, air conditioning, and became passenger/baggage car No. 111, while coach No. 10 received large picture windows, lengthened from 60 feet to 77.5 feet, air conditioning, and became passenger/baggage car No. 110. (*C. Able photograph—Clifford R. Scholes collection*)

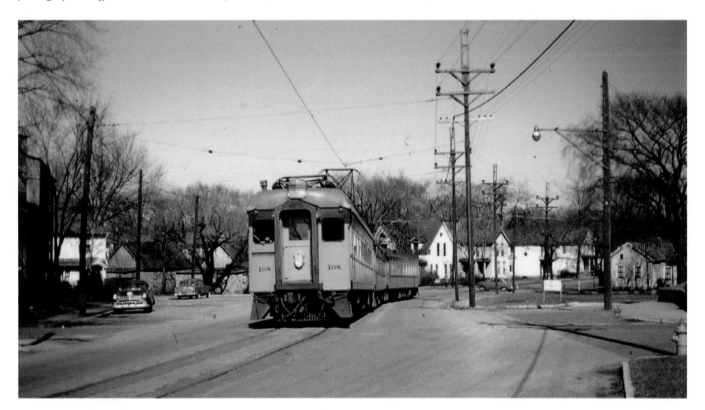

Westbound CSS&SBR coach/baggage car No. 108 is on 11th Street at Cedar Street, which is about two blocks east of the Michigan City 11th Street South Shore station on March 31, 1956. Car No. 108 was lengthened from 60 feet to 77.5 feet in 1943, and in 1949, it received wide picture windows and was air conditioned. (*C. Able photograph—Clifford R. Scholes collection*)

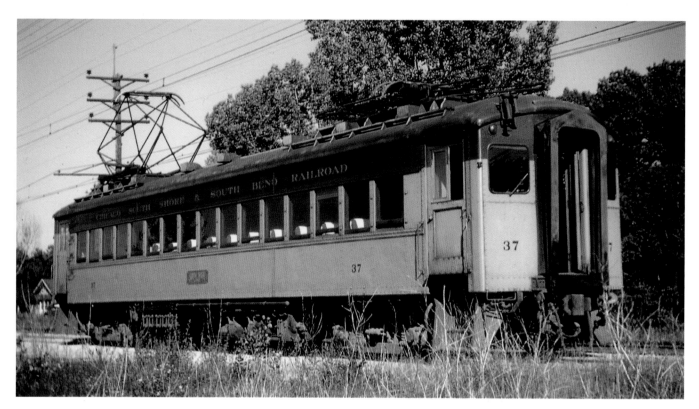

Unincorporated Tremont, Indiana, is the location of CSS&SBR coach No. 37 on June 17, 1956. In 1908, the Tremont train station opened. After the U.S. Congress in 1966 authorized the creation of the Indiana Dunes National Lakeshore, land condemnation proceedings began and Tremont ceased to exist, resulting in the closure of the train station, which was replaced by the Dune Park station. (*C. Able photograph— Clifford R. Scholes collection*)

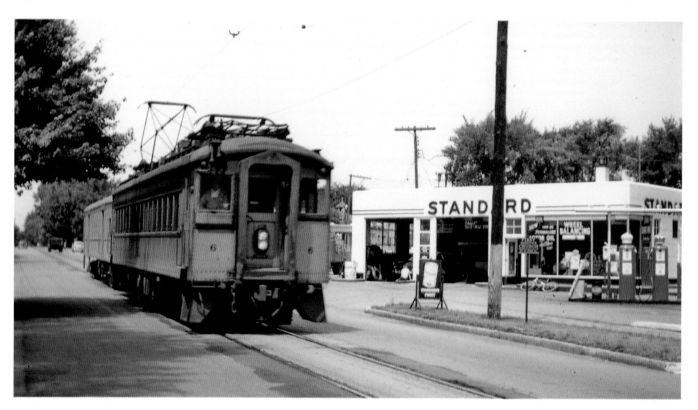

On July 7, 1956, CSS&SBR coach No. 6 and baggage trailer car No. 504 (formerly Indiana Railway car No. 377) are cruising along 11th Street in Michigan City. Car No. 6 was acquired by the East Troy electric Railroad Museum in 2010. (*C. Able photograph—Clifford R. Scholes collection*)

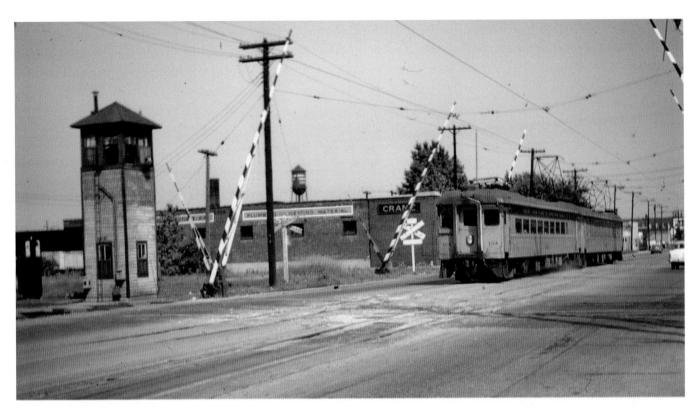

Chicago Avenue at Calumet Avenue with the at grade crossing of the Pennsylvania Railroad in East Chicago, Indiana, is the location of CSS&SBR two-car train headed by coach/baggage car No. 104 on September 8, 1956. Car No. 104 was lengthened from 60 feet to 77.5 feet in 1943, and received wide picture windows plus air conditioning by 1950. (*C. Able photograph—Clifford R. Scholes collection*)

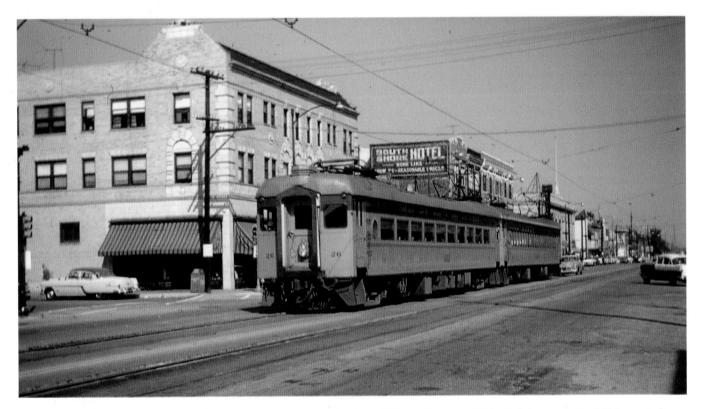

On September 8, 1956, CSS&SBR coach No. 26 is part of a two-car train on Chicago Avenue at White Oak Avenue in East Chicago, Indiana. In 1948, car No. 26 was lengthened from 61 feet to 78.5 feet, plus it received wide picture windows and was air conditioned. (*C. Able photograph—Clifford R. Scholes collection*)

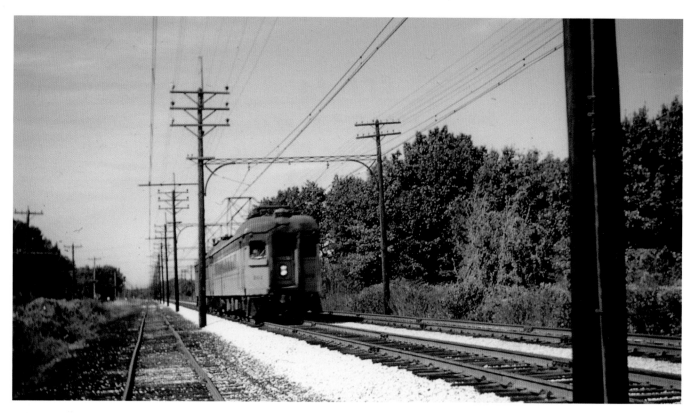

Wilson siding east of Ogden Dunes, Indiana, is the location of CSS&SBR trailer car No. 201 (lengthened from 61 feet to 78.5 feet in 1946), which is part of a two-car train on September 16, 1956. (*C. Able photograph—Clifford R. Scholes collection*)

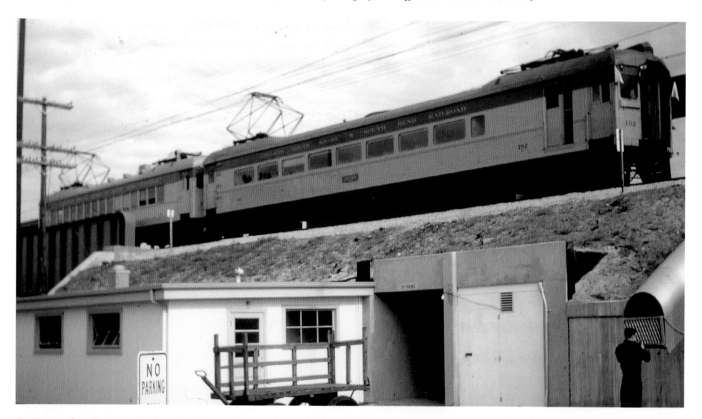

On September 16, 1956, the first day of operation on the new relocated line extending from Cline Avenue in Gary to Columbia Avenue in Hammond, CSS&SBR coach/baggage car No. 102 with coach No. 34 on a Central Electric Railfan's Association (CERA) rail excursion are operating on the new line along the Indiana Toll Road, which eliminated twenty-seven railroad crossings and twenty-eight street crossings. (*C. Able photograph—Clifford R. Scholes collection*)

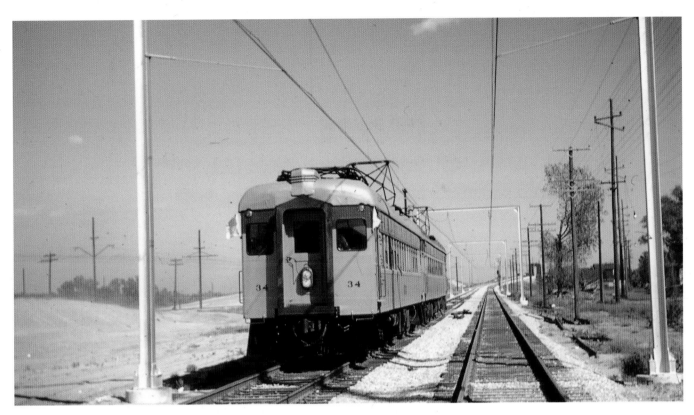

CSS&SBR coach No. 34 and coach/baggage car No. 102 on a CERA rail excursion is traversing the relocated line near East Chicago, Indiana, on September 16, 1956. (*C. Able photograph—Clifford R. Scholes collection*)

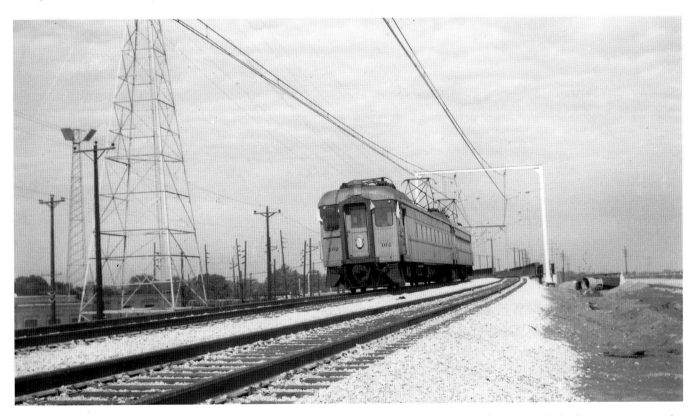

On September 16, 1956, CSS&SBR coach/baggage car No. 102 with coach No. 34 on a CERA rail excursion is the first train to cover the opening of the well-built relocated line paralleling the Indiana Toll Road and bypassing East Chicago, Illinois. (*Clifford R. Scholes collection*)

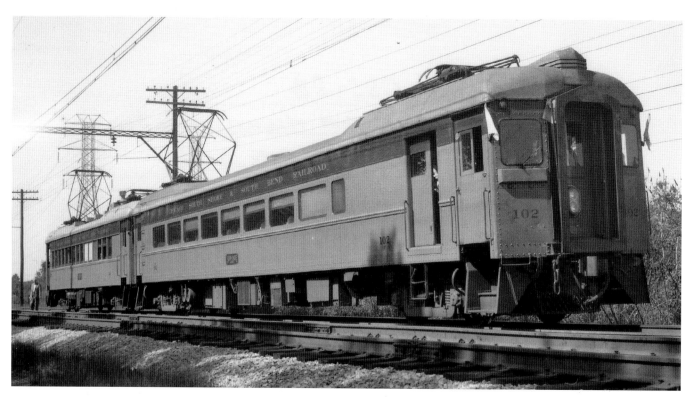

The CERA rail excursion train consisting of cars 102 and 34 are at the Dunes, Indiana, siding, operating on the opening day of the relocated line on September 16, 1956. (*Clifford R. Scholes collection*)

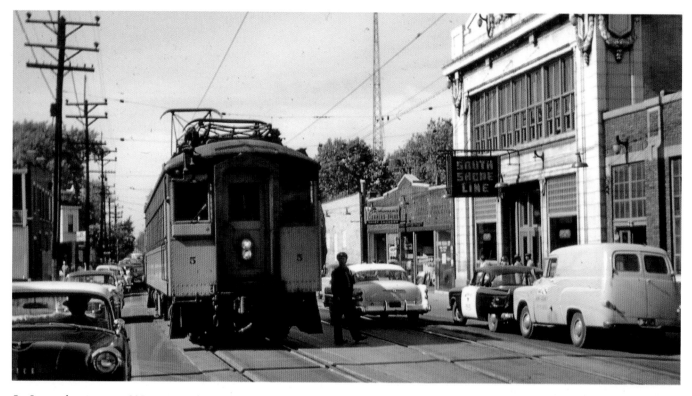

On September 29, 1956, CSS&SBR coach No. 5 is making a passenger stop at the 11th Street station in Michigan City, Indiana. Over thirty-five years earlier, a Thursday May 19, 1921 Michigan City newspaper article announced that the formal opening of the station would be "Saturday night of this week between the hours of 7 p.m. an 11 p.m. An orchestra will furnish music for dancing in the station proper, and a band concert will be given in the garage." Built by the P. H. Lorenz Company of Moline, Illinois, at a cost of $200,000, this handsome two-story station (with its large doors and wide plate glass windows) opened on Saturday May 21, 1927 with rail passengers handled at the front of the station and bus passengers handled at the rear of the station. (*C. Able photograph—Clifford R. Scholes collection*)

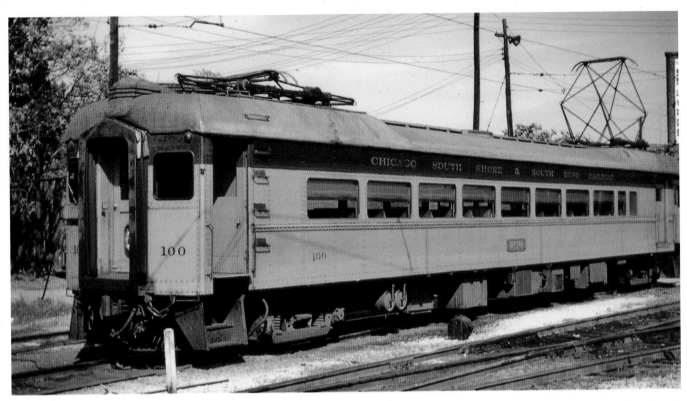

The CSS&SBR storage yard at South Bend, Indiana, is the location of coach/baggage car No. 100 on September 29, 1956. This car (lengthened from 60 feet to 77.5 feet in 1943, received air conditioning and large picture windows in 1949) had been in service for thirty years when this picture was taken. (*C. Able photograph—Clifford R. Scholes collection*)

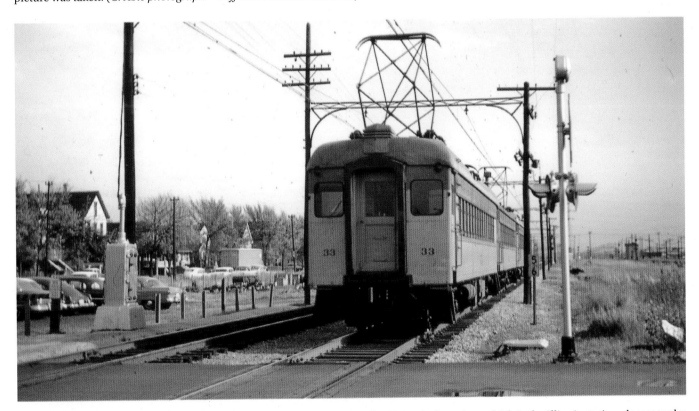

On October 6, 1956, CSS&SBR coach No. 33 is part of a train of cars at the Hegewisch station, which is the Illinois station closest to the Illinois–Indiana border. Car No. 33 was acquired by the East Troy Electric Railway in 2010. This neighborhood on Chicago's far south side was named for Adolph Hegewisch, president of the U.S. Rolling Stock Company, who laid out the town in 1883. The town was annexed by Chicago in 1889. (*C. Able photograph—Clifford R. Scholes collection*)

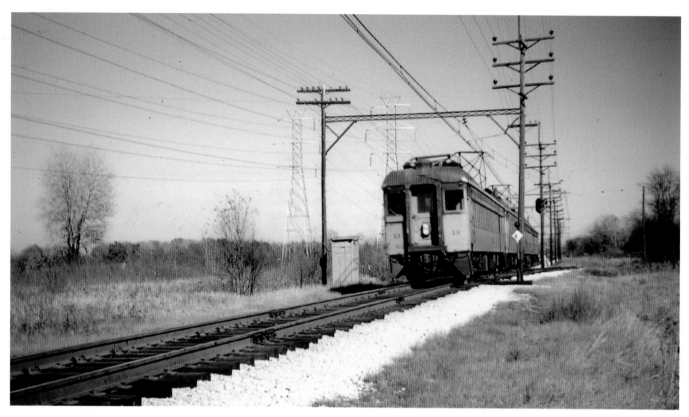

A four-car CSS&SBR train headed by coach No. 13 (lengthened from 60 feet to 77.5 feet in 1946) is at Keiser siding west of Beverly Shores, Indiana, on October 27, 1956. Car No. 13 was acquired by the East Troy Electric Railway Museum in 1998. (*C. Able photograph—Clifford R. Scholes collection*)

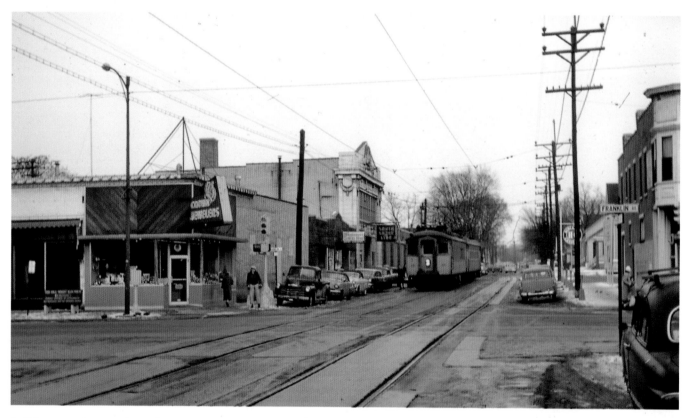

In February 1957, a westbound two-car CSS&SBR train headed by coach No. 35 is making a passenger stop at the downtown Michigan City station on 11th Street just east of Franklin Street. The approximately 2-mile stretch of track that runs in the middle of 10th and 11th Streets in Michigan City is what makes the CSS&SBR the last real interurban line in the United States. (*C. Able photograph—Clifford R. Scholes collection*)

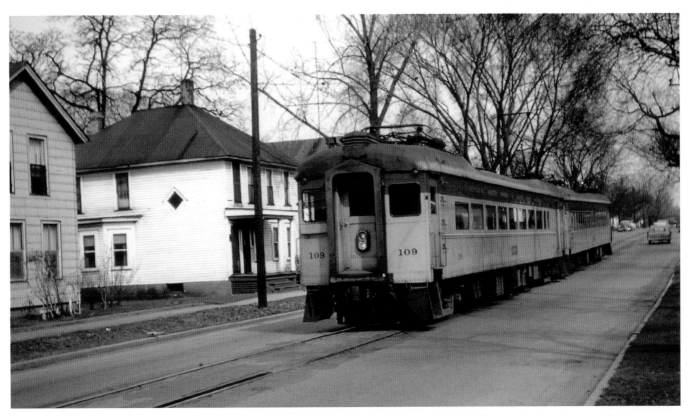

CSS&SBR coach/baggage car No. 109 and another car are on 11th Street in Michigan City on March 23, 1957. Car No. 109 was lengthened from 60 feet to 77.5 feet in 1944, and by 1950, it received picture windows and air conditioning. (*C. Able photograph—Clifford R. Scholes collection*)

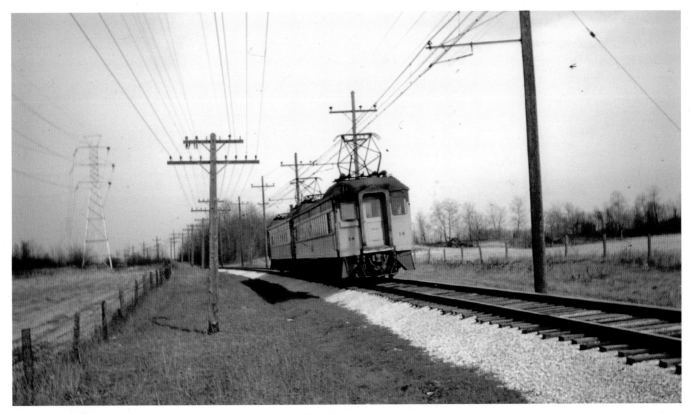

Just like an interurban scene of days past, CSS&SBR coach No. 14 (the second 60-foot-long car lengthened from 60 feet to 77.5 feet in 1942) is part of a two-car train on a single stretch of well-maintained track near Michigan City on March 23, 1957. (*C. Able photograph—Clifford R. Scholes collection*)

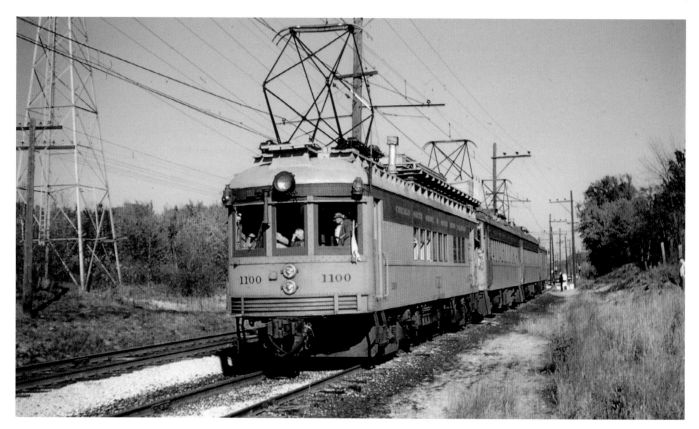

On October 13, 1957, CSS&SBR line car No. 1100 is leading a four-car train at Davis siding east of Michigan City on what appears to be a photo stop in a rail excursion. (*Clifford R. Scholes collection*)

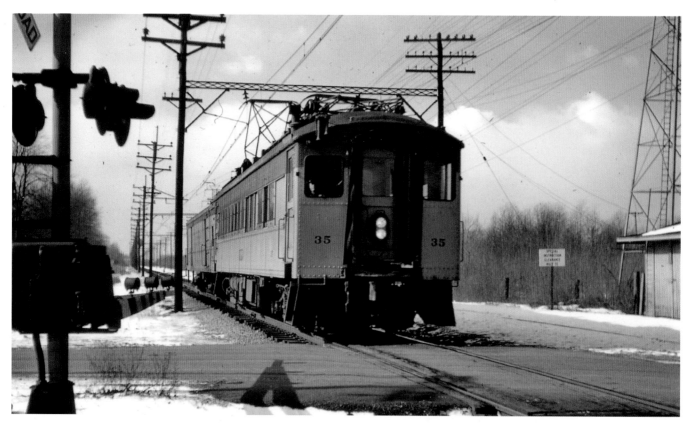

On a snow-covered February 8, 1958, CSS&SBR coach No. 35 and baggage car No. 503 are at Tremont, Indiana. (*C. Able photograph—Clifford R. Scholes collection*)

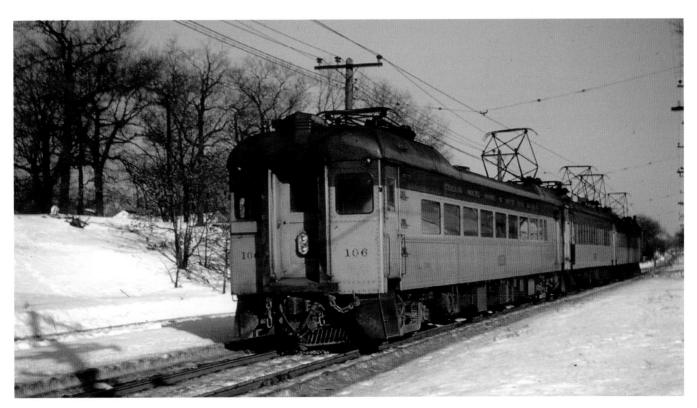

A February 23, 1958 winter scene finds CSS&SBR coach/baggage car No. 106 part of a three-car train near the Michigan City shops. (*C. Able photograph—Clifford R. Scholes collection*)

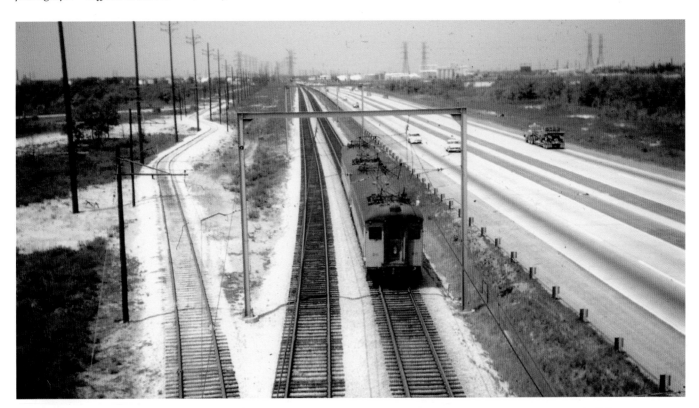

CSS&SBR coach No. 28 plus another car are on the double-track section parallel to the Indiana Toll Road near East Chicago, Indiana, on May 24, 1958. This was one of ten coaches, Nos. 26–35, built by Standard Car Company in 1928. These 61-foot-long, 129,600-pound cars were each powered by four Westinghouse type W567-C11 motors, rode on Baldwin type 84-60AA trucks, and seated forty-eight passengers. In 1948, car No. 28 was lengthened to 78.5 feet and received picture windows and air conditioning. Car No. 28 is now preserved at the Illinois Railway Museum. (*C. Able photograph—Clifford R. Scholes collection*)

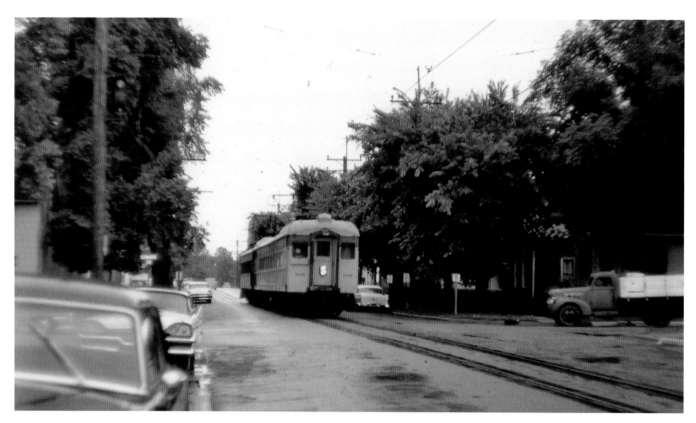

On a rainy June 15, 1959, CSS&SBR coach/baggage car No. 106 and coach No. 7 glide along the 11th Street trackage in Michigan City. (*C. Able photograph—Clifford R. Scholes collection*)

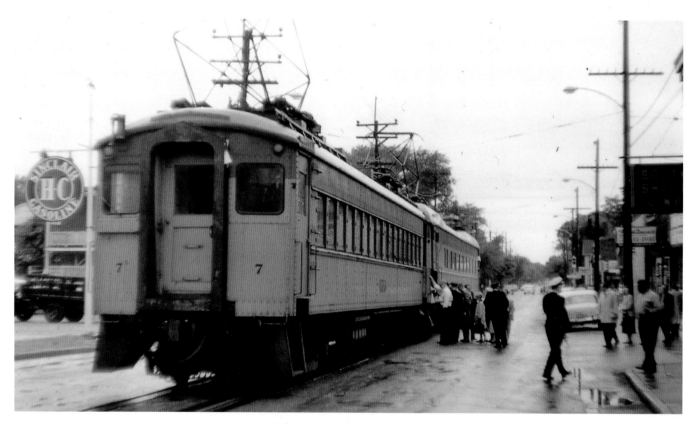

There is a flurry of activity as passengers board CSS&SBR train No. 16, comprised of coach Nos. 7 and 106 at the 11th Street near Franklin Street station in Michigan City on June 15, 1959. (*C. Able photograph—Clifford R. Scholes collection*)

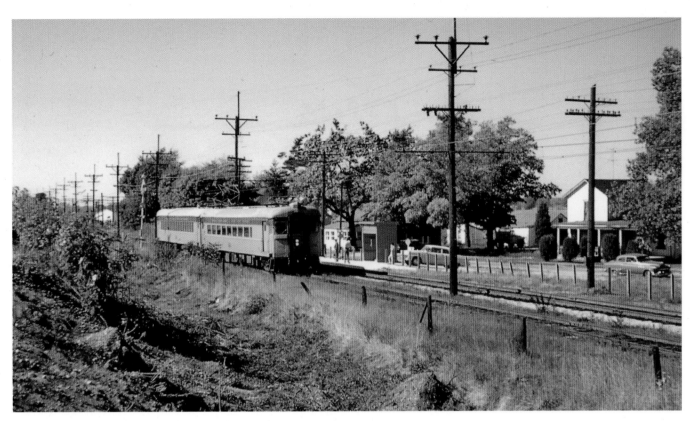

New Carlisle, Indiana, station shelter is the location of CSS&SBR coach/baggage car No. 109 and another car on October 9, 1960. (*Clifford R. Scholes collection*)

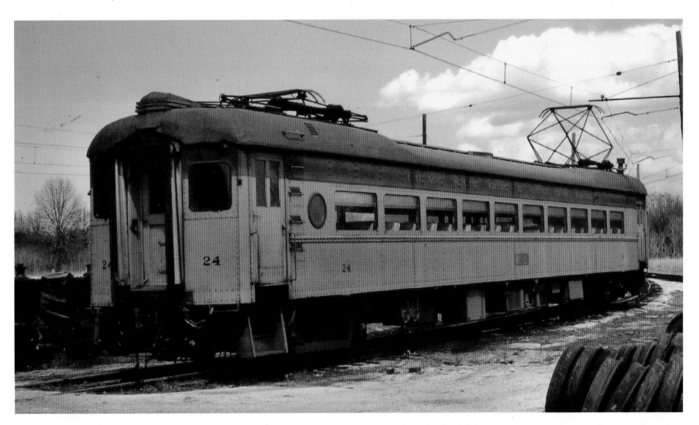

On April 30, 1961, CSS&SBR coach No. 24 (lengthened from 61 feet to 68.5 feet, plus rebuilt with large picture windows and air conditioning in 1947) is at the Michigan City yard waiting for the next assignment. This car was acquired by the East Troy Electric Railroad Museum in 1992. (*Clifford R. Scholes collection*)

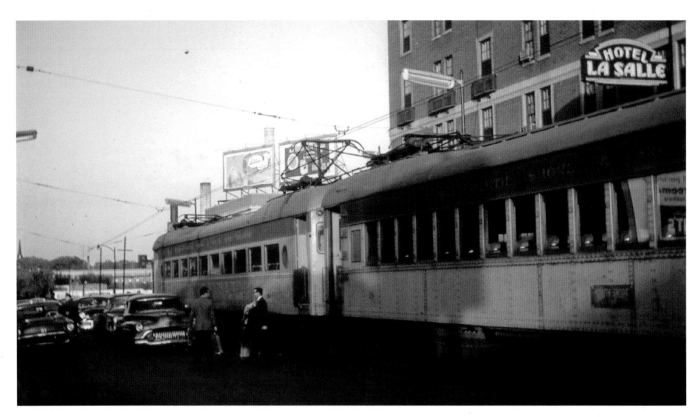

At the downtown South Bend, Indiana, station on LaSalle Avenue at Michigan Street by the Hotel LaSalle, CSS&SBR coaches Nos. 19 and 18 have passengers ready to board the train in April 1960. The Hotel LaSalle (named for explorer Rene Robert Cavelier, sieur de LaSalle, who had canoed down the Mississippi River to the Gulf of Mexico and on April 9, 1682 claimed the Mississippi basin for France and named it Louisiana) was built at a cost of $750,000 in 1921. (*Clifford R. Scholes collection*)

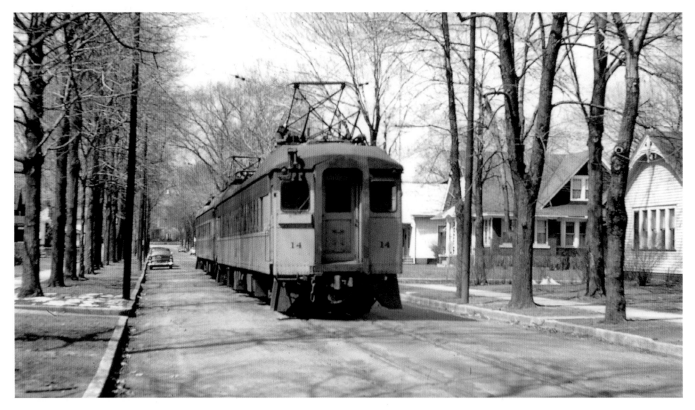

In true interurban style, CSS&SBR coach No. 14 and another car are traveling along this neat residential street with trees on both sides along Colfax Avenue in South Bend on April 8, 1962. (*C. Able photograph—Clifford R. Scholes collection*)

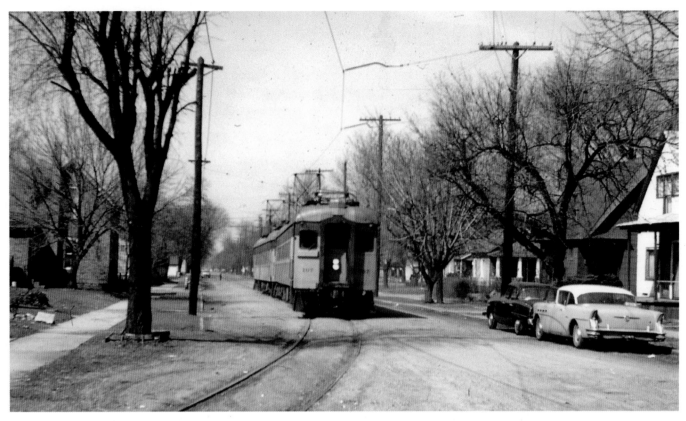

On April 8, 1962, CSS&SBR coach/baggage car No. 107 plus another car are turning from Colfax Avenue to Orange Street in South Bend. (*Bob Crockett photograph—Clifford R. Scholes collection*)

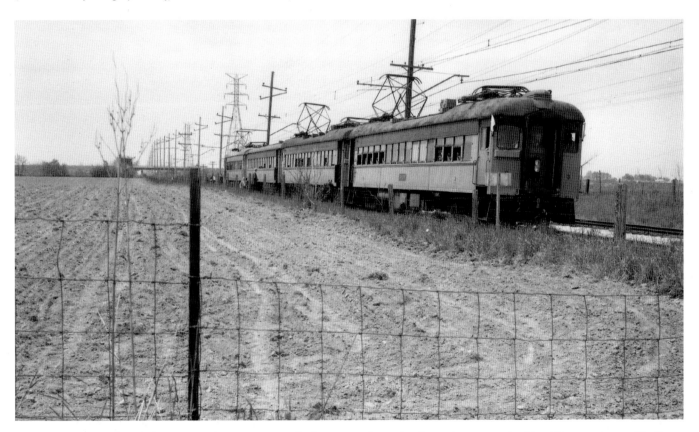

Displaying a white flag, CSS&SBR coach No. 3 is part of a four-car train posing for a picture stop in this 1963 scene in rural Indiana. (*Ed O'Meara photograph—Clifford R. Scholes collection*)

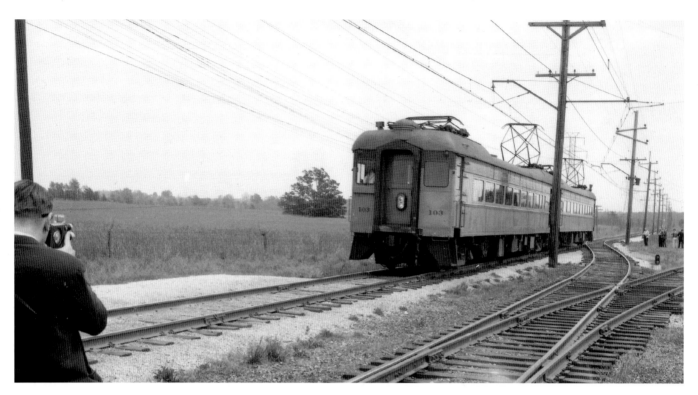

In 1963, CSS&SBR coach/baggage car No. 103 with another car are at Birchim siding in a rural area near Hudson Lake, Indiana. This was probably a photo stop on a rail excursion as evidenced by the gentleman with camera in hand taking a picture. (*Ed O'Meara photograph—Clifford R. Scholes collection*)

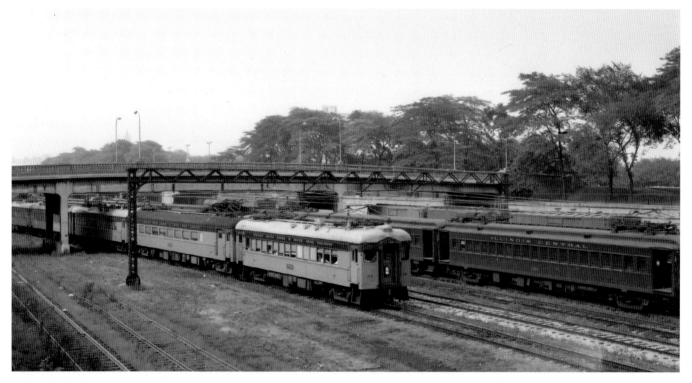

A five-car CSS&SBR train headed by coach No. 35 is on the trackage also used by the Illinois Central Railroad south of Roosevelt Road in Chicago during 1963. For 14.4 miles from Randolph Street station (renamed Millennium Station in 2007) in downtown Chicago to 115th Street, the CSS&SBR operated on the Illinois Central Railroad (ICR). On August 10, 1972, the ICR merged with the Gulf, Mobile & Ohio Railroad to form the Illinois Central Gulf Railroad (ICGR). In 1982, the Northeast Illinois Regional Railroad Corporation was created and became known as Metra, which stands for Metropolitan Rail. Metra purchased the ICGR's electrified commuter line in 1987. (*Ed O'Meara photograph—Clifford R. Scholes collection*)

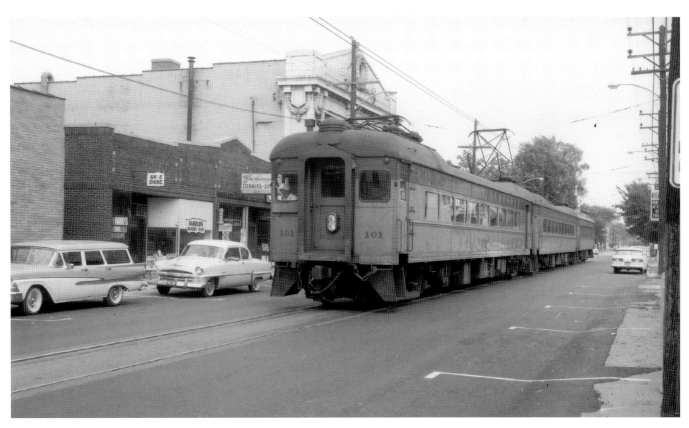

In 1963, a CSS&SBR westbound, three-car train headed by coach/baggage car No. 101 is at the 11th Street station in Michigan City. This car was lengthened from 60 feet to 77.5 feet in 1943. Since the heavy steel car was constructed to steam railroad standards, the motors and trucks were able to handle the lengthened car's increased weight. (*Ed O'Meara photograph—Clifford R. Scholes collection*)

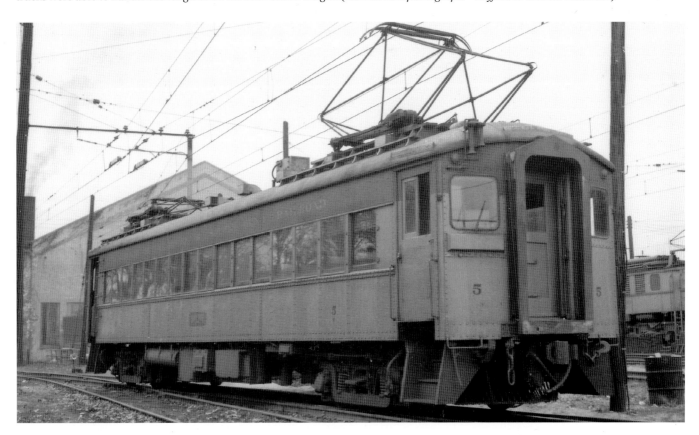

CSS&SBR coach No. 5 is in front of a Michigan City shop building in 1965. (*Clifford R. Scholes collection*)

CHICAGO SOUTH SHORE AND SOUTH BEND RAILROAD
Issued October 29, 1967 ALL TIME SHOWN IS CHICAGO LOCAL TIME

<--WEEKDAYS (MONDAY through FRIDAY)-->

EASTBOUND
Time shown is that in effect in Chicago

	1 bc	3 bc	105	5	107	9 bc	211	13 bc	215 bc	17 bc	219 bc	21 bc	125	225 bc	27 bc	201	127	203	29	129	31 bc	
	AM	AM	AM	AM	AM	AM	AM	AM	AM	AM	PM	PM	PM	PM	PM	PM	PM	PM	PM	PM	PM	
Lv CHICAGO Randolph St.	12.45	2.30	6.03		6.30	7.14	8.30	9.20	10.25	11.30	12.30	1.50	3.00	3.30	4.05	4.28	4.49	5.05	5.18	5.30	6.00	
Lv Van Buren St.	12.47	2.32	6.05		6.32	7.16	8.32	9.22	10.27	11.32	12.32	1.52	3.02	3.32	4.07	4.30	4.51	5.07	5.20	5.32	6.02	
Lv Roosevelt Rd. (Cen. Sta.)	12.49	2.34	6.07		6.34	7.18	8.34	9.24	10.29	11.34	12.34	1.54	3.04	3.34	4.09	4.32	4.53	5.09		5.34	6.04	
Lv 57th St. (Univ. of Chgo.)	12.55	2.40	6.13		6.40	7.24	8.41	9.30	10.35	11.40	12.40	2.00	3.10	3.40	4.15	4.38	4.59	5.17	5.31	5.40	6.10	
Lv Woodlawn (63rd St.)	12.58	2.42	6.15		6.42	7.26	8.43	9.32	10.37	11.42	12.42	2.02	3.12	3.42	4.17	4.40	5.01	5.18		5.42	6.12	
Lv KENSINGTON	1.06	2.51	6.24		6.51	7.35	8.51	9.41	10.46	11.51	12.51	2.11	3.21	3.51	4.26	4.49	5.11		5.39	5.51	6.21	
Lv Calumet Harbor	f 1.09	2.54	f 6.29		f 6.54		f 8.55	f 9.45	f 10.50		f 12.55		3.25		3.58		4.57	5.19	5.35	5.56		
Lv HEGEWISCH	1.13	2.57	6.30		6.57	7.42	8.58	9.48	10.53	11.58	12.59	2.18	3.28	3.58	4.03	4.36	5.02	5.40	5.40	6.00	6.28	
Lv HAMMOND	1.17	3.02	6.34		7.02	7.46	9.02	9.52	10.58	12.02	1.02	2.23	3.32	4.03		4.36	5.07	5.30	5.40	6.10	6.33	
Lv EAST CHICAGO	1.22	3.07	6.38		7.07	7.50	9.06	9.57	11.03	12.07	1.07	2.28	3.37	4.08	4.41		5.07	5.45			6.38	
Lv Clark Road	B 1.26		B 6.43		B 7.11	c 7.54	B 9.10				B 1.11		B 3.41	B 4.12		B 5.11	B 5.34				B 6.15	
Lv Ambridge Ave. (Gary)	f 1.29	f 3.12	B 6.45		B 7.12	f 7.56	f 9.12	f 10.03	f 11.09	f 12.13	f 1.13	2.34				B 5.13	B 5.36				B 6.17	
Lv Buchanan St. (Gary)	f.		f.		B.	f.	f.	f.	f.	f.	f.			c.		f.					f.	
Ar GARY	1.35	3.15	6.50			7.15	8.00	9.17	11.20	11.20	1.20	2.40	3.50		4.20	4.50	5.18	5.40	5.55	6.01	6.25	6.50
Lv GARY	1.35	3.15				8.00	9.17	10.10	11.20	12.20	1.20	2.40			4.20	4.50	5.18		6.03	6.01	6.50	
Lv Miller	1.41	3.20				f 8.05	f 9.23	f 10.16	f 11.25	f 12.25	f 1.25	2.44			f 4.25	f 4.56	5.23		6.10	6.56		
Lv Ogden Dunes	B 1.44	B 3.25				f 8.10	f 9.27	B 10.21	f 11.30	B 12.30	f 1.30	2.50			f 4.30	f 5.01	5.28		6.22	6.20	7.00	
Lv Midwest (Wilson)						f 8.12	f 9.28	f 10.22	f 11.31		f 1.31	2.51					5.35		6.27		7.07	
Lv Bailly	B 1.51					f 9.33		f 11.36		f 1.36												
Lv Dune Acres (Mineral Spgs.)	B.					f.	B 9.34	B.	B.		B 1.37	B 2.56		B 4.37		f 5.36		6.28		7.08		
Lv Port Chester							B.									f 5.11	5.37	6.29			7.09	
Lv TREMONT (The Dunes)	f 1.55	f 3.35				f 8.21	f 9.37	f 10.31	f 11.41	f 12.40	f 1.40	2.59		f 4.40	f 5.13	5.40	6.31		7.11			
Lv Beverly Shores	f 1.59	f 3.39				f 8.26	f 9.41	f 10.37	f 11.45	f 12.44	f 1.45	3.03		f 4.45	f 5.18	5.45	6.35		7.15			
Lv Pines (Tamarack)										c 12.46												
Lv MICHIGAN CITY	2.10	4.00		6.28		8.35	9.50	10.45	11.58	12.55	1.55	3.15		4.55	5.30	5.55	6.46	6.30	7.25			
Lv Shops	2.15	4.10		6.33		8.40	9.55	10.50	12.10	1.00	2.00	3.20		5.00	5.35	6.00	6.50	6.35	7.30			
Lv Springville				f 6.38																		
Lv LaLumiere				f 6.41		B 8.48																
Lv Tee Lake				f 6.42																		
Lv Smith				f 6.43										f 5.44								
Lv Rolling Prairie (Birchim)		f 4.23		f 6.46																		
Lv Lake Park	f 2.31	f 4.26		f 6.49		f 8.57			f 1.16					f 5.53			K	f 7.48				
Lv Hudson Lake		f 4.27		f 6.51		f 8.59		f 11.08	f 1.17		f 3.38						f 7.49					
Lv NEW CARLISLE	f 2.34	f 4.29		f 6.53		f 9.02		f 11.10	f 1.19		f 3.39			f 5.54			f 7.58					
Lv Lydick				f 6.58				f 11.17	f 1.26		f 3.48											
Lv Chain O'Lakes																f 8.07						
Lv Bendix Drive	w 2.47	w 4.43		f 7.04		w 9.14		w 11.22	w 1.34		w 3.53			w 6.06		7.10	w 8.15					
Ar SOUTH BEND	2.55	4.50		7.11		9.20		11.30	1.42		4.01			6.13								
	AM	AM		AM		AM	AM	AM	PM	PM	PM	PM	PM	PM	PM	PM	PM	PM	PM	PM		

<--WEEKDAYS (MONDAY through FRIDAY)-->

WESTBOUND
Time shown is that in effect in Chicago

	4	6	200	106	8 bc	108	204	10	110	12 bc	214 bc	16 bc	218 bc	20 bc	24 bc	226 bc	126	28 bc	128	34 bc
	AM	AM	AM	AM	AM	AM	AM	AM	AM	AM	AM	AM	AM	AM	PM	PM	PM	PM	PM	PM
Lv SOUTH BEND Ind.					5.50		6.35		7.40		9.50		11.59	1.25			3.20		4.50	
Lv Bendix Drive "					c 5.58				c 7.47	c 9.57		c 12.07	c 1.34			c 3.28		4.57		
Lv Chain O'Lakes "												f 12.11					5.02			
Lv Lydick "					f 6.04							f 12.13				f 3.32	5.03			
Lv NEW CARLISLE "					f 6.10				f 7.59	f 10.09		f 12.19	f 1.44			f 3.40	5.09			
Lv Hudson Lake "					f 6.13				f 8.02			f 12.22				f 3.44	5.11			
Lv Lake Park "					f 6.15					f 10.13			f 1.48			f 3.46	5.13			
Lv Rolling Prairie (Birchim) "					f 6.17								f 1.52			f 3.49	f 5.16			
Lv Smith "																	f 5.20			
Lv Tee Lake "																				
Lv LaLumiere "																H 3.54	H 5.22			
Lv Springville "																				
Lv Shops "	4.25	5.20	6.00		6.33		6.55	7.12		8.20	9.35	10.30	11.35	12.39	2.05	3.00		4.05	5.35	
Lv MICHIGAN CITY "	4.30	5.25	6.05		6.40		7.00	7.19		8.25	9.40	10.35	11.40	12.45	2.10	3.05		4.10	5.45	
Lv Pines (Tamarack) "		f 5.32	f 6.12									11.50								
Lv Beverly Shores "	f 4.38	f 5.33	f 6.13		f 6.49		7.09			f 8.35	f 9.52	f 10.46	f 11.52	f 12.54	f 2.19	f 3.14		f 4.20	f 5.55	
Lv TREMONT (The Dunes) "	f 4.42	f 5.37	f 6.19		f 6.54		7.14	f 7.30		f 8.40	f 9.55	f 10.50	f 11.55	f 12.57	f 2.23	f 3.19		f 4.24	f 6.00	
Lv Port Chester "		f 5.39	f 6.22				f.									o.				
Lv Dune Acres (Mineral Spgs.) "	f 4.46	f 5.41	f 6.23		f 6.58		7.19			f 8.43	f 9.58	f 10.53			f 3.22		f 4.27	f 6.03		
Lv Bailly "		f 5.42	f 6.24		6.59		f 7.20			f 9.59			f 1.02	f 2.27	f 3.23		f 4.28	f 6.04		
Lv Midwest (Wilson) "	f 4.48		f 6.26		7.01		f 7.22			f 8.45	f 10.00		f 12.00	2.28	3.24		f 4.29	6.05		
Lv Ogden Dunes "	f 4.52	f 5.49	f 6.31		7.06		f 7.26			c 8.50	f 10.05		f 12.05	c 1.08	2.33		f 4.34	6.12		
Lv Miller "	f 4.57	f 5.55	f 6.36		7.11		f 7.33	7.49			f 10.09	f 11.03	f 12.09	f 1.12		f 3.33		f 4.38	6.15	
Ar GARY "	5.05	6.05	6.48		7.20		7.45	7.45	9.00	10.15	11.10	12.15	1.20	2.45	3.40		4.45	6.20		
Lv GARY "	5.05	6.05	6.48	7.05	7.20	7.32	7.45	7.49	8.20	10.15	11.10	12.15	1.20	2.45	3.40	4.15	4.45	5.50	6.20	
Lv Buchanan St. (Gary) "					f.		f.											f.	f.	
Lv Ambridge Ave. (Gary) "	f 5.08	f 6.09	f 6.51	f 7.09		f 7.36	f 7.48		f 8.24	f 9.04	f 10.19	f 11.14	f 12.19	f 1.24	f 2.49	f 3.44	f 4.19		f 5.54	f 6.23
Lv Clark Road "	f 5.10	f 6.11	f 6.53			f 7.38			f 8.25		c 10.21	c 11.15	c 12.21		f 2.51		f 4.21		f 5.56	
Lv EAST CHICAGO "	5.14	6.16	6.57	7.15	7.30	7.43		7.56	8.30	9.10	10.25	11.20	12.25	1.30	2.55	3.50	4.25	4.55	6.00	6.29
Lv HAMMOND "	5.18	6.21	7.02	7.20	7.35	7.48		8.00	8.35	9.15	10.30	11.25	12.30	1.35	3.00	3.55	4.30	5.00	6.05	6.34
Lv HEGEWISCHIll.	5.22	6.26	7.06	7.25		7.53		8.00	8.39	9.19	10.35	11.29	12.35	1.39	3.04	3.59	4.34	5.04	6.09	6.39
Lv Calumet Harbor "									f 8.42		12.38			4.37	6.12					
Ar KENSINGTON "	5.29	6.32	7.17	7.31	7.48	8.02	8.08	8.48	9.27	10.43	11.38	12.43	1.46	3.14	4.08	4.43	5.10	6.18	6.47	
Ar Woodlawn (63rd St.) "	5.38	6.41	7.26	7.42	7.57	8.10	8.17	8.21	8.56	9.35	10.51	11.47	12.51	1.55	3.23	4.19	4.51	5.19	6.26	6.56
Ar 57th St. (Univ. of Chgo.) "	5.40	6.44	7.28	7.44	7.59	8.12	8.19	8.23	8.59	9.38	10.54	11.49	12.53	1.57	4.19	4.53	5.21	6.28	6.58	
Ar Roosevelt Rd. (Cen. Sta.) "	5.46	6.51	7.35	7.51	8.06	8.21	8.26	8.31	9.07	9.46	11.01	11.57	1.01	2.06	3.31	4.26	5.01	5.28	6.36	7.07
Ar Van Buren St. "	5.48	6.53	7.37	7.53	8.08	8.23	8.28	8.33	9.08	9.48	11.03	11.57	1.03	2.08	3.33	4.28	5.03	5.30	6.38	7.09
Ar Randolph St. "	5.50	6.55	7.40	7.55	8.10	8.25	8.30	8.35	9.10	9.50	11.05	11.59	1.05	2.10	3.35	4.30	5.05	5.32	6.40	7.10
Ar CHICAGOIll.	AM	AM	AM	AM	AM	AM	AM	AM	AM	AM	AM	AM	PM	PM	PM	PM	PM	PM	PM	PM

The October 29, 1967 CSS&SBR schedule shows eleven trips—Monday through Friday—both eastbound and westbound, between Chicago and South Bend with last trips shown on page 55. Reference marks are "F" stops on signal use light at night, "B" stops on signal to discharge revenue passengers, "C" stops on signal to receive revenue passengers, "K" stops on signal to discharge Chicago revenue passengers, and "W" stops on signal to receive or discharge revenue passengers.

CHICAGO SOUTH SHORE AND SOUTH BEND RAILROAD
Issued October 29, 1967 ALL TIME SHOWN IS CHICAGO LOCAL TIME

MONDAY-FRIDAY--><--SATURDAYS, SUNDAYS, AND HOLIDAYS-->

131	33 bc	35 bc	237 bc	239	EASTBOUND Time shown is that in effect in Chicago	501 bc	3 bc	409	311 bc	413	315 bc	417	319 bc	419	523 bc	425	27 bc	529	31 bc	433	35 bc	239	
PM	PM	PM	PM	PM		AM	AM	AM	AM	AM	AM	AM	AM	AM	PM	PM	PM	PM	PM	PM	PM	PM	
6.30	7.00	8.30	9.30	11.35	Lv Randolph St. CHICAGO	12.45	2.30	7.00	8.00	9.00	10.00	11.00	11.59	1.00	2.00	3.00	4.05	5.00	6.00	7.30	8.30	11.35	
6.32	7.02	8.32	9.32	11.36	Lv Van Buren St.	12.47	2.32	7.02	8.02	9.02	10.02	11.02	12.01	1.02	2.02	3.02	4.07	5.02	6.02	7.32	8.32	11.36	
6.34	7.04	8.34	9.34	11.38	Lv Roosevelt Rd. (Cen. Sta.)	12.49	2.34	7.04	8.04	9.04	10.04	11.04	12.03	1.04	2.04	3.04	4.09	5.04	6.04	7.34	8.34	11.38	
6.40	7.10	8.40	9.40	11.45	Lv 57th St. (Univ. of Chgo.)	12.55	2.40	7.10	8.10	9.10	10.10	11.10	12.09	1.10	2.10	3.10	4.15	5.10	6.10	7.40	8.40	11.45	
6.43	7.12	8.42	9.42	11.47	Lv Woodlawn (63rd St.)	12.58	2.42	7.12	8.12	9.12	10.12	11.12	12.12	1.12	2.12	3.12	4.17	5.12	6.12	7.42	8.42	11.47	
6.51	7.21	8.51	9.51	11.56	Lv KENSINGTON	1.06	2.51	7.21	8.21	9.21	10.21	11.21	12.21	1.21	2.21	3.21	4.26	5.21	6.21	7.51	8.51	12.00	
f 6.56	f	f 8.55	f 9.55	f 12.00	Lv Calumet Harbor	f 1.09	f 2.54	f 7.24	f 8.25	f 9.25				f 1.26	f 3.25		4.32	5.28	6.28	7.59	8.58	12.03	
6.59	7.28	8.58	9.58	12.03	Lv HEGEWISCH	1.13	2.57	7.27	8.28	9.28	10.28	11.28	12.28	1.28	2.28	3.28	4.36	5.32	6.32	8.03	9.02	12.07	
7.03	7.32	9.02	10.02	12.07	Lv HAMMOND	1.17	3.02	7.31	8.33	9.33	10.33	11.33	12.33	1.33	2.33	3.33	4.41	5.37	6.38	8.08	9.07	12.11	
7.08	7.37	9.07	10.07	12.11	Lv EAST CHICAGO	1.22	3.07	7.35	8.38	9.38	10.38	11.38	12.38	1.38	2.37	3.37	4.45	5.39		8.12	9.11	12.16	
B 7.12		B 9.11	B 10.11	B 12.14	Lv Clark Road	B 1.26		B 7.39	B 8.42	B 9.42		B 11.42	B 12.42	B 1.42	B 2.42	B 3.41	B 4.47	5.43	6.44	B	B 8.14	B 9.13	B 12.16
B 7.14	f 7.44	f 9.13	f 10.14	f 12.16	Lv Ambridge Ave. (Gary)	f 1.29	f 3.12	B 7.41	B 8.44	B 9.44	f 10.44	B 11.44	B 12.44	B 1.44	f	B 3.43			6.50		B.	9.20	12.20
		f.	f.	f.	Lv Buchanan St. (Gary)	f.	f.		B.	B.	f.	B.	f.	f.					6.50		B.		12.20
7.20	7.50	9.20	10.20	12.20	Ar GARY	1.35	3.15	7.45	8.50	9.50	10.50	11.50	12.50	1.50	2.50	3.50	4.50	5.50	6.50		9.20	12.20	
	7.50	9.20	10.20	12.20	Lv GARY	1.35	3.15		8.50		10.50		12.50		2.50		4.50	5.50	6.50		9.26	12.25	
	f 7.55	f 9.26	f 10.25	f 12.25	Lv Miller	f 1.41	f 3.20		8.55		10.55		f 12.55		f 2.55		4.56	5.57	6.56		9.30	12.30	
	f 8.00	f 9.30	f 10.30	f 12.30	Lv Ogden Dunes	B 1.44	B 3.25		8.59		11.00		f 1.00		3.00		5.01	6.02	7.02			12.36	
			10.31		Lv Midwest (Wilson)				9.01		11.01						5.03		7.07				
	f 9.36	f 10.36	f 12.36		Lv Bailly	B 1.51			9.06		11.05		f 1.06				5.08	6.09	7.07		f 9.36	f 12.36	
	f 8.08	B 9.37	f 10.38	f 12.38	Lv Dune Acres (Mineral Spgs.)	B			B 9.07		f 11.06		f 1.07		f 3.07		5.10	6.11	7.08		B 9.37	f 12.38	
					Lv Port Chester				B.		f 11.07						5.11		7.09				
	f 8.11	f 9.40	f 10.41	f 12.41	Lv TREMONT (The Dunes)	f 1.55	f 3.35		9.11		f 11.09		f 1.10		f 3.10		5.13	6.13	7.11		f 9.40	f 12.41	
	f 8.15	f 9.45	f 10.45	f 12.45	Lv Beverly Shores	f 1.59	f 3.39		9.16		f 11.13		f 1.13		f 3.14		5.18	6.18	7.15		f 9.45	f 12.45	
					Lv Pines (Tamarack)								c 1.16					6.19				12.55	
	8.25	9.55	10.55	12.55	Lv MICHIGAN CITY	2.10	4.00		9.25		11.25		1.25		3.25		5.30	6.30	7.25		9.55	1.00	
	8.30	10.00	11.00	1.00	Lv Shops	2.15	4.10		9.30		11.30		1.30		3.30		5.35	6.30	7.30		10.00		
					Lv Springville														f.		f 10.07		
					Lv LaLumiere																		
					Lv Tee Lake												5.44		7.41				
					Lv Smith												5.48		7.44				
					Lv Rolling Prairie (Birchim)	f 4.23			f 9.44				f 1.46						7.48		f 10.16		
					Lv Lake Park	f 4.26			f 9.47				f 1.47				5.53		7.49				
	f 8.46	f 10.16			Lv Hudson Lake				B 9.48				f 1.49				5.54		7.51		f 10.19		
	f 8.48	f 10.19			Lv NEW CARLISLE	f 4.29			f 9.49		f 11.48		f 1.56						7.58				
					Lv Lydick				9.55		f 11.49												
					Lv Chain O'Lakes								f 2.02				6.06				w 10.31		
	w 9.00	w 10.31			Lv Bendix Drive	w 4.43			w 10.00		w 12.07		f 2.10				6.13		w 8.07		10.40		
	9.10	10.40			Ar SOUTH BEND	4.50			10.07		12.10								8.15				
PM	PM	PM	PM	AM		AM	AM	AM	AM	AM	AM	AM	PM	AM	PM	PM	PM	PM	PM	PM	PM	AM	

MONDAY-FRIDAY><--SATURDAYS, SUNDAYS, AND HOLIDAYS-->

130 bc	36 bc	40 bc	42	WESTBOUND Time shown is that in effect in Chicago	4	6 ▲	406	310	412 bc	514 bc	416 ▲	316 bc	418	320 bc	424	326 bc	426	328 bc	534 bc	334 bc	340 bc
PM	PM	PM	PM		AM	AM	AM	AM	AM	AM	AM	AM	PM	PM	PM	PM	PM	PM	PM	PM	PM
	8.00	9.30	11.00	Lv SOUTH BEND.......Ind.				6.35				10.30		12.30		2.30		4.35		6.30	10.00
	c 8.07	c 9.37	c 11.07	Lv Bendix Drive				c 6.42				c 10.37		c 12.38		c 2.38		c 4.42		c 6.37	c 10.07
				Lv Chain O'Lakes																	
	8.12	f 9.43	f 11.13	Lv Lydick				f 6.46				f 10.43		f 12.44		f 2.44		f 4.48		6.45	f 10.13
	8.19	f 9.49	f 11.19	Lv NEW CARLISLE				f 6.50				f 10.49		f 12.50		f 2.50		f 4.54		6.51	f 10.19
	8.22	f 9.51	f 11.21	Lv Hudson Lake				f 6.52				f 10.52		f 12.53		f 2.53		f 4.57		6.53	f 10.21
	8.23	f 9.53	f 11.23	Lv Lake Park				f 6.53				f 10.53		f 12.54				f 4.58		6.55	f 10.23
		f 9.56		Lv Rolling Prairie (Birchim)				f 6.56								f 2.57				6.58	f 10.26
				Lv Smith		Runs Saturdays only															
				Lv Tee Lake														B 5.06		B 7.03	
				Lv LaLumiere																	
				Lv Springville																	
	8.43	10.11	11.40	Lv Shops	4.25	5.20		7.13		9.05		11.10		1.10		3.10		5.15	6.10	7.10	10.40
	8.48	10.15	11.45	Lv MICHIGAN CITY	4.30	5.25		7.19		9.10		11.15		1.15		3.15		5.20	6.15	7.15	10.45
				Lv Pines (Tamarack)		5.32															
	8.58	f 10.24	f 11.53	Lv Beverly Shores	f 4.38	f 5.33		7.28		f 9.20		f 11.25		f 1.24		f 3.24		f 5.30	6.26	7.25	f 10.54
	9.02	f 10.28	f 11.56	Lv TREMONT (The Dunes)	f 4.42	f 5.37		7.32		f 9.24		f 11.29		f 1.28		f 3.28		f 5.34	6.30	7.30	f 10.57
				Lv Port Chester		f.		7.35		f 9.27		f.		f.		f 3.31		f 5.37	6.33	7.35	
				Lv Dune Acres (Mineral Spgs.)	f 4.46	f 5.41		7.35		f 9.27		f 11.31		f 1.31		f 3.31		f 5.37	6.33	f 7.35	
		f 11.59		Lv Bailly		f 5.42		7.36		f 9.28		f 11.33								f 7.38	f 11.02
	f 9.12	f 10.33	f 12.01	Lv Midwest (Wilson)				7.37		9.29		f 11.35		f 1.38		f 3.38		f 5.45	6.40	7.43	f 11.06
	9.16	f 10.37	f 12.06	Lv Ogden Dunes	f 4.52	f 5.49		7.42		9.34		f 11.39		f 1.42		f 3.42		f 5.50	6.44	f 7.48	f 11.11
		f 10.42	f 12.11	Lv Miller	f 4.57	f 5.55		7.46		9.38		f 11.44		1.50		3.50		6.00	6.50	7.55	11.17
	9.25	10.48	12.20	Ar GARY	5.05	6.05	7.00	7.55	9.00	9.45	10.45	11.50	12.45	1.50	2.50	3.50	4.50	6.00	6.50	7.55	11.17
7.20	9.25	10.48	12.20	Lv GARY	5.05	6.05	7.00	7.55	9.00	9.45	10.45	11.50	12.45	1.50	2.50	3.50	4.50	6.00	6.50	7.55	11.17
f.	f.	f.	f.	Lv Buchanan St. (Gary)	f 5.08	f 6.09	f 7.04	o...	o...	f 9.04	f 10.49	f 11.54	f 12.49	f 1.54	f 2.54	f 3.54	f 4.54	f 6.04	6.54	f 7.59	f 11.21
7.23	9.28	f 10.51	f 12.23	Lv Ambridge Ave. (Gary)	c 5.10	6.11				9.06	9.51	11.56	12.51		2.56	3.56	4.56	6.08	6.57	8.01	
7.26	9.30			Lv Clark Road									c 12.51		c 2.56	c					
7.29	9.35	10.57	12.29	Lv EAST CHICAGO	5.14	6.16	7.10	8.05	9.10	9.55	10.55	12.01	1.00	2.00	3.00	4.00	5.00	6.12	7.01	8.05	11.27
7.34	9.43	11.01	12.34	Lv HAMMOND	5.18	6.21	7.14	8.10	9.14	10.00	11.00	12.06	1.04	2.05	3.05	4.05	5.05	6.17	7.06	8.10	11.32
7.39	9.46	11.05	12.38	Lv HEGEWISCH.......Ill.	5.22	6.26	7.18	8.15	9.19	10.05	11.04	12.10	1.06	2.09	3.08	4.09	5.11	6.21	7.11	8.17	11.36
7.41				Lv Calumet Harbor					f 9.22	f 10.08	f 11.07	f 12.13	f 1.06							f.	
7.47	9.54	11.10	12.44	Ar KENSINGTON	5.29	6.32	7.24	8.23	9.28	10.14	11.13	12.18	1.11	2.16	3.17	4.16	5.16	6.28	7.17	8.22	11.43
7.55	10.02	11.19	12.52	Ar Woodlawn (63rd St.)	5.38	6.41	7.32	8.31	9.37	10.22	11.22	12.26	1.20	2.27	3.27	4.27	5.27	6.37	7.27	8.31	11.52
7.57	10.04	11.21	12.54	Ar 57th St. (Univ. of Chgo.)	5.40	6.44	7.34	8.33	9.39	10.24	11.24	12.29	1.23	2.29	3.29	4.29	5.29	6.39	7.29	8.34	11.54
8.05	10.11	11.28	1.01	Ar Roosevelt Rd. (Cen. Sta.)	5.46	6.51	7.41	8.41	9.46	10.31	11.31	12.36	1.31	2.36	3.36	4.36	5.36	6.46	7.36	8.41	12.01
8.07	10.13	11.30	1.03	Ar Van Buren St.	5.48	6.53	7.43	8.43	9.48	10.33	11.33	12.38	1.33	2.38	3.38	4.38	5.38	6.48	7.38	8.43	12.03
8.10	10.15	11.32	1.05	Ar Randolph St. CHICAGO.....Ill.	5.50	6.55	7.45	8.45	9.50	10.35	11.35	12.40	1.35	2.40	3.40	4.40	5.40	6.50	7.40	8.45	12.05
PM	PM	PM	PM		AM	AM	AM	AM	AM	AM	AM	PM	PM	PM	PM	PM	PM	PM	PM	PM	AM

The October 29, 1967 CSS&BR schedule shows seven trips—Saturdays, Sundays, and Holidays—eastbound and seven westbound trips between Chicago and South Bend. Reference marks for this schedule are "F" stops on signal use light at night, "B" stops on signal to discharge revenue passengers, "C" stops on signal to receive revenue passengers, and "W" stops on signal to receive or discharge revenue passengers.

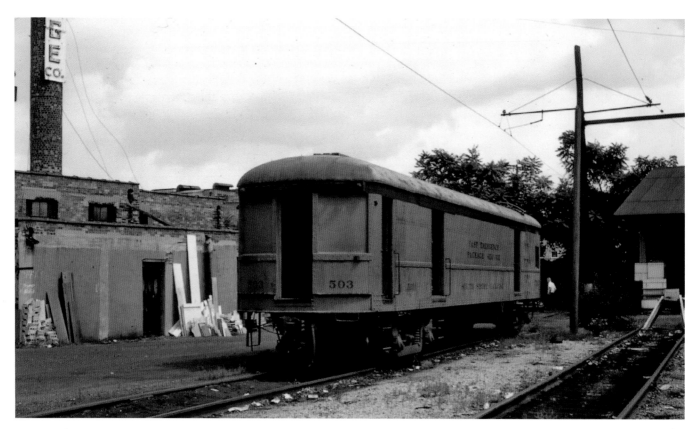

CSS&SBR baggage car No. 503 is at the South Bend yard on August 28, 1966. This car was built in 1926 as Indiana Railroad car No. 375, was rebuilt as baggage car No. 503 in 1941, and was rebuilt again in 1952, adding doors and removing windows. (*Clifford R. Scholes collection*)

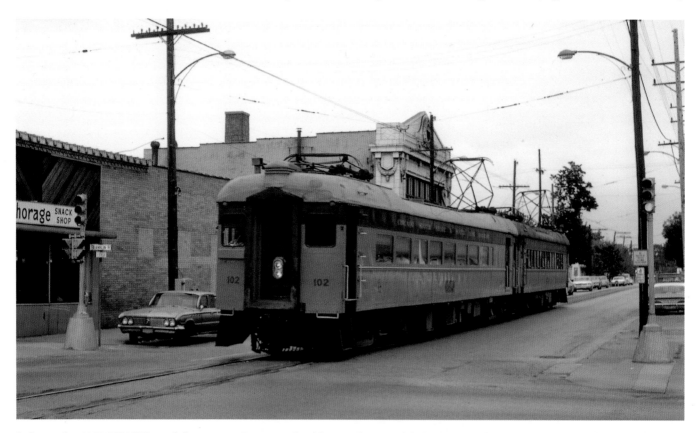

In September 1967, CSS&SBR coach/baggage car No. 102 and coach No. 12 have just left the downtown Michigan City Station (large building with white façade at center of picture) on 11th Street at Franklin Street heading west for Chicago. (*C. Able photograph—Clifford R. Scholes collection*)

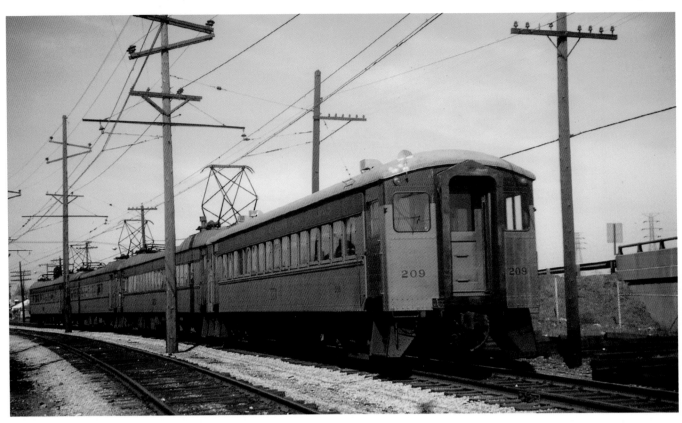

CSS&SBR trailer car No. 209 is at the end of a four-car train just west of the Gary, Indiana, station on a sunny April 12, 1968. (*Kenneth C. Springirth photograph*)

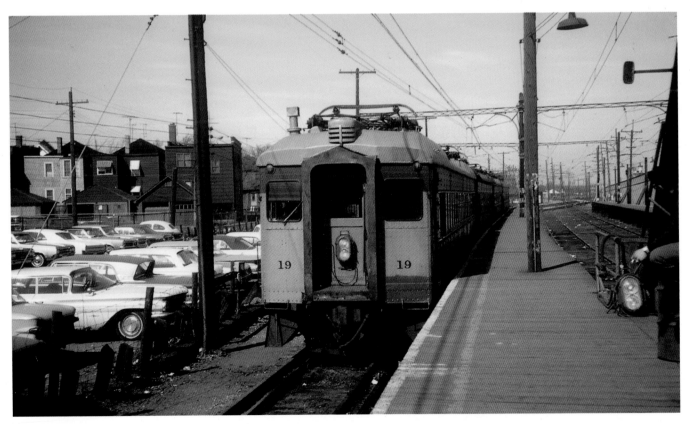

On April 12, 1968, CSS&SBR coach No. 19 (lengthened from 61 feet to 78.5 feet in 1945) is in the lineup of cars at the Gary station. This car is now preserved at the Illinois Railway Museum. (*Kenneth C. Springirth photograph*)

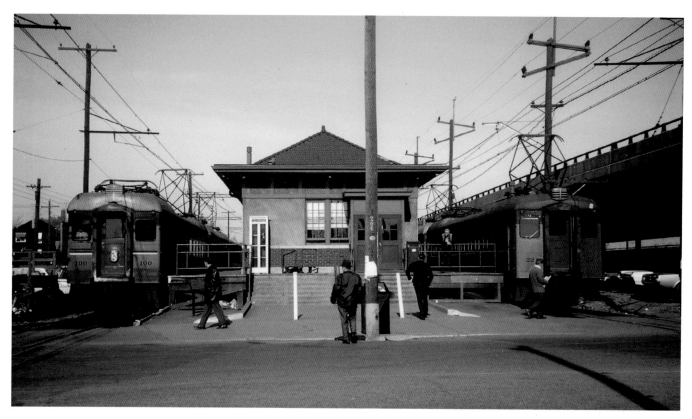

From left to right: CSS&SBR coach/baggage car No. 100 and coach No. 22 are at the busy Gary station on April 12, 1968. This scene changed dramatically sixteen years later in June 1984, when the City of Gary, Federal Highway Administration, and the Indiana Toll Road Commission completed the Gary Metro Center station on an elevated line through downtown Gary. (*Kenneth C. Springirth photograph*)

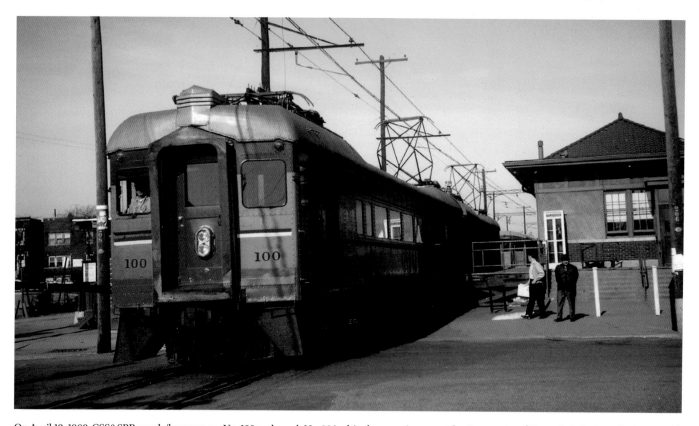

On April 12, 1968, CSS&SBR coach/baggage car No. 100 and coach No. 22 in this close up view are at the Gary station. (*Kenneth C. Springirth photograph*)

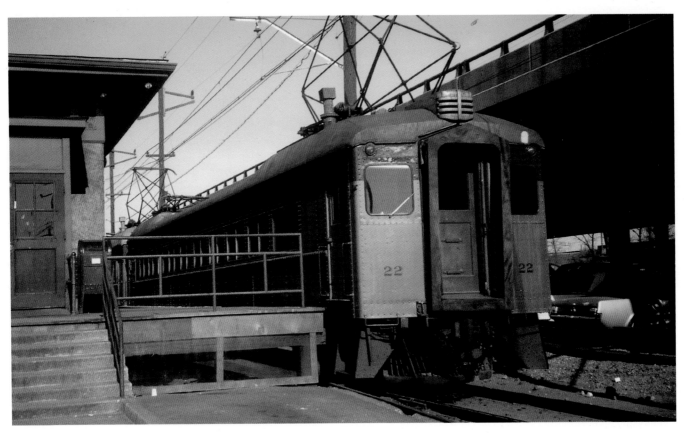

CSS&SBR coach No. 22 is at the Gary station in this April 12, 1968 view with the Indiana Toll Road on the right. (*Kenneth C. Springirth photograph*)

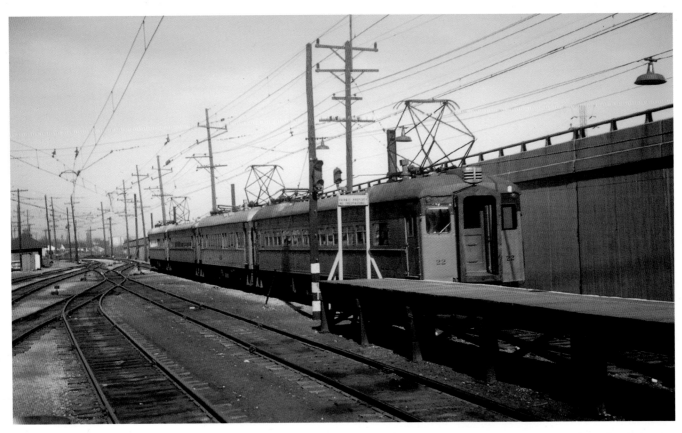

On April 12, 1968, CSS&SBR coach No. 22 (lengthened from 61 feet to 78.5 feet in 1945) is at the end of a four-car eastbound train leaving the Gary station. (*Kenneth C. Springirth photograph*)

CSSB&SBR coach No. 25 (lengthened from 61 feet to 78.5 feet, and rebuilt with large picture windows and air conditioning in 1947) is part of an eastbound train at the Gary station on April 12, 1968. This car was acquired by the East Troy Electric Railway Museum in 1983. (*Kenneth C. Springirth photograph*)

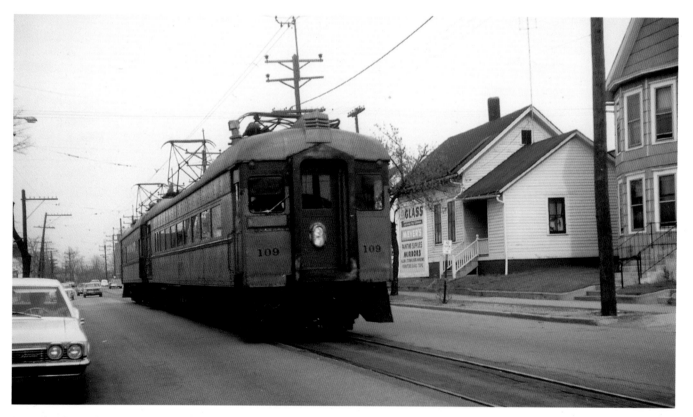

On a cloudy April 12, 1968, CSS&SBR coach/baggage car No. 109 is leading a two-car train on 11th Street in Michigan City. (*Kenneth C. Springirth photograph*)

A two-car CSS&SBR train with coach/baggage car No. 111 at the end is making a passenger stop on 11th Street in front of the Michigan City Station on April 12, 1968. (*Kenneth C. Springirth photograph*)

On April 12, 1968, a CSS&SBR baggage handler is ready to haul away packages received from coach /baggage car No. 109 at the 11th Street Michigan City Station, with coach No. 7 on the left. (*Kenneth C. Springirth photograph*)

CSS&SBR coach No. 7 is part of a two-car train on 11th Street at Franklin Street in Michigan City on April 12, 1968. Over the years, the South Shore Line has been an important link between the towns and cities of Northwestern Indiana and the large employment center of Chicago's central business district. (*Kenneth C. Springirth photograph*)

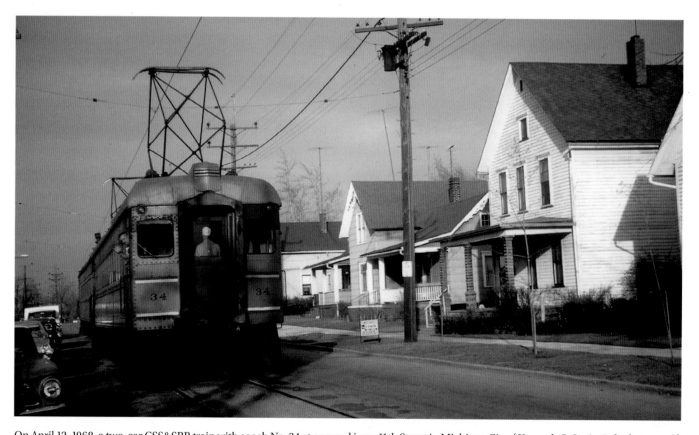

On April 12, 1968, a two-car CSS&SBR train with coach No. 34 at one end is on 11th Street in Michigan City. (*Kenneth C. Springirth photograph*)

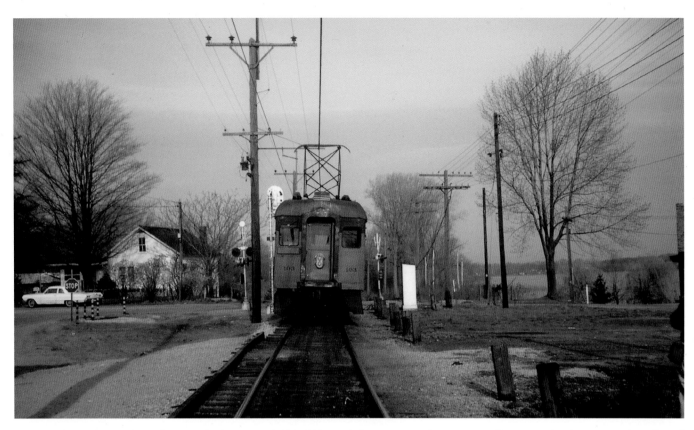

Picturesque Hudson Lake, Indiana, is the location of CSS&SBR coach/baggage car No. 103 on April 13, 1968. Car No. 103 was lengthened from 60 feet to 77.5 feet in 1943, and by 1950, it had received picture windows and air conditioning. (*Kenneth C. Springirth photograph*)

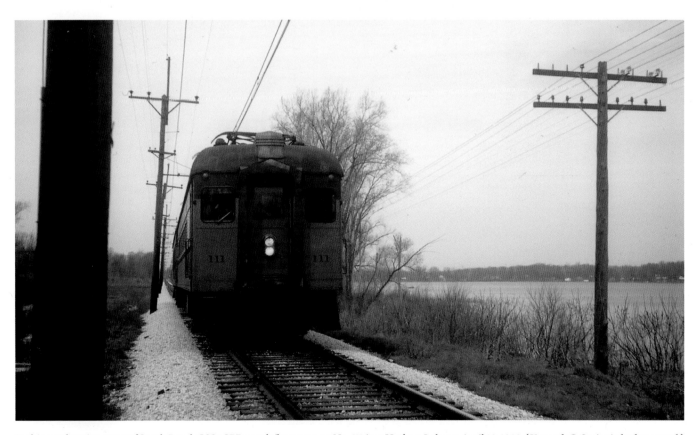

In this rural setting, west of South Bend, CSS&SBR coach/baggage car No. 111 is at Hudson Lake on April 13, 1968. (*Kenneth C. Springirth photograph*)

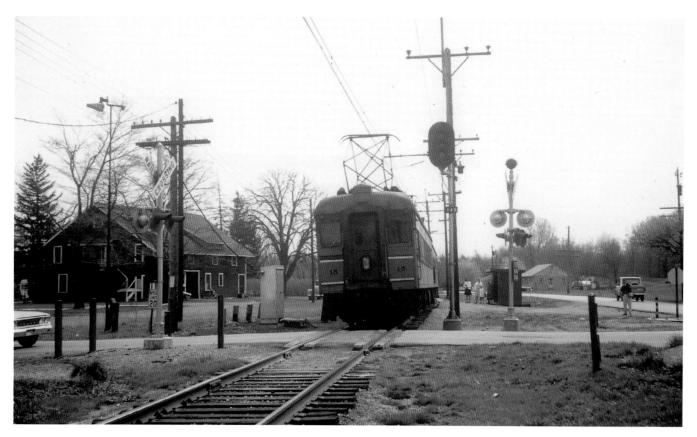

On April 13, 1968, CSS&SBR coach No. 15 and passenger/baggage car No. 111 are at the Hudson Lake passenger stop. (*Kenneth C. Springirth photograph*)

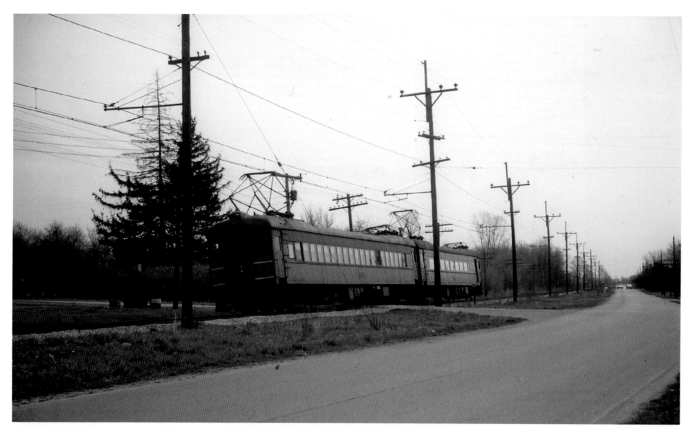

CSS&SBR coach No. 15 and coach/baggage car No. 111 on April 13, 1968 typify why this is the last real interurban line in the United States with its side of the road right of way at Hudson Lake. (*Kenneth C. Springirth photograph*)

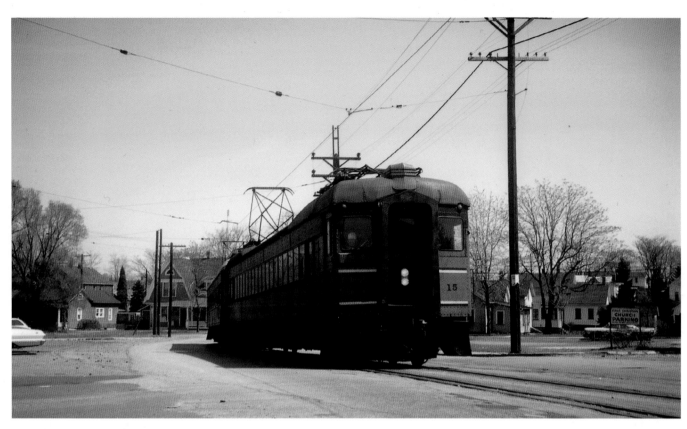

A westbound CSS&SBR train headed by coach No. 15 is on 11th Street at Cedar Street in Michigan City, just about two blocks east of its next stop at the Michigan City South Shore station on April 12, 1968. (*Kenneth C. Springirth photograph*)

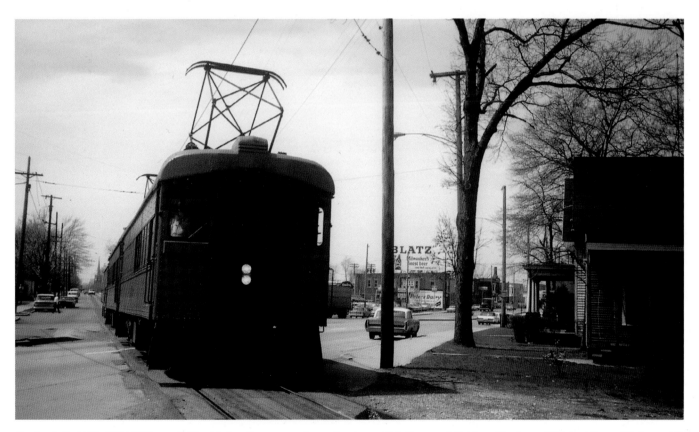

On April 12, 1968, CSS&SBR coach No. 4 is heading an eastbound train on 11th Street at Michigan Boulevard (United States Highway 35) in Michigan City. (*Kenneth C. Springirth photograph*)

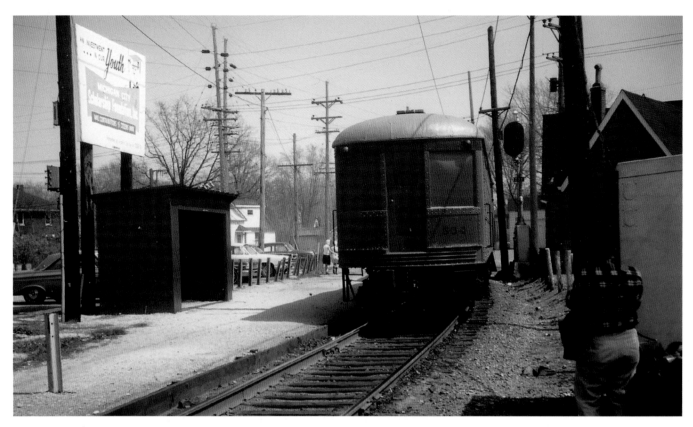

Michigan Boulevard and 11th Street in Michigan City is the location of CSS&SBR baggage trailer car No. 504 (formerly Indiana Railroad car No. 377) on April 12, 1968. (*Kenneth C. Springirth photograph*)

The interior of CSS&SBR coach/baggage car No. 103 exhibits a clean, comfortable, and practical look in this April 13, 1969 view. (*Kenneth C. Springirth photograph*)

The skilled mechanics of the CSS&SBR Michigan City shops have done an amazing job over the years in maintaining the passenger fleet and electric freight locomotives in this inside view of the work in progress on April 12, 1968. A small portion of car No. 35 is on the right side of the picture. The fully equipped facility handled car inspection and included wheel, electrical, blacksmith, carpenter, paint, and machine shops. (*Kenneth C. Springirth photograph*)

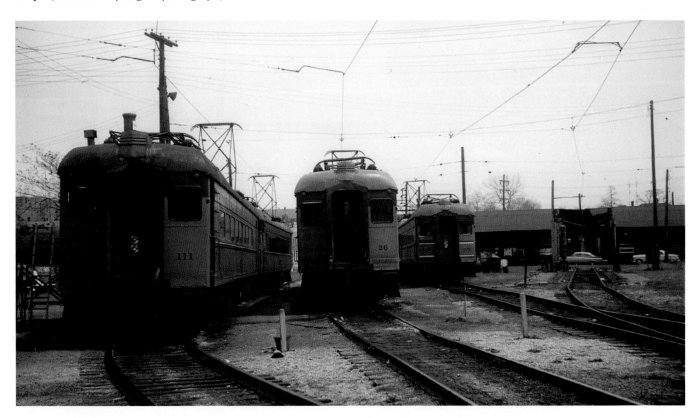

On April 13, 1968, the CSS&SBR South Bend, Indiana, yard shows a lineup of rolling stock in the lead position on each track. *From left to right*: coach baggage car No. 111, coach No. 26, and coach/baggage car No. 100. (*Kenneth C. Springirth photograph*)

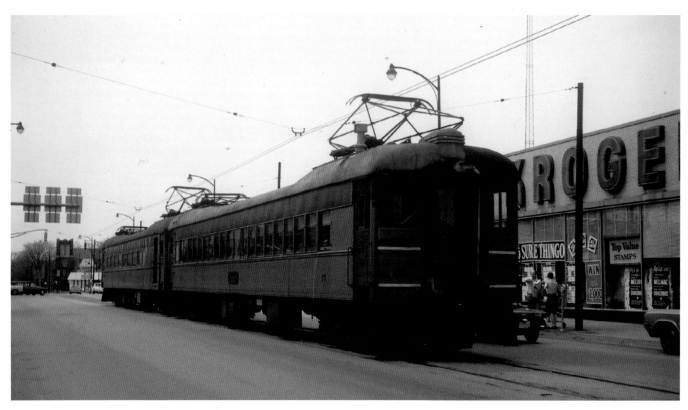

LaSalle Avenue in downtown South Bend is the location of CSS&SBR coach No. 15 and coach/baggage car No. 111 on April 13, 1968. The railroad entered South Bend on the west side past the Bendix plant, east on Colfax, went north to LaSalle, east on LaSalle to the station at Michigan Street, and continued east on LaSalle to the service yard east of the St. Joseph River. (*Kenneth C. Springirth photograph*)

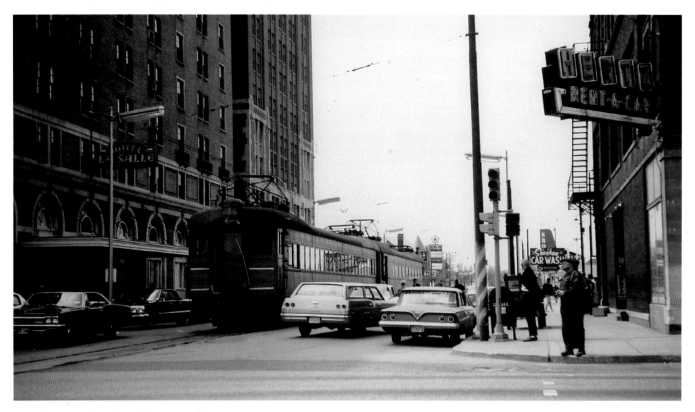

On April 13, 1968, CSS&SBR coach No. 15 (lengthened from 60 to 77.5 feet in 1942) and coach/baggage car No. 11 (lengthened from 60 to 77.5 feet in 1945) are at the South Bend terminus on LaSalle Avenue at Michigan Street. On the left is the nine-story Georgian Revival-style Hotel LaSalle with its elaborate lower windows designed by architect Willard M. Ellwood. (*Kenneth C. Springirth photograph*)

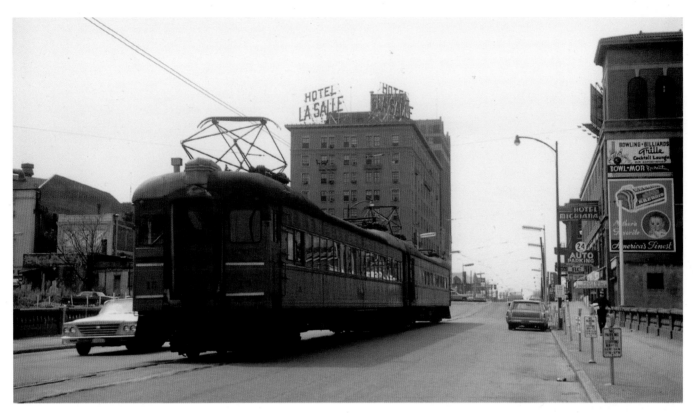

On April 13, 1968, CSS&SBR, coach No. 15 and coach/baggage car No. 111 are on La Salle Avenue heading toward the La Salle Hotel (seen in background). (*Kenneth C. Springirth photograph*)

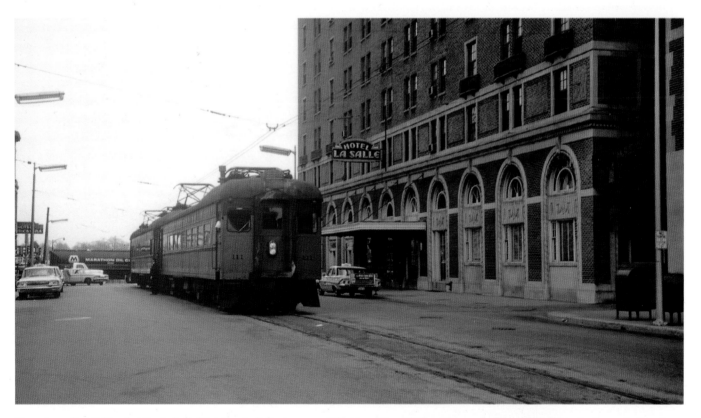

Downtown South Bend at the LaSalle Hotel on LaSalle Avenue at Michigan Street is the other end of the CSS&SBR train shown in the above picture, consisting of cars Nos. 111 and 15 on April 13, 1968. The LaSalle Hotel with its 233 rooms plus banquet and ballroom facilities had an excellent business for many years with the CSS&SBR right at its front door. (*Kenneth C. Springirth photograph*)

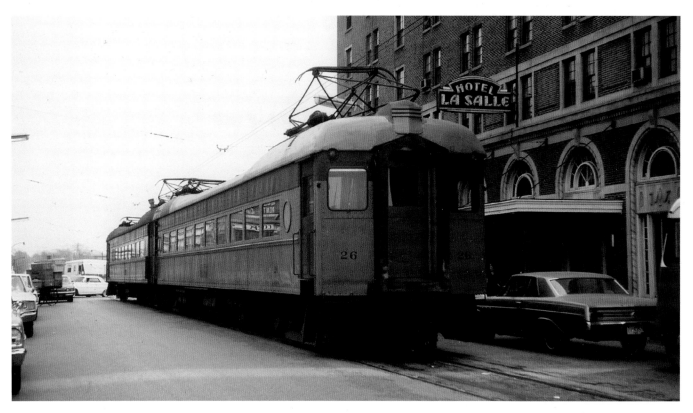

LaSalle Hotel guests have a convenient connection with the CSS&SBR terminus virtually door to door as shown by coach No. 26 and another car on La Salle Avenue at Michigan Avenue on April 13, 1968. The downtown passenger station on LaSalle Avenue at Michigan Street was relocated on July 7, 1969 to the western end of South Bend. In 1975, the hotel building was purchased by the Charismatic Renewal Services Inc.; however, it later became vacant and was refurbished into the LaSalle Apartments. (*Kenneth C. Springirth photograph*)

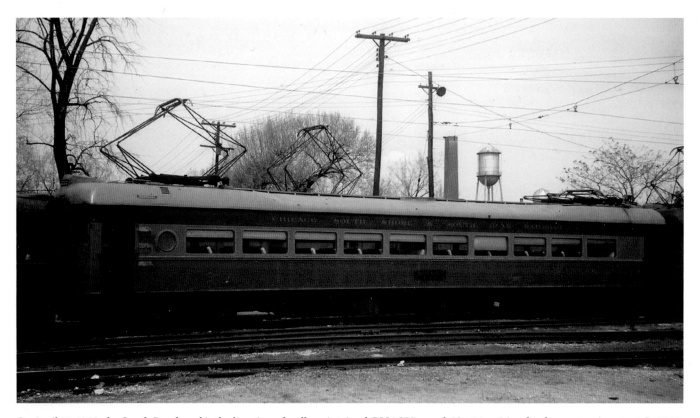

On April 13, 1968, the South Bend yard is the location of well-maintained CSS&SBR coach No. 26 waiting for the next assignment. In 1948, this car was lengthened from 61 feet to 78.5 feet, received large picture windows, and air conditioning. (*Kenneth C. Springirth photograph*)

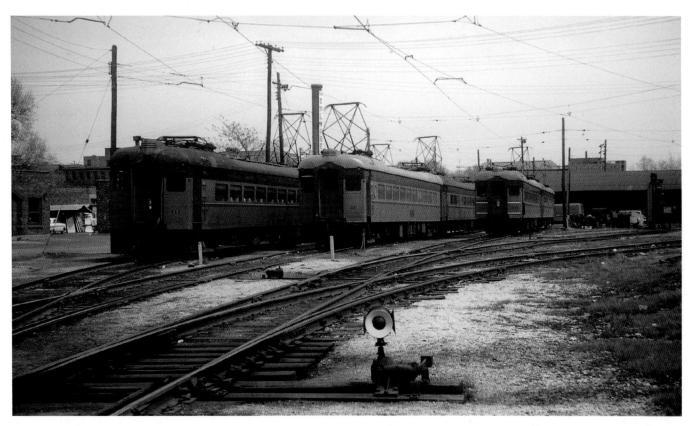

The South Bend yard on April 13, 1968 shows a lineup of CSS&SBR rolling stock. *From left to right*: coach/baggage car No. 111, coach No. 26, and coach/baggage car No. 100. (*Kenneth C. Springirth photograph*)

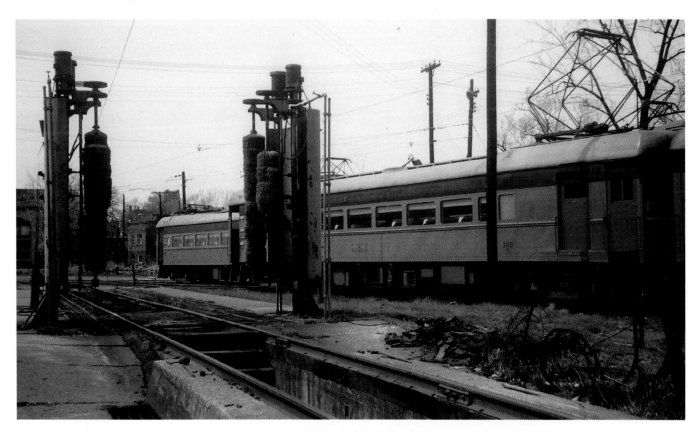

On April 13, 1968, CSS&SBR coach/baggage car No. 100 is adjacent to the South Bend yard carwash. This car was lengthened from 60 feet to 77.5 feet in 1943. Between 1949 and 1950, cars Nos. 100–109 received picture windows and air conditioning. (*Kenneth C. Springirth photograph*)

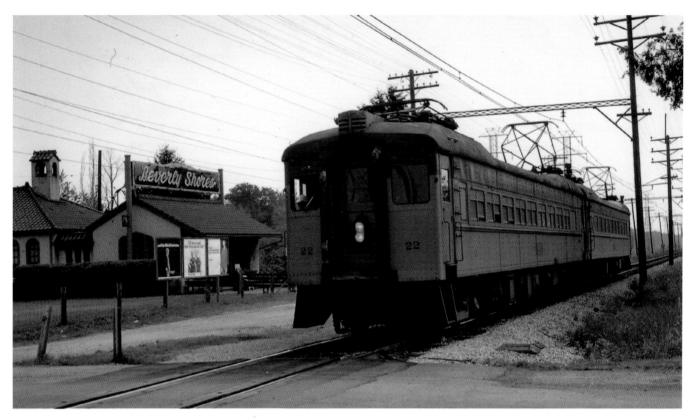

A two-car CSS&SBR train headed by coach No. 22 is at Beverly Shores station in June 1968. This station serves the Dunes area of Indiana. Summer homes developed just north of the station along Lake Michigan because of the accessibility to Chicago by the rail line. (*Clifford R. Scholes collection*)

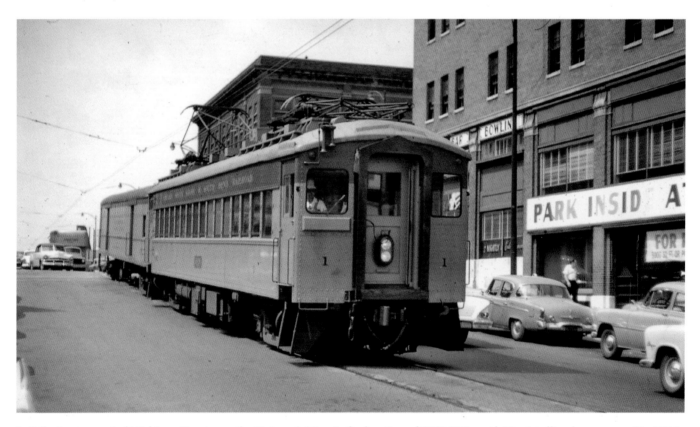

LaSalle Avenue east of Michigan Street near the St. Joseph River is the location of CSS&SBR coach No. 1 pulling baggage car No. 503 in September 1968. (*Clifford R. Scholes collection*)

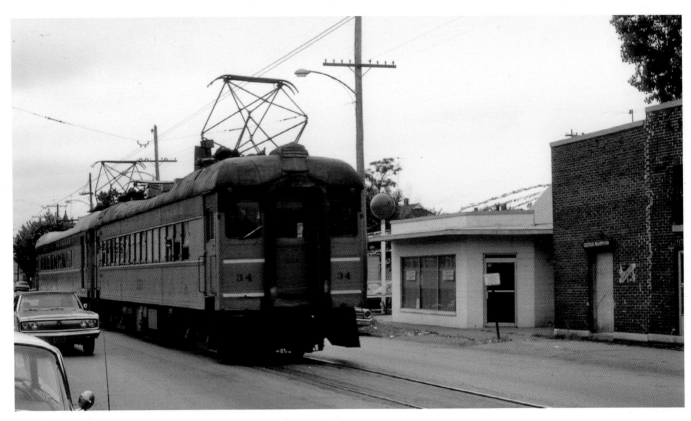

CSS&SBR coach No. 34 is part of a two-car train on 11th Street near the Michigan City station in August 1969. This car is now preserved at the Illinois Railway Museum. (*Clifford R. Scholes collection*)

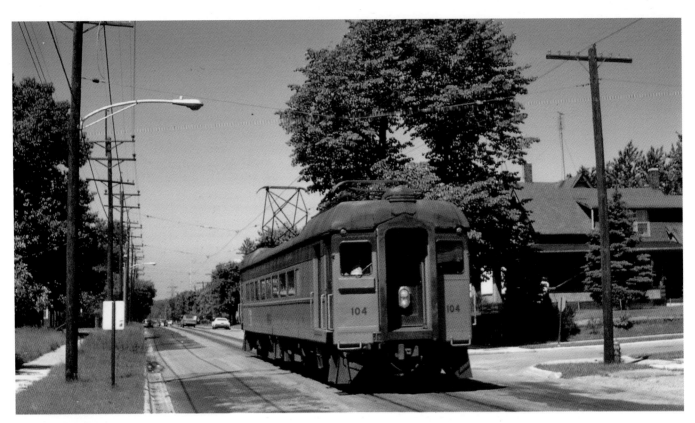

In 1974, CSS&SBR coach/baggage car No. 104 is carefully traversing 11th Street through Michigan City. This car was lengthened from 60 feet to 77.5 feet in 1943. (*Clifford R. Scholes collection*)

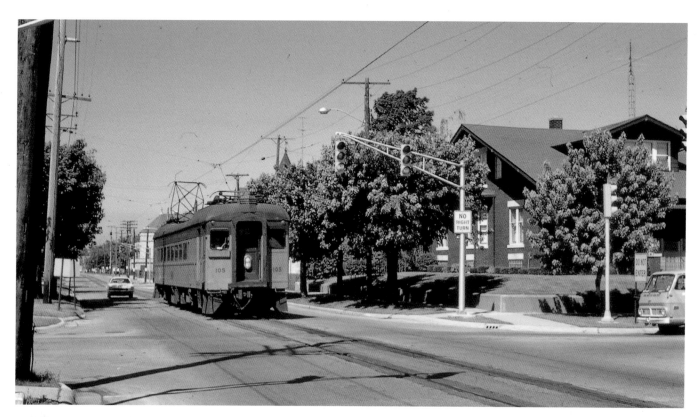

La Salle Avenue in South Bend is the location of CSS&SBR coach/baggage car No. 105 in May 1974. This car was lengthened from 60 feet to 77.5 feet in 1944 and, by 1950, had received picture glass windows and air conditioning. (*Clifford R. Scholes collection*)

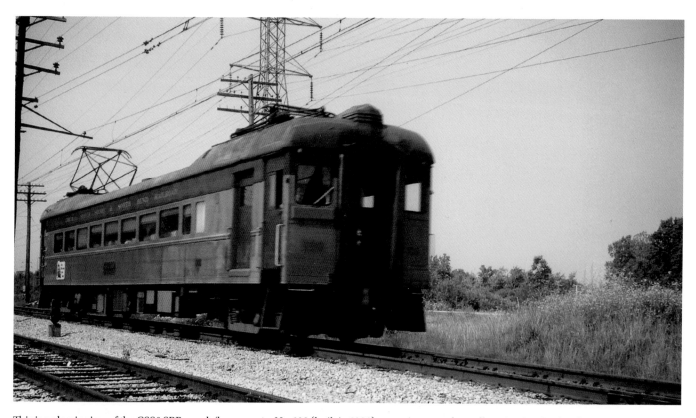

This is a classic view of the CSS&SBR coach/baggage car No. 108 (built in 1926) operating over the well-maintained right of way east of Michigan City in 1974. However, while freight service was profitable, passenger service was showing mounting losses, and it was becoming more difficult to get replacement parts for the railroad's passenger cars that had reached forty-eight years old in 1974. (*Kenneth C. Springirth photograph*)

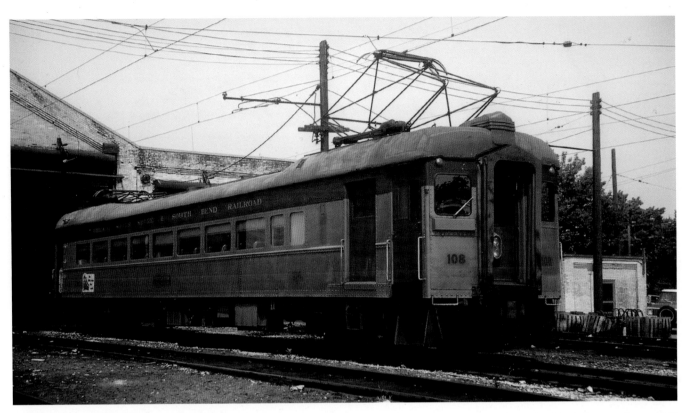

On July 25, 1974, CSS&SBR coach/baggage car No. 108 is outside of the Michigan City shop with a special decal "the little train that could" noted under the last window towards the rear of the car. Traction orange with a maroon upper band spelling out the railroad's name is pleasing to the eye. (*Kenneth C. Springirth photograph*)

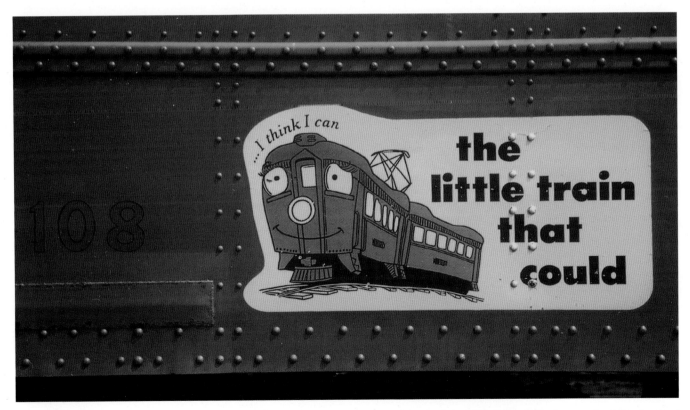

A close up of the decal "the little train that could" on the above car No. 108 on July 25, 1974 signified the difficult times the CSS&SBR had faced including the threat of abandonment of passenger service. While other interurban lines ended service, the railroad with the creation of the Northern Indiana Commuter Transportation District was able to continue passenger service. (*Kenneth C. Springirth photograph*)

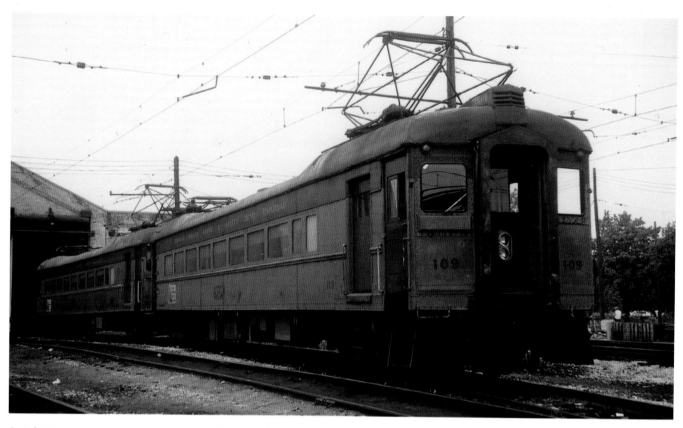

On July 25, 1974, CSS&SBR coach/baggage car No. 109 and another car are at the Michigan City yard by the shop. (*Kenneth C. Springirth photograph*)

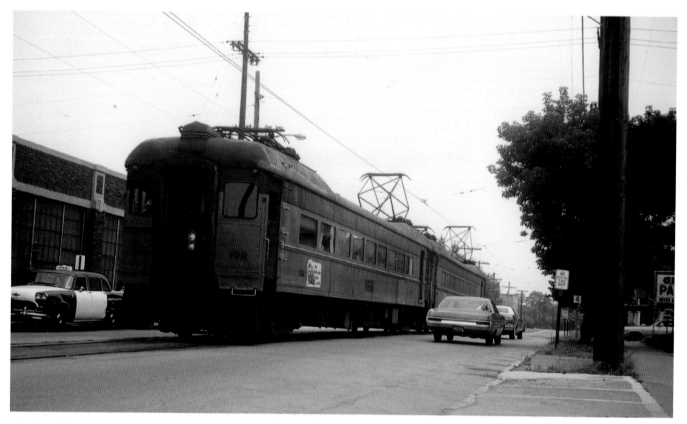

Westbound CSS&SBR coach/baggage cars Nos. 108 and 109 are on 11th Street east of Franklin Street in Michigan City on July 25, 1974. (*Kenneth C. Springirth photograph*)

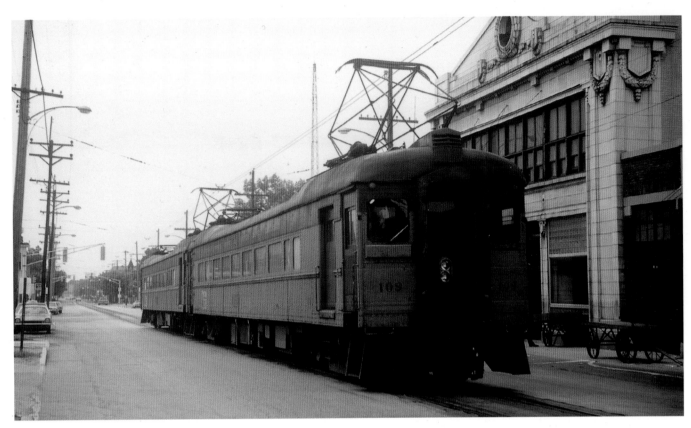

On July 25, 1974, CSS&SBR coach/baggage cars Nos. 108 and 109 are making a passenger stop on 11th Street east of Franklin Street in front of the Michigan City station. (*Kenneth C. Springirth photograph*)

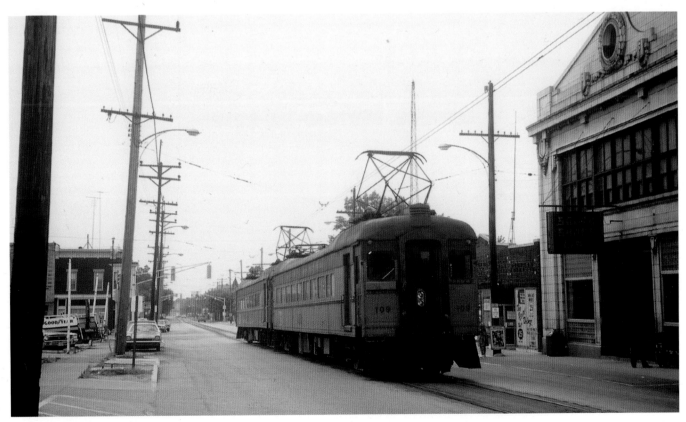

CSS&SBR train consisting of cars Nos. 108 and 109 are leaving the Michigan City station on 11th Street and will shortly cross Franklin Street on July 25, 1974 on their westbound trip to Chicago. (*Kenneth C. Springirth photograph*)

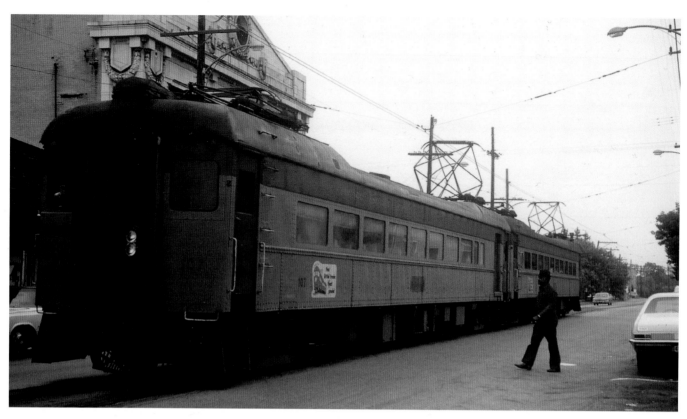

On July 25, 1974, CSS&SBR coach/baggage car No. 107 with the very visible decal "the little train that could" is part of a two-car train on 11th Street in front of the Michigan City Station. This car was acquired by the East Troy Electric Railway Museum in 2010. (*Kenneth C. Springirth photograph*)

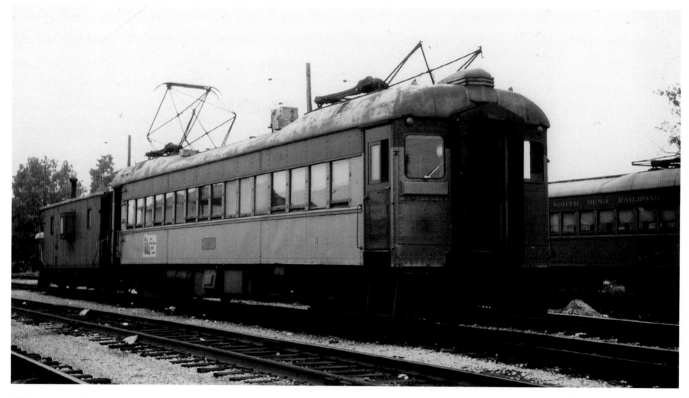

CSS&SBR coach No. 3 is in the Michigan City yard next to a bay window caboose on July 25, 1974. (*Kenneth C. Springirth photograph*)

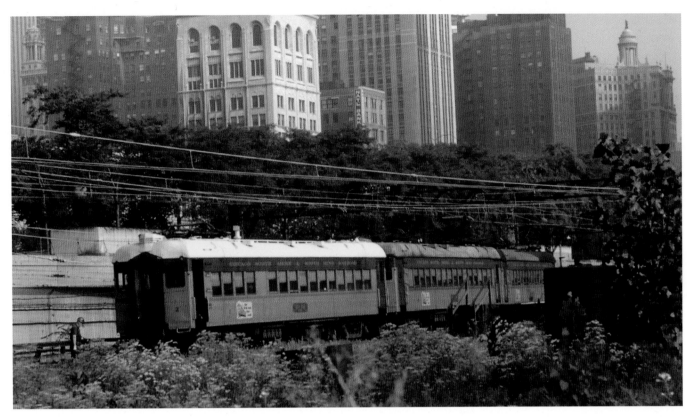

On September 10, 1975, CSS&SBR coach No. 2 (powered by four Westinghouse type 567-C11 motors and riding on Baldwin type 84-60AA trucks) is part of a three-car train south of the Randolph Street Station in Chicago. (*Clifford R. Scholes collection*)

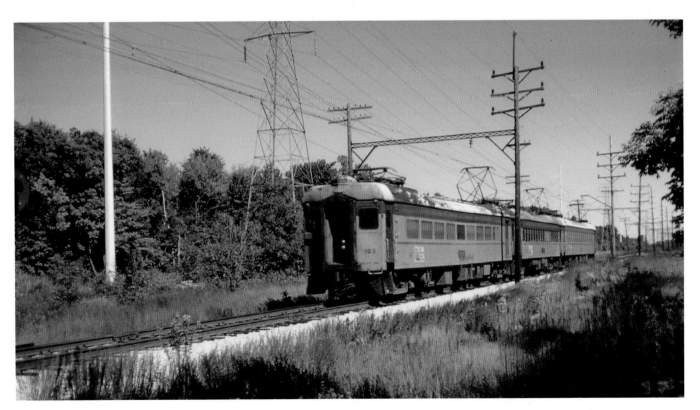

A westbound CSS&SBR three-car train headed by coach/baggage car No. 103 is west of the historic Beverly Shores station in September 1978. Car No. 103 was lengthened from 60 feet to 77.5 feet in 1943, and by 1950, it had received picture windows and air conditioning. (*C. Able photograph—Clifford R. Scholes collection*)

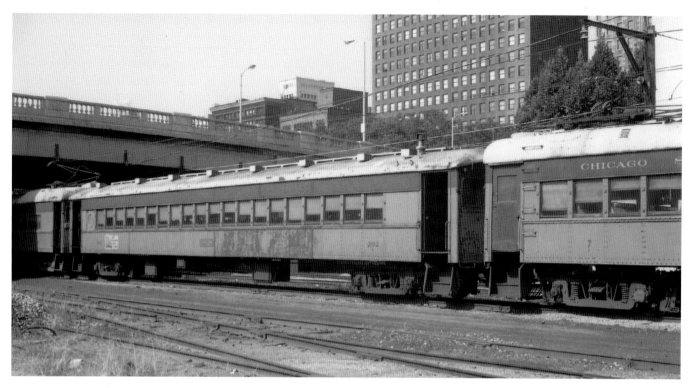

CSS&SBR coach No. 7, trailer car No. 202, and another car are at the Randolph Street Station on June 20, 1982. This station was also used by the Illinois Central Railroad (ICR), which merged with the Gulf, Mobile & Ohio Railroad to form the Illinois Central Gulf Railroad (ICGR) on August 10, 1972. The Regional Transportation Authority, created in 1974, became known as Metra in 1985, which took over the ICGR electrified commuter lines in 1987. Randolph Street Station was renamed Millennium Station in 2007. (*Clifford R. Scholes collection*)

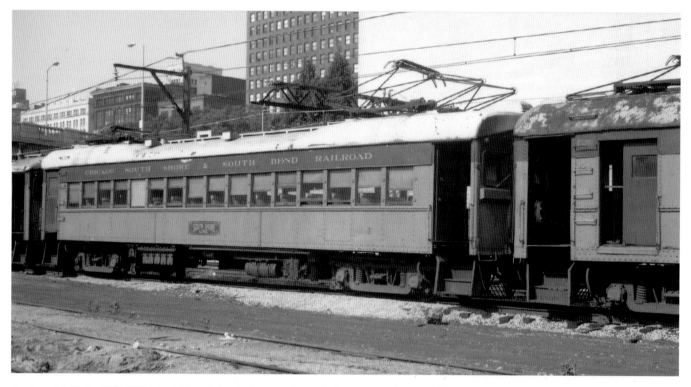

On June 20, 1982, CSS&SBR coach No. 7 is in the lineup of cars at the Randolph Street Station in Chicago. This station opened in 1856 as the Central Depot (sometimes called Central Station) and became Randolph Street station in 1893, when a new Central Station was built at Roosevelt Road. While the old Central Depot building at Randolph was demolished at that time, a terminal was maintained there. Randolph Street Station was rebuilt with high-level platforms in 1926 with the electrification of the Illinois Central Railroad suburban lines and became Millenium Station in 2007. (*Clifford R. Scholes collection*)

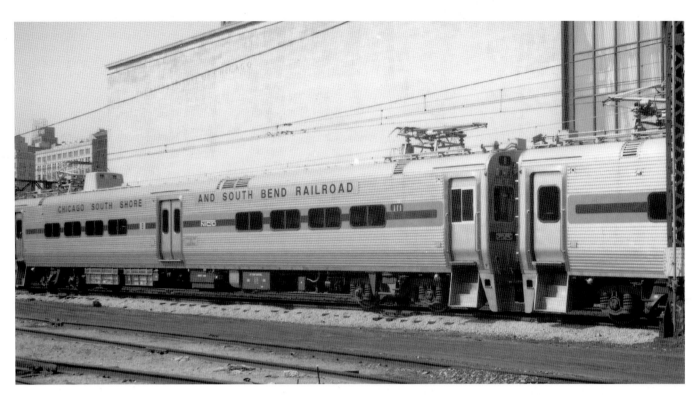

Modern electric multiple unit CSS&SBR coach No. 8 with another are waiting for the next assignment at the Randolph Street Station on April 20, 1983. The article in the Friday November 19, 1982 *Michigan City News Dispatch* newspaper announced: "Six new passenger cars will begin carrying passengers on the South Shore Railroad on Monday (November 22, 1982) transportation officials announced today." Each of the forty-four new cars ordered from Nippon Sharyo USA upon completion was shipped to Michigan City and run through a series of acceptance tests before being placed in revenue service. (*Clifford R. Scholes collection*)

On April 20, 1983, CSS&SBR coaches Nos. 24 (in service since 1927) and 26 (in service since 1929) are at the Randolph Street Station in Chicago. Time was running out for these cars, which provided many years of service. The forty-four new multiple-unit commuter cars provided all of the service by the fall of 1983. (*Clifford R. Scholes collection*)

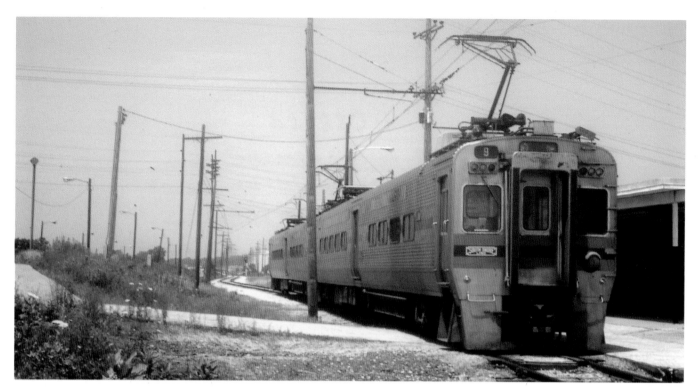

In June 1984, CSS&SBR coach No. 9 (one of forty-four coaches, Nos. 1–44, built by Nippon Sharyo USA during 1982–1983) is part of a two-car train at the relocated South Bend west side station at 2702 West Washington Avenue after the street running trackage in South Bend was abandoned on July 7, 1969. The single-story concrete block station was built to serve both the CSS&SBR and Amtrak. On November 20, 1992, the CSS&SBR rerouted its trackage into the Michiana Regional Airport west of South Bend, Indiana. (*Clifford R. Scholes collection*)

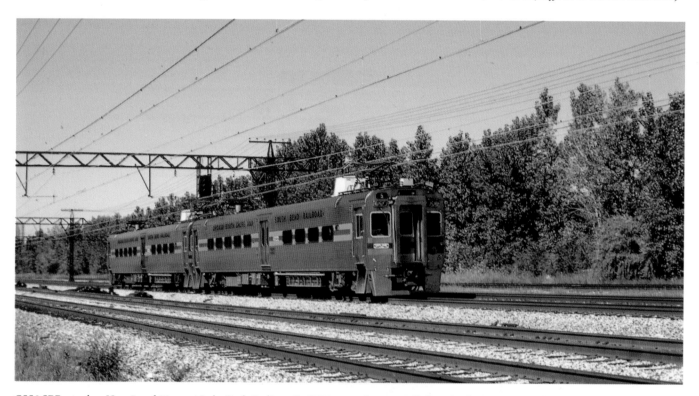

CSS&SBR coaches Nos. 5 and 16 are at Lake Park, Indiana, in 1988 on trackage paralleling the former New York Central Railroad, which, in 2018, is operated by the Norfolk Southern Railway. These are two of forty-four multiple-unit coaches, Nos. 1–44, built by Nippon-Sharyo USA during 1982–1983. According to the October 21, 1982 *Michigan City News Dispatch*, the bodies and wheel assemblies were built in Japan at the Japan Rolling Stock Manufacturing Company plant near Tokyo, and the General Electric shops in Cleveland, Ohio, completed the final assembly. (*Myron Lane photograph—Clifford R. Scholes collection*)

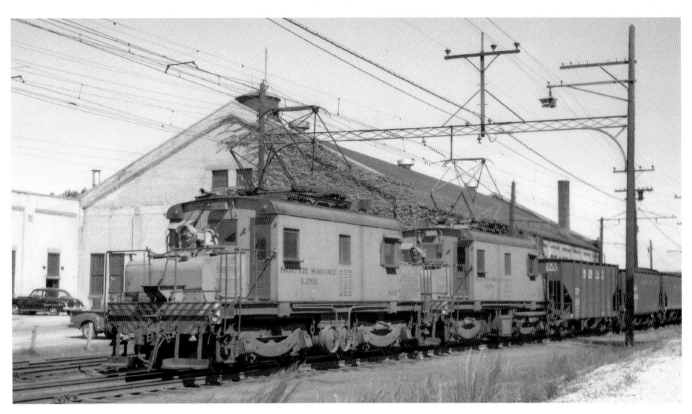

Built by Baldwin-Westinghouse in September 1929, steeple cab locomotive No. 902 (originally ICR No. 10002 and became CSS&SBR No. 902 in March 1941) and No. 901 (originally ICR No. 10003 and became CSS&SBR No. 901 in March 1941) are passing through the Michigan City yard in August 1950. (*Clifford R. Scholes collection*)

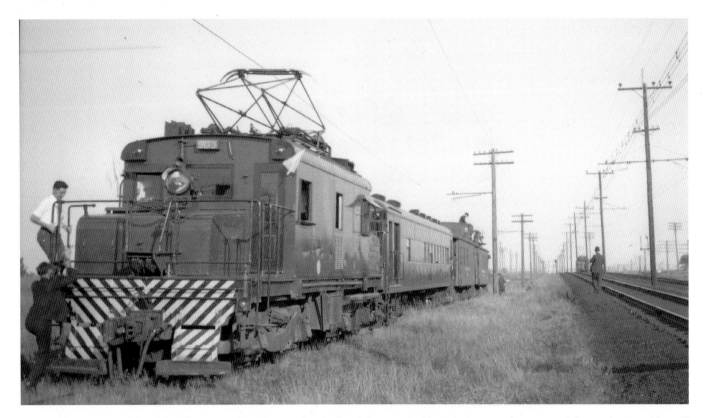

On a siding at New Carlisle, Indiana, in 1942, CSS&SBR steeple cab electric locomotive No. 903 appears to be on a special excursion as evidenced by the white flag on the locomotive pulling car No. 503 plus cabooses Nos. 1055 and 1066. This locomotive was originally ICR No. 10001 built by Baldwin-Westinghouse in September 1929 and became CSS&SBR No. 903 in July 1941. (*Bob Crockett photograph—Clifford R. Scholes collection*)

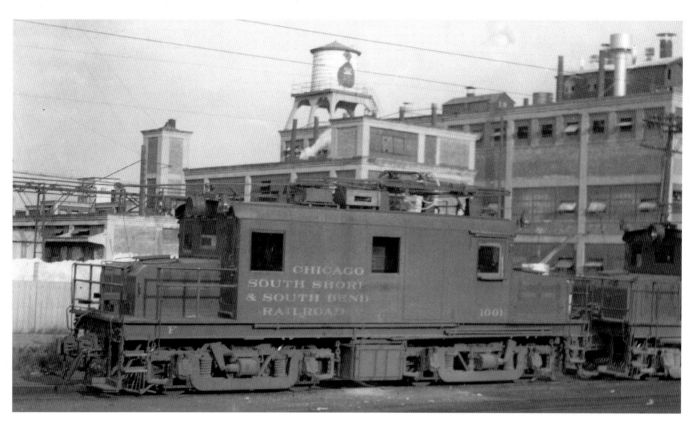

In 1936, Kensington, Illinois, is the location of CSS&SBR electric steeple cab locomotives Nos. 1001 and 1002—two of four locomotives, Nos. 1001–1004, built by Baldwin Westinghouse in 1926. The drop equalizer trucks were designed with outside brake cylinders. (*Clifford R. Scholes collection*)

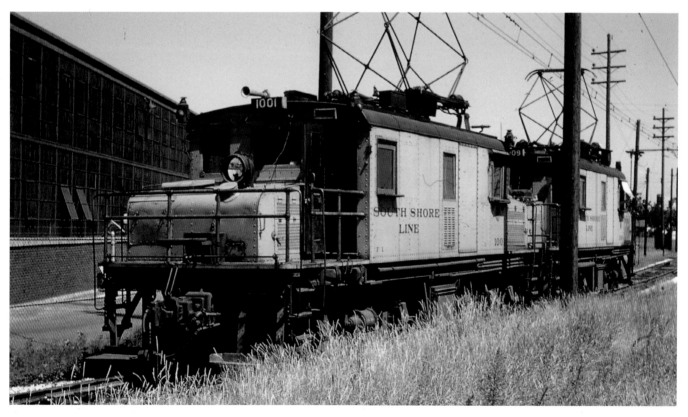

CSS&SBR electric steeple cab Baldwin-Westinghouse-built locomotives Nos. 1001 (built in 1926) and 1009 (built in 1927) are on a siding near South Bend on August 5, 1950. (*Pat Carmody photograph—Clifford R. Scholes collection*)

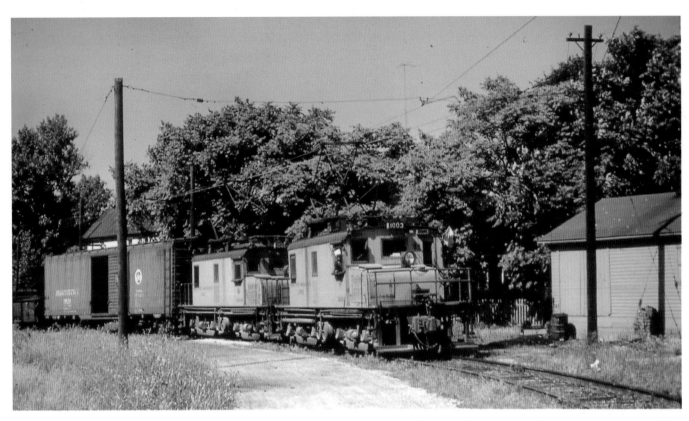

On August 13, 1950, CSS&SBR electric steeple cab locomotives Nos. 1003 and 1004, built by Baldwin-Westinghouse in 1926, are on a siding in South Bend, Indiana. (*Pat Carmody photograph—Clifford R. Scholes collection*)

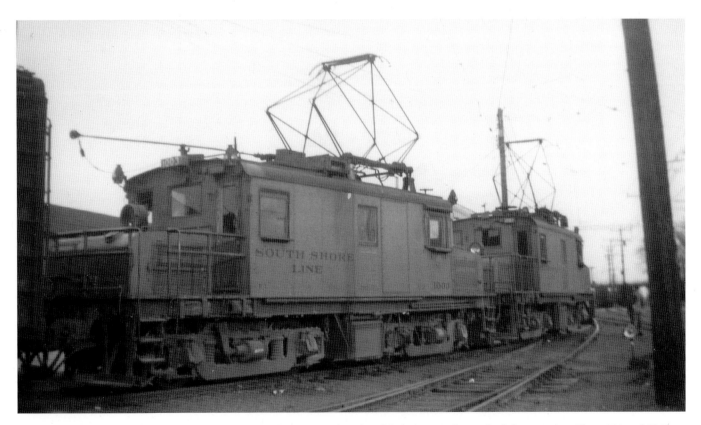

The Michigan City yard is the location of CSS&SBR electric steeple cab Baldwin-Westinghouse-built locomotives Nos. 1003 and 1007 on October 25, 1946. (*Clifford R. Scholes collection*)

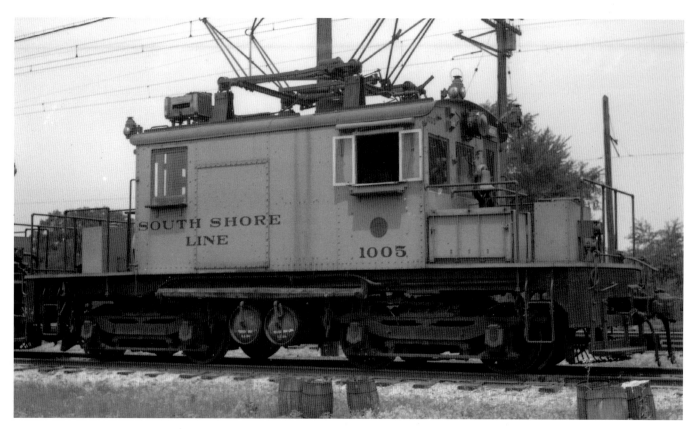

In 1942, CSS&SBR electric steeple cab locomotive No. 1005, built by Baldwin-Westinghouse, is waiting for the next assignment at the Michigan City yard. (*Bob Crockett photograph—Clifford R. Scholes collection*)

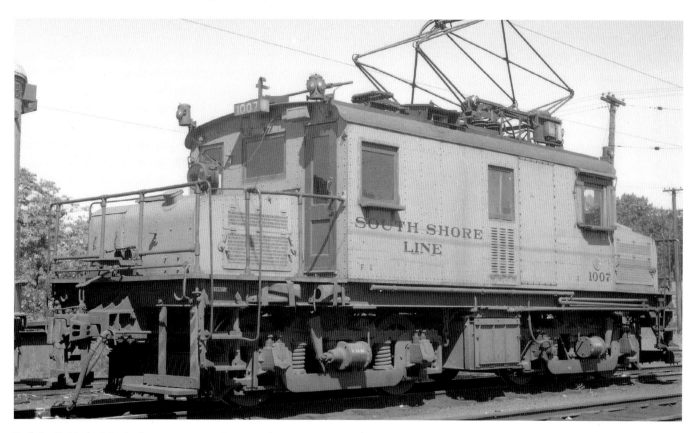

Built by Baldwin-Westinghouse in 1927, CSS&SBR electric steeple cab locomotive No. 1007 is at the Michigan City yard in August 1950. (*Clifford R. Scholes collection*)

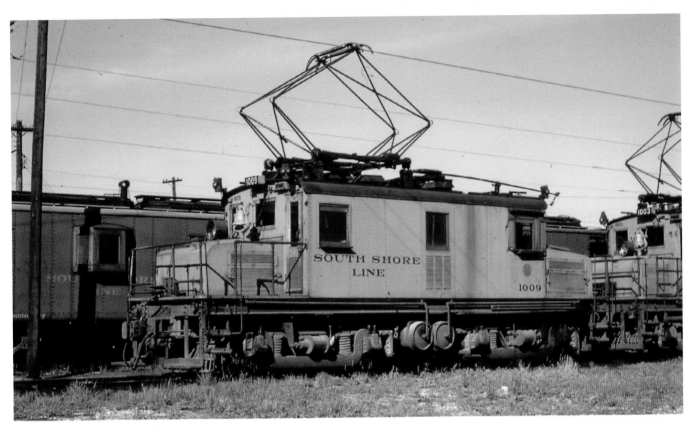

On July 1, 1950, Baldwin-Westinghouse electric steeple cab locomotives Nos. 1009 and 1003 are at the Michigan City yard. (*Pat Carmody photograph—Clifford R. Scholes collection*)

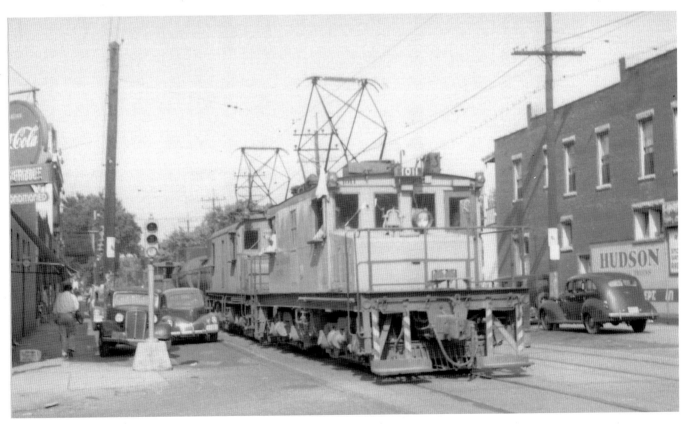

Carefully travelling along 11th Street, a westbound CSS&SBR freight train powered by locomotives Nos. 1011 (built by Baldwin-General Electric) and 1009 (built by Baldwin-Westinghouse) is crossing Franklin Street in downtown Michigan City on July 11, 1947. (*Clifford R. Scholes collection*)

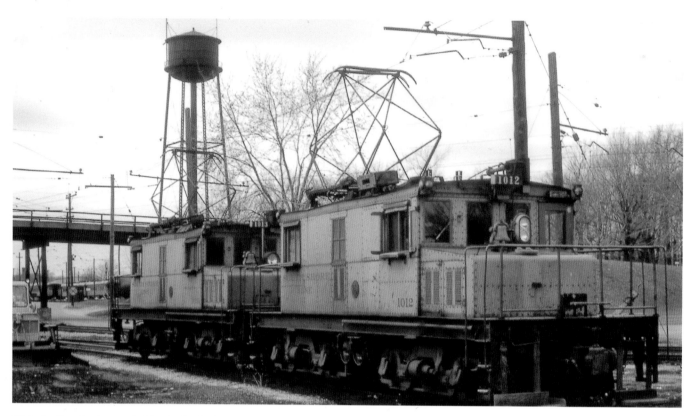

With the Roeske Avenue bridge in the background, CSS&SBR electric steeple cab locomotives Nos. 1012 and 1013 are at the Michigan City yard in March 1965. These were two of three locomotives, Nos. 1011–1013, built by Baldwin-General Electric during 1929–1930. Each 80-ton, 1,600-horsepower locomotive was powered by four General Electric type 704A motors and was equipped with Baldwin trucks having 42-inch-diameter driving wheels. (*Pat Carmody photograph—Clifford R. Scholes collection*)

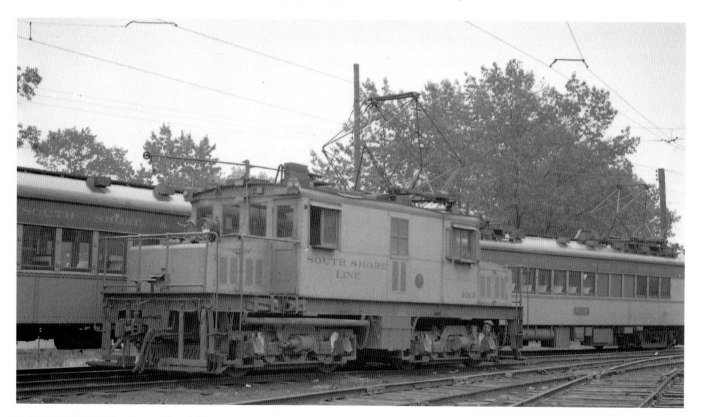

In 1946, CSS&SBR electric steeple cab locomotive No. 1013 is at the Michigan City yard. With an overall length of 39.708 feet, this locomotive had a tractive effort of 29,200 pounds, which is the force that a locomotive can apply to its coupler to pull a train. (*Clifford R. Scholes collection*)

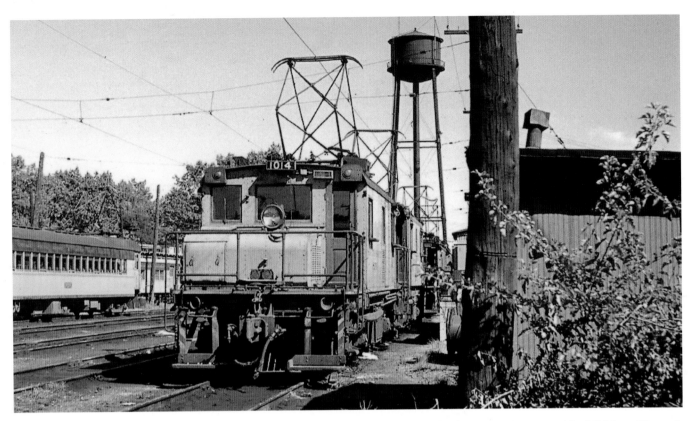

On September 20, 1948, CSS&SBR electric steeple cab locomotive No. 1014 is waiting for the next assignment at the Michigan City yard. Built by Baldwin-Westinghouse in 1931, this was the last steeple cab electric locomotive built for the CSS&SBR. (*Bob Crockett photograph— Clifford R. Scholes collection*)

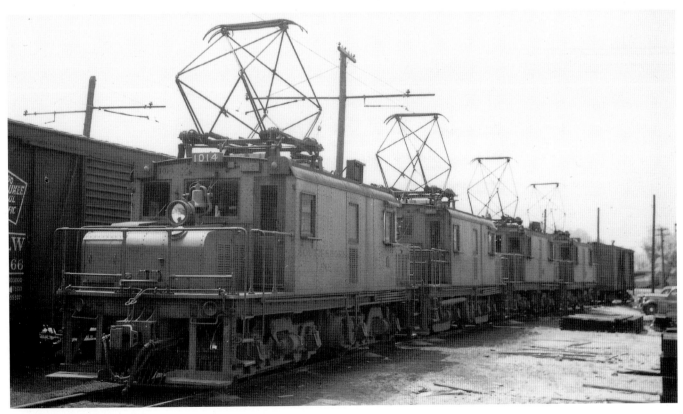

A lineup of CSS&SBR electric steeple cab locomotives headed by No. 1014 makes an interesting scene at the Michigan City yard in 1950. (*Clifford R. Scholes collection*)

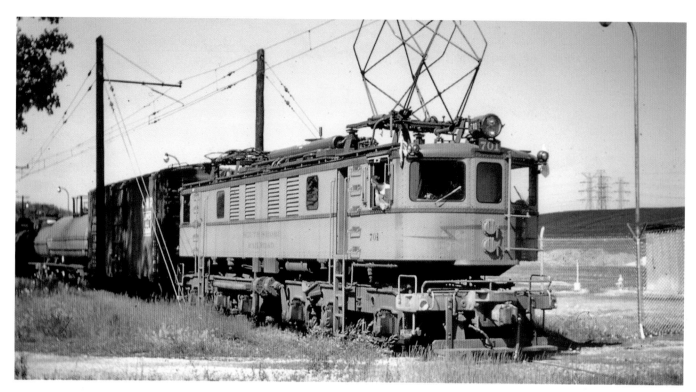

On June 30, 1956, CSS&SBR 3,000-horsepower box cab electric locomotive No. 701 (one of seven locomotives, Nos. 701–707, powered by six General Electric type 268B motors) is serving the Northern Indiana Public Service Company Michigan City Generating Station. Built by American Locomotive-General Electric as No. 1208 class R-2 for the New York Central Railroad (NYC) in December 1930, it was designed for 660-volt DC third rail operation in the New York City area and became No. 308 in August 1936. In 1955, it was purchased by the CSS&SBR, rewired for 1,500-volt DC with pantographs added for overhead wire operation, and renumbered 701. It was scrapped in 1976. (*C. Able photograph—Clifford R. Scholes collection*)

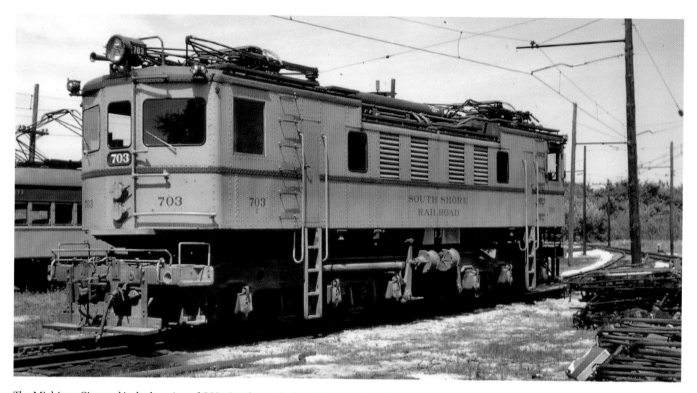

The Michigan City yard is the location of CSS&SBR box cab electric locomotive No. 703 on May 24, 1958. Built by American Locomotive-General Electric as No. 1203 class R-2 for the NYC in December 1930, it was renumbered 303 in August 1936, purchased by CSS&SBR, and rebuilt as No. 703 in 1955. It was scrapped in 1976. (*C. Able photograph—Clifford R. Scholes collection*)

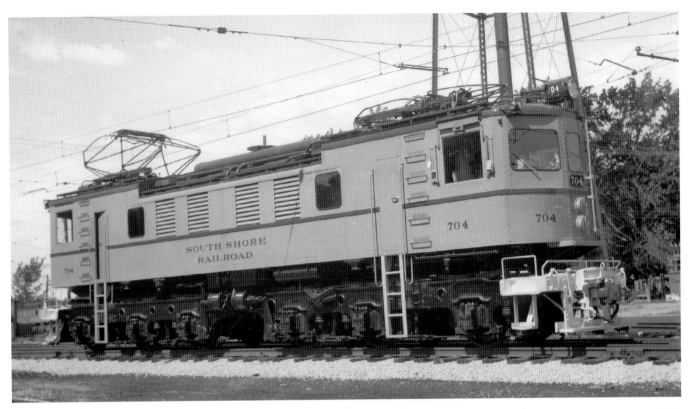

On September 16, 1956, freshly painted CSS&SBR box cab electric locomotive No. 704 is at the Michigan City yard ready for action. Built by American Locomotive-General Electric as No. 1243 class R-2 for the NYC in June 1931, it was renumbered 343 in August 1936, purchased by CSS&SBR, and rebuilt as No. 704 in 1956. It was scrapped in 1976. (*Clifford R. Scholes collection*)

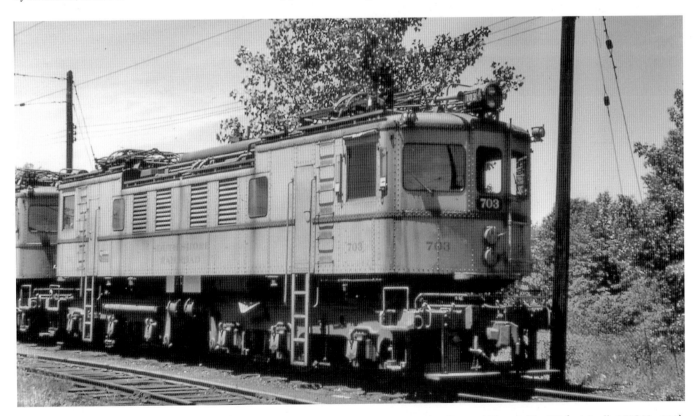

On June 15, 1959, CSS&SBR box cab electric locomotives built by American Locomotive-General Electric No. 703 (originally NYC No. 303), with No. 704 behind it (originally NYC No. 343) are at the Michigan City yard. (*C. Able photograph—Clifford R. Scholes collection*)

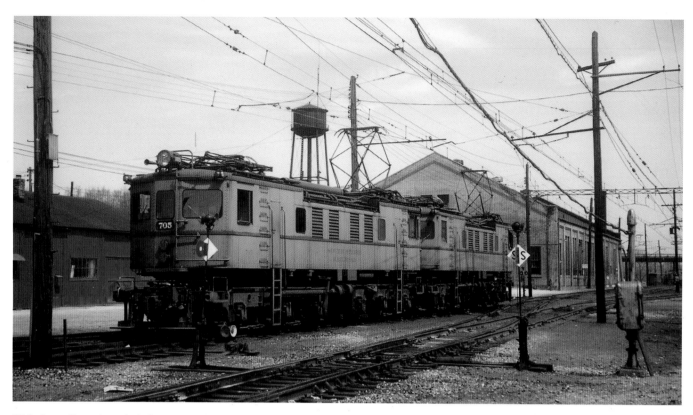

With the well-equipped Michigan City shop building in the background, CSS&SBR box cab electric locomotive No. 705 (built by American Locomotive-General Electric) with another 700 series locomotive behind it are ready for the next switching move on April 12, 1968. This class R-2 NYC locomotive No. 340 was purchased by CSS&SBR and rebuilt as No. 705 in 1957. (*Kenneth C. Springirth photograph*)

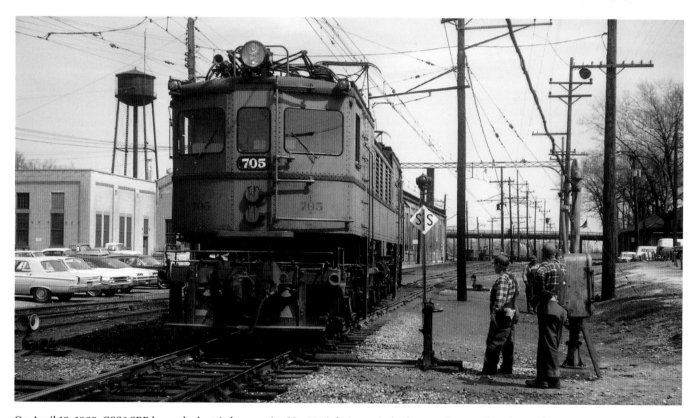

On April 12, 1968, CSS&SBR box cab electric locomotive No. 705 is being switched to another track at the Michigan City yard. Ten of these former class R-2 locomotives had been purchased from the NYC. The CSS&SBR rebuilt seven locomotives, which became Nos. 701–707, and the remaining three were used for spare parts. The Roeske Avenue bridge is in the distance. (*Kenneth C. Springirth photograph*)

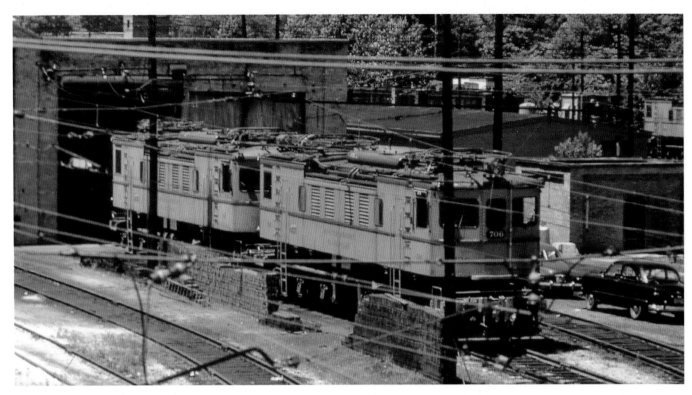

CSS&SBR box cab electric locomotives built by American Locomotive-General Electric Nos. 706 (ex-NYC No. 341 purchased by CSS&SBR and rebuilt in 1958) and 707 (ex-NYC No. 1242 and renumbered No. 342 in August 1936, was purchased by CSS&SBR and rebuilt as No. 707 in 1968) are at the Michigan City yard on June 15, 1959. (*C. Able photograph—Clifford R. Scholes collection*)

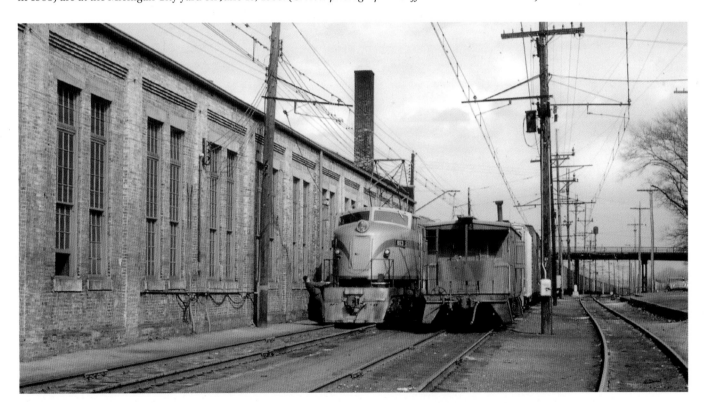

In March 1965, CSS&SBR electric locomotive No. 801 alongside a caboose is at the Michigan City yard. This 800 series electric locomotive had a 2-D+D-2 wheel arrangement which, by the Association of American Railroads (AAR) definition is "Two sets of articulated axles under the unit. Within each of these sets, there is a truck with two idler axles, and inboard of it are four powered axles. Two of these articulated sets are placed back to back and connected by a hinge." Under the AAR system "2" is two idler axles in a row, "D" is four powered axles in a row, a dash "-" separates trucks, and a plus sign "+" refers to articulation. (*Pat Carmody photograph—Clifford R. Scholes collection*)

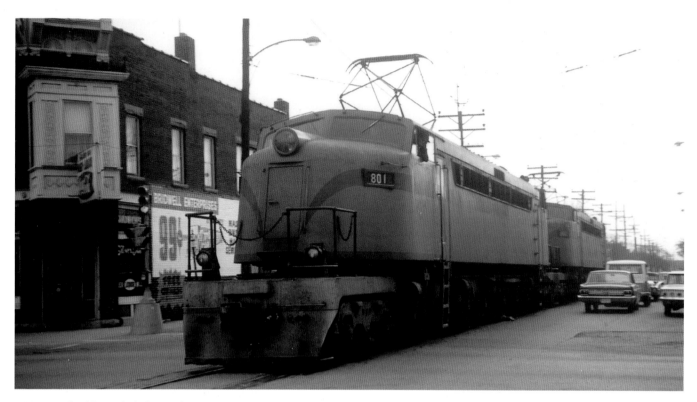

CSS&SBR double-ended electric locomotive No. 801 with another 800 series locomotive behind it are on 11th Street crossing Franklin Street in Michigan City on April 12, 1968. Locomotives Nos. 801–803 were built by General Electric for the U.S.S.R. (Russia); however, the U.S. Department of State banned strategic shipments to Russia in October 1948, and the order was cancelled. Fortunately, General Electric completed the locomotives, and CSS&SBR acquired them in 1949. (*Kenneth C. Springirth photograph*)

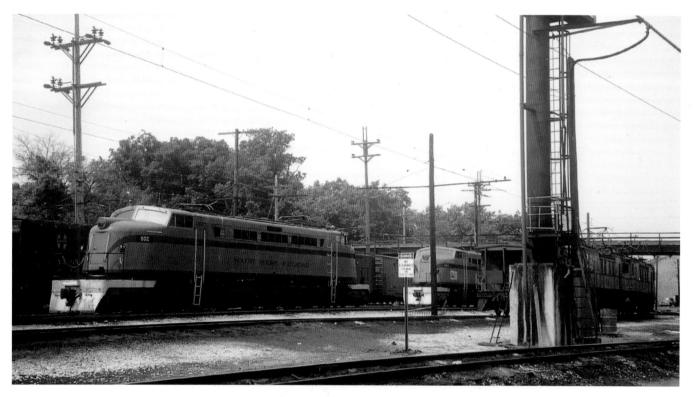

On July 25, 1974, CSS&SBR locomotive No. 802 and No. 803 (behind) are in the Michigan City yard waiting for the next assignment. The three locomotives Nos. 801–803 were originally wired for a 3,300-volt DC catenary. After the CSS&SBR purchased the locomotives in 1949, their Michigan City shop rewired and modified the units to operate on their 1,500-volt DC system, plus they removed the multiple unit control and regenerative braking features that were not needed. (*Kenneth C. Springirth photograph*)

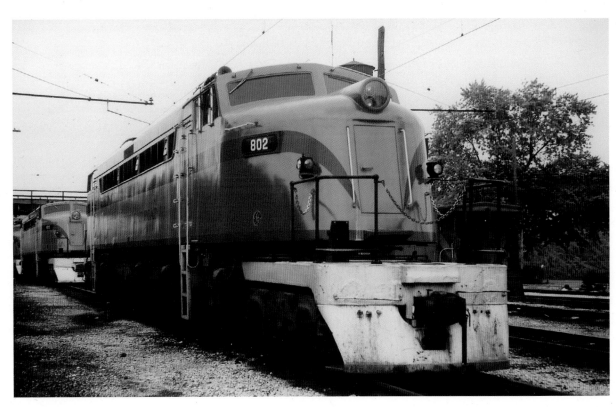

CSS&SBR electric locomotives Nos. 802, 803, and 801 in their bright orange paint scheme are ready for the next assignment at the Michigan City yard on July 25, 1974. Each locomotive was powered by eight General Electric type 750 traction motors. The locomotive was rated at 5,120 horsepower, tractive effort was 77,000 pounds, and had a maximum speed of 68 mph, making them ideal for fast freight service. (*Kenneth C. Springirth photograph*)

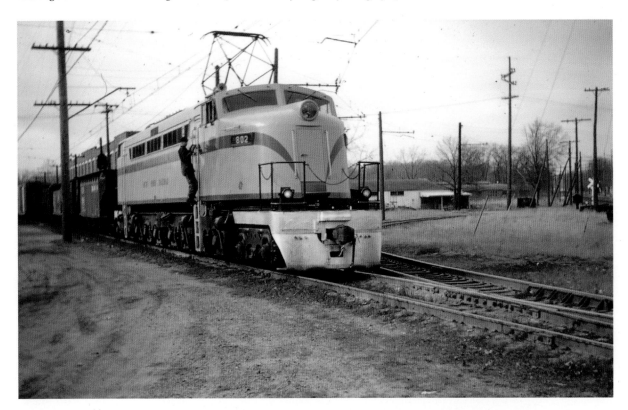

In November 1960, electric locomotive No. 802 is west of Michigan City serving the Northern Indiana Public Service power plant. The locomotive weight totaled 545,600 pounds, and the length over couplers was 87.8125 feet. This locomotive is on display at the Lake Shore Railway Museum at 31 Wall Street in North East, Pennsylvania 16428. (*Clifford R. Scholes collection*)

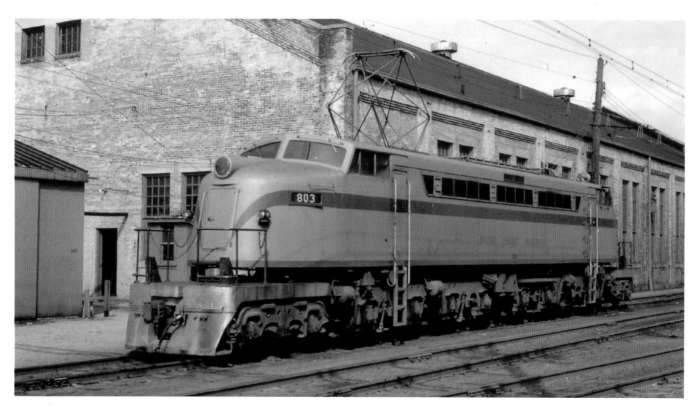

Electric locomotive No. 803 is parked alongside one of the Michigan City shop buildings in this March 1965 scene. Over the years, the skilled shop personnel handled not only maintenance but also special projects, such as the rewiring the three 800 series locomotives from their original 3,300-volt catenary service to the CSS&SBR 1,500-volt system. (*Pat Carmody photograph—Clifford R. Scholes collection*)

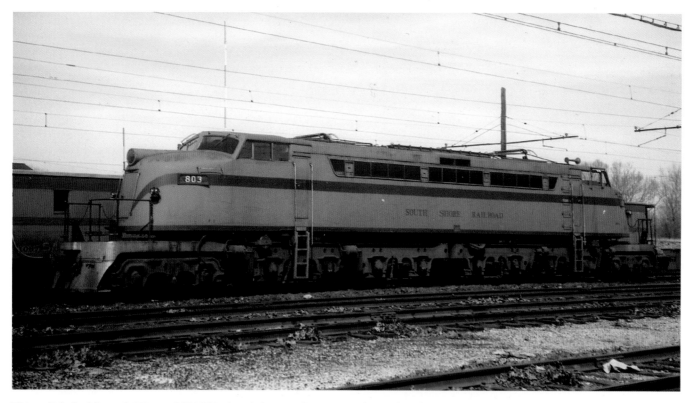

This stylish double-end, 273-ton CSS&SBR electric locomotive No. 803 alongside caboose No. 1067 on April 12, 1968 at the Michigan City yard is a tribute to the engineers involved with its design and the factory workers who turned the drawings into the final product. The locomotive's non-powered trucks had 37.375-inch-diameter wheels and the motor axles had 47.25-inch-diameter wheels. No. 803 has been preserved at the Illinois Railway Museum. (*Kenneth C. Springirth photograph*)

4

Carroll Avenue, Michigan City Shops

The CSS&SBR major shops and yard areas are located at Carroll Avenue on the east side of Michigan City in LaPorte County, Indiana, about 51 miles east of Chicago and 39 miles west of South Bend. The shops were established to handle major rolling stock repairs, overhaul, inspection, painting, and car washing. Beginning and after World War II, the shops handled the lengthening, updating, and air conditioning of a number of the railroad's passenger cars. Three locomotives, Nos. 801–803, originally built by General Electric Company were rewired and modified at the shop. Seven former New York Central Railroad class R-2 electric locomotives were extensively rewired and rebuilt at the shops. In the CSS&SBR *Shore Lines Vol. 1 No. 3* publication issued around 1968 to keep the railroad's passengers informed, it was noted: "On an average day, 10 of the South Shore's 64 cars need major repairs-and with only that number out of action it is still possible to fill all of the equipment sheets and maintain complete schedules. Recently, however, there were between 15 and 22 cars sidelined at one time as a result of snow, wind, and cold." Under those winter conditions, the publication noted: "When the bank of spare motors is exhausted and company electricians can't keep up, even with overtime, motors are sent to Hammond, Chicago, and even as far away as St. Louis for rewinding and other repairs. About 60 percent of the work in the shop is electrical-on motors, controls, heating, and lighting. The rest is mechanical-replacing worn wheels, repairing and servicing air brakes, and replacing damaged steps and grab rails."

At the west end of the shops and yard area is the Carroll Avenue Station. Crossing CSS&SBR west of the station is the former Norfolk Southern Railway branch that once was a New York Chicago & St. Louis Railroad line to Indianapolis, Indiana. That branch line was cut back to Dillon, Indiana, serving the Kingsbury Industrial Park and was purchased in 2001 by the Anacostia & Pacific Company which operates South Shore freight service.

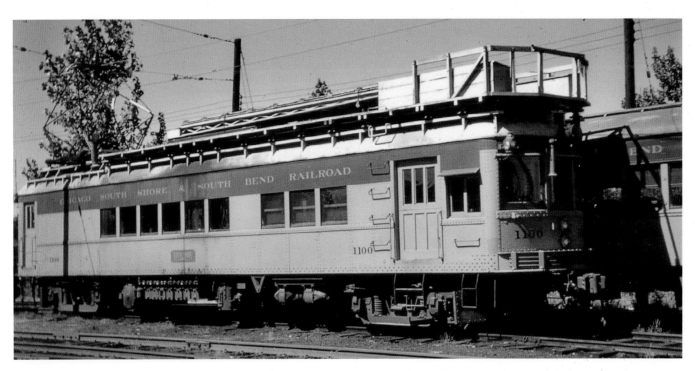

On September 5, 1955, CSS&SBR line car No. 1100 is at the Michigan City yard. This car was built in 1926 by St. Louis Car Company as Indiana Service Corporation parlor car No. 376, sold to Indiana Railroad in 1932, where it was rebuilt into a passenger/railway post office car in 1935, and sold to CSS&SBR in 1941, where it was used as an express car and converted to a line car in 1947 performing most of the overhead wire repairs. (*C. Able photograph—Clifford R. Scholes collection*)

Former Arlington & Fairfax Electric Railway (A&FER) Evans Products Company auto-railer No. 50 is at the Michigan City yard in 1955 (purchased by CSS&SBR in 1955 and equipped with a tower for the installation of insulators for the overhead wires). After Evans Products Company of Plymouth, Michigan, purchased the A&FER in 1936, the trolley cars were replaced by auto-railers, which last ran in September 1939. (*C. Able photograph—Clifford R. Scholes collection*)

In March 1965, CSS&SBR auto-railer No. 50 is at the Michigan City shops. This vehicle had front and rear steel pilot flanged railroad wheels that could be raised for highway operation and lowered to operate on rail. The vehicle ran on its own tires over the rails with the pilot wheels guiding it along the track. In 1956, No. 50 was used in the overhead wire construction of the East Chicago bypass. (*Pat Carmody photograph—Clifford R. Scholes collection*)

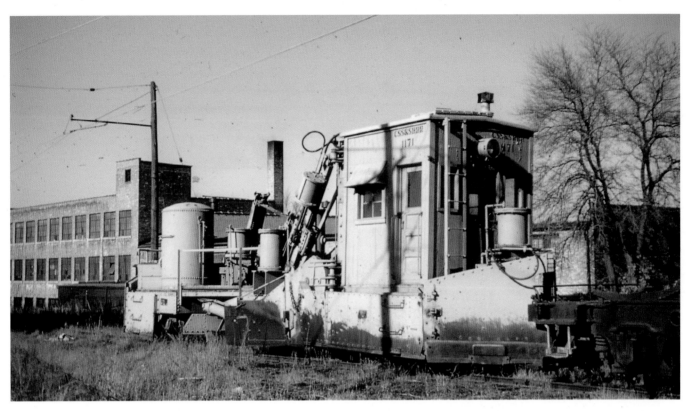

On December 26, 1955, the Michigan City yard is the location of No. 1171 Jordan Spreader used by the CSS&SBR for ballast and snow work. Oswald Jordan developed the Jordan Spreader (an angled plow to which can be attached wings that slope to fit the contour of the railroad right of way giving the ballast a uniform neat appearance) and his factory, established in 1911, began building them. Ballast (usually crushed stone) is a support base for the ties and rails plus drains water away from the rails. (*C. Able photograph—Clifford R. Scholes collection*)

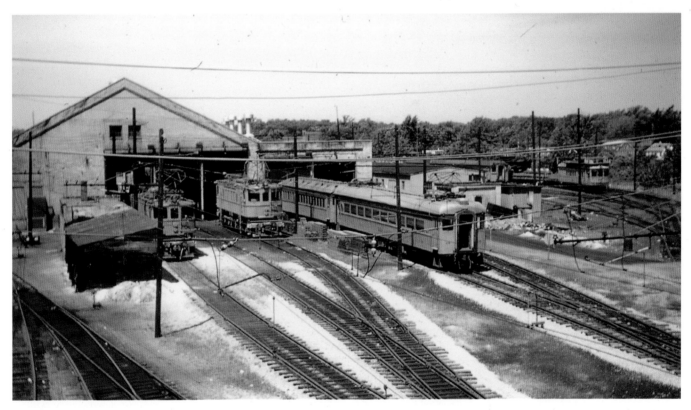

In this June 30, 1956 view taken of the Michigan City yard from the Roeske Avenue bridge, CSS&SBR electric locomotive No. 703 is left of coach No. 26 in the center of the picture. (*C. Able photograph—Clifford R. Scholes collection*)

With the Roeske Avenue bridge in the background, CSS&SBR electric locomotive No. 802, with its massive cast steel truck frame, is leading a westbound freight train through the Michigan City yard on March 23, 1957. When locomotives Nos. 801–803 were purchased in 1949, they were the world's largest straight electric locomotives. (*C. Able photograph—Clifford R. Scholes collection*)

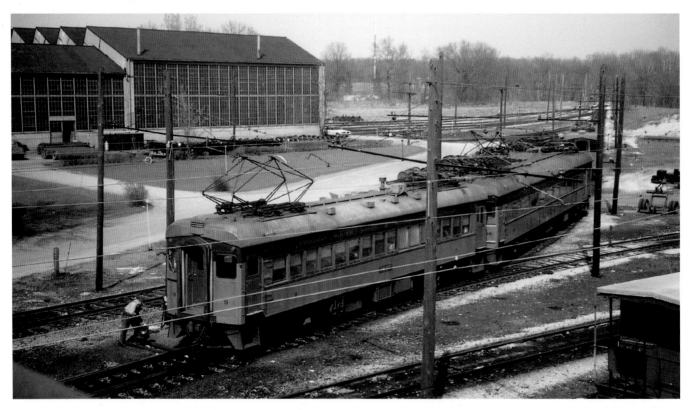

Over the years, the CSS&SB shop workers have done wonders in maintaining the rolling stock such as coach No. 9, which was built in 1926 around forty-two years earlier than this April 12, 1968 view. This car was acquired by the East Troy Electric Railroad Museum in 1990. (*Kenneth C. Springirth photograph*)

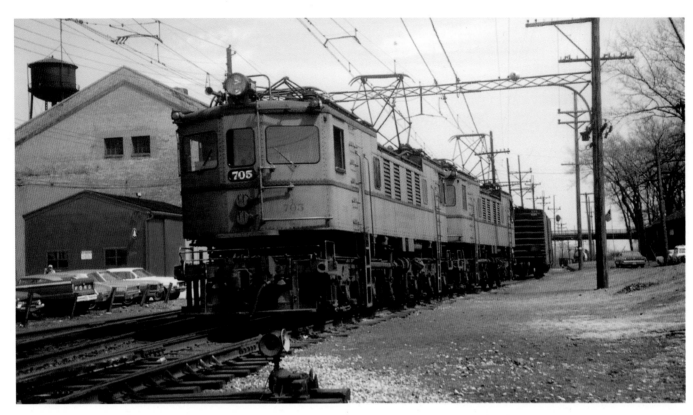

On April 12, 1968, CSS&SBR electric locomotive No. 705 with another 700 series locomotive are doing switching operations adjacent to the Michigan City shop building. These were two of seven locomotives, Nos. 701–707, with a C-C truck arrangement that, under the AAR definition, "C" is three powered axles in a row and dash "-" separates two truck or wheel assemblies. Equipped for multiple unit operation, these locomotives mostly operated in pairs in freight service. (*Kenneth C. Springirth photograph*)

In this inside view of the Michigan City shop, CSS &CBR coach No. 1 is being rebuilt in 1963. This was the first car received from Pullman Car & Manufacturing Company in 1926 as part of the modernization program. (*Ed O'Meara photograph—Clifford R. Scholes collection*)

On April 12, 1968 CSS&SBR coach No. 3 and former NYC locomotive No. 342 are inside the Michigan City shop. Using motor blowers, air compressors, and pantographs from Cleveland Union Terminal "P" motors, the Michigan City shop rebuilt seven of these 600-volt DC third rail locomotives into 1,500-volt DC electric locomotives, Nos. 701–707. (*Kenneth C. Springirth photograph*)

CSS&SBR coach /baggage car No. 101 is undergoing repairs at the Michigan City Shop on April 12, 1968. (*Kenneth C. Springirth photograph*)

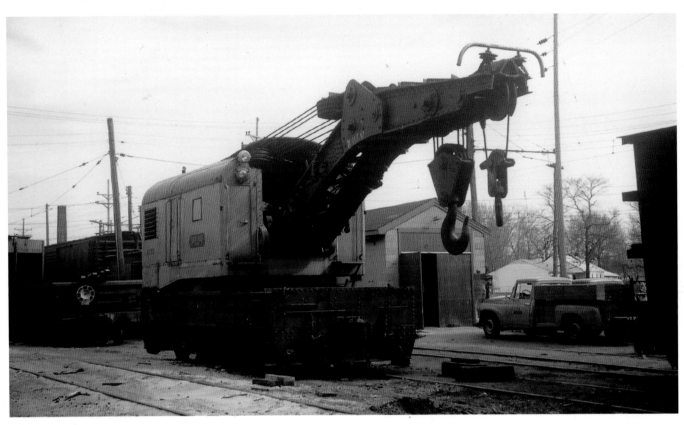

A CSS&SBR 100-ton crane, No. X1150, big enough to handle any job, is at the Michigan City yard on April 12, 1968. It was purchased secondhand and was sold during the time the railroad was operated by the Chesapeake & Ohio Railway. (*Kenneth C. Springirth photograph*)

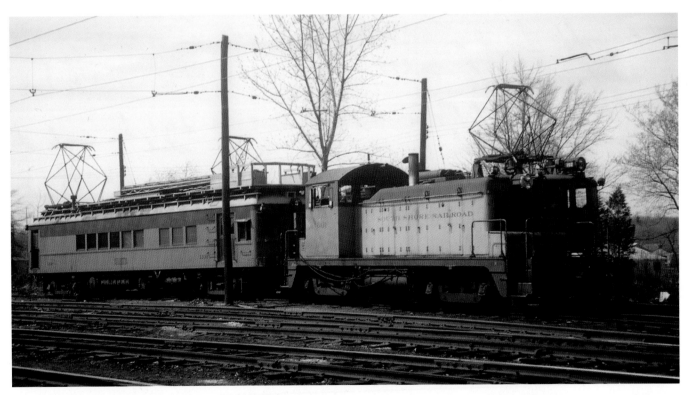

On April 12, 1968, CSS&SBR 600-horsepower, single-stack type SW1 diesel electric switcher No. 601 (built by the Electro-Motive Division of General Motors Corporation as No. 42 in March 1940 for the Buffalo Creek Railway) is at the Michigan City yard. This was the first diesel switcher used on the CSS&SBR and was used to pull line car No. 1100 to install the overhead wire for the East Chicago bypass, which opened on September 16, 1956. It was later sold to the Columbus & Greenville Railway and became No. 514. (*Kenneth C. Springirth photograph*)

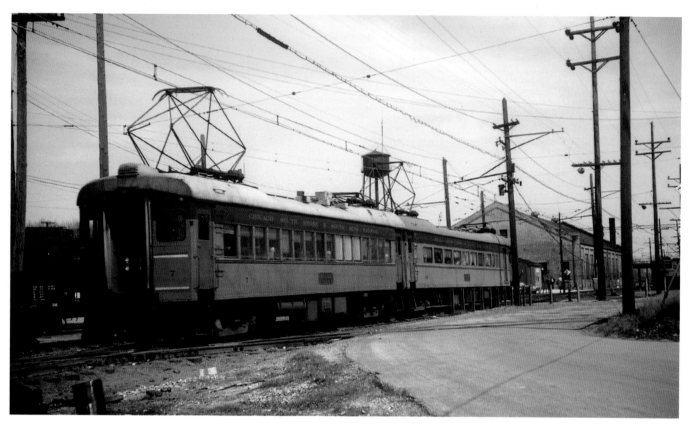

The Michigan City yard, in this April 12, 1968, scene is the location of CSS&SBR multiple unit coach No. 7 with the original window design and another car that had later been modernized with the wide picture windows. (*Kenneth C. Springirth photograph*)

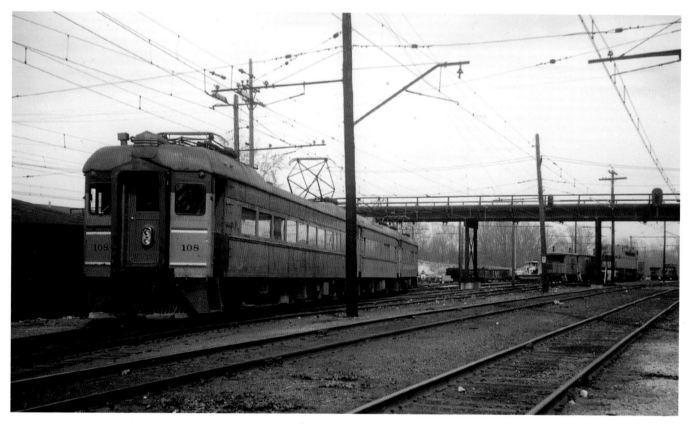

On April 12, 1968, CSS&SBR coach/baggage car No. 108 is heading a lineup of cars at the Michigan City yard with the Roeske Avenue bridge in the background. (*Kenneth C. Springirth photograph*)

5

South Shore Diesel Freight Service

Under C&O control, eleven used GP7 Electro-Motive Division of General Motors Corporation diesel locomotives were acquired in the 1960s, and they largely replaced the electric freight locomotives. In 1981, ten 2,000-horsepower, new GP38-2 Electro-Motive Division of General Motors Corporation diesel locomotives replaced both the GP7 diesel fleet and the last remaining electric locomotives. Electric locomotive No. 803 made the last electric freight locomotive run on January 31, 1981. The Venango River Corporation took over the railroad in 1984, and over a period of time, the diesel locomotives were repainted traction orange and maroon. On January 1, 1990, the Anacostia & Pacific Company acquired the railroad, which became known as the Chicago South Shore & South Bend Railroad (CSS).

The CSS serves the U.S. Steel Midwest plant on the south shore of Lake Michigan at Portage, Indiana. The plant produces tin mill products plus hot dipped, cold rolled, and electrical lamination steels used by customers in the automotive, construction, container, and electrical markets. Another large customer for the South Shore is ArcelorMittal located on the south shore of Lake Michigan at Burns Harbor, Indiana. This is the only steelmaking facility in the United States that is bordered on two sides by a national park (Indiana Dunes National Lakeshore). The plant produces hot-rolled, cold-rolled, and coated sheet products plus steel plate for automobiles, appliances, rail cars, and ships. CSS handles coal trains to and from the Northern Indiana Public Service Company Michigan City and Bailly generating stations, plus switches freight cars from Canadian National Railway, Norfolk Southern Railway, and CSX Transportation to deliver freight to northwestern Indiana customers.

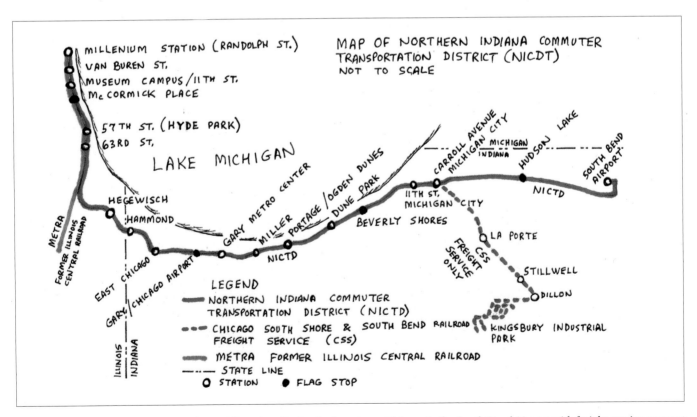

This map shows the passenger route from Millennium Station in downtown Chicago to the South Bend Airport with freight service on most of that route. The line from Carroll Avenue in Michigan City to the Kingsburg Industrial Park is freight only. Commodities handled by the railroad include chemicals, coal, grain, manufactured products, paper, pig iron, steel, and roofing materials.

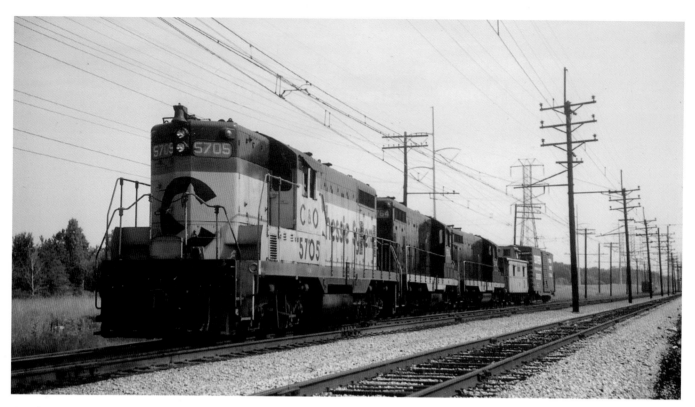

On July 25, 1974, with the CSS&SBR under Chesapeake & Ohio Railroad (C&O) control, C&O 1,500-horsepower, four-axle type GP7 road switcher diesel electric locomotives Nos. 5705, 5764, and 5747 (part of a group of locomotives, Nos. 5700–5809 built by the Electro-Motive Division of General Motors Corporation during April 1950–June 1952) are powering a short freight train. There were eleven GP7 locomotives assigned to the CSS&SBR, with most receiving minor paint revisions such as the South Shore decal on Nos. 5747 and 5764. (*Kenneth C. Springirth photograph*)

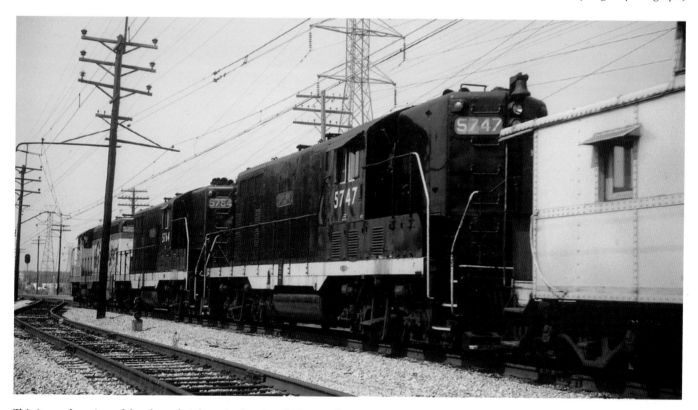

This is another view of the above freight train showing C&O 1,500-horsepower type GP7 diesel electric locomotives Nos. 5705, 5764, and 5747 on July 25, 1974. GP stands for general purpose, and this type of locomotive was reliable, well built, and had strong pulling power. (*Kenneth C. Springirth photograph*)

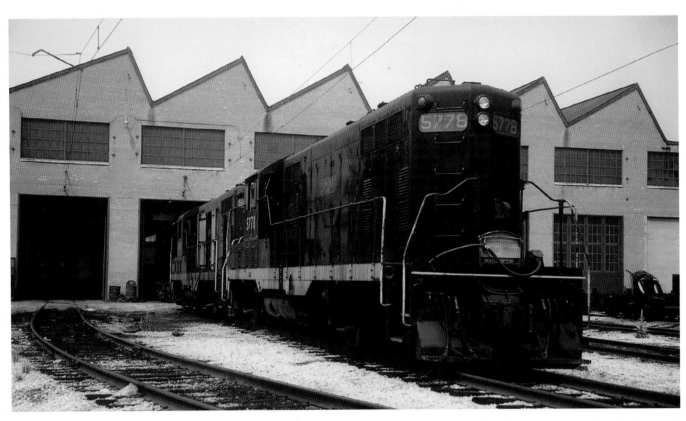

The Michigan City yard, on July 25, 1974, is the location of type GP7 locomotive No. 5778 with another GP7 locomotive behind it (both built by the Electro-Motive Division of General Motors Corporation). (*Kenneth C. Springirth photograph*)

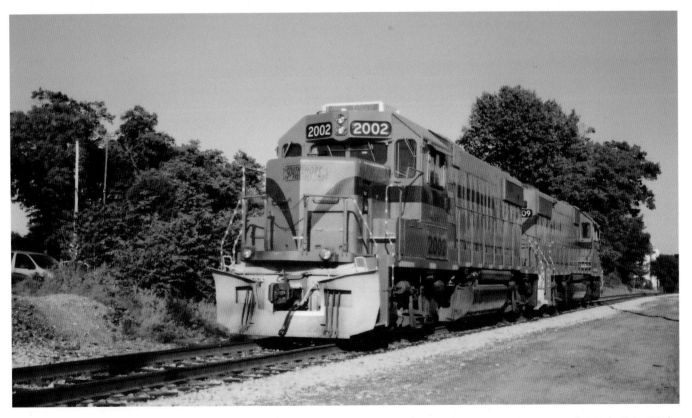

On June 1, 2017, Chicago South Shore six-axle, 2,000-horsepower type GP38-2 diesel electric locomotives Nos. 2002 and 2009, built in 1981 by the Electro-Motive Division of General Motors Corporation, are just south of the Carroll Street station in Michigan City on the former New York, Chicago & St. Louis Railroad that once went south to Indianapolis but has been cutback to Dillon, Indiana. (*Kenneth C. Springirth photograph*)

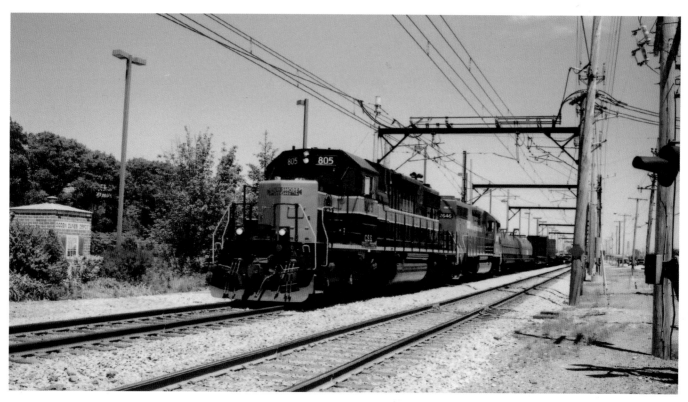

A westbound Chicago South Shore freight train headed by Electro-Motive Division of General Motors Corporation-built locomotives Nos. 805 (type SD38-2, built in October 1978) and 2646 (type GP38-2, built in August 1973) are passing by the Portage/Ogden Dunes station on June 1, 2017. (*Kenneth C. Springirth photograph*)

Looking in the opposite direction of the above westbound freight train headed by locomotives Nos. 805 and 2646 at the Portage–Ogden Dunes station on June 1, 2017, locomotive No. 2646 was leased by GMTX Locomotive Group that buys, sells, trades, and leases locomotives. (*Kenneth C. Springirth photograph*)

On June 2, 2017, GATX locomotive No. 2646 with two other Chicago South Shore locomotives are at the Carroll Street station in Michigan City. (*Kenneth C. Springirth photograph*)

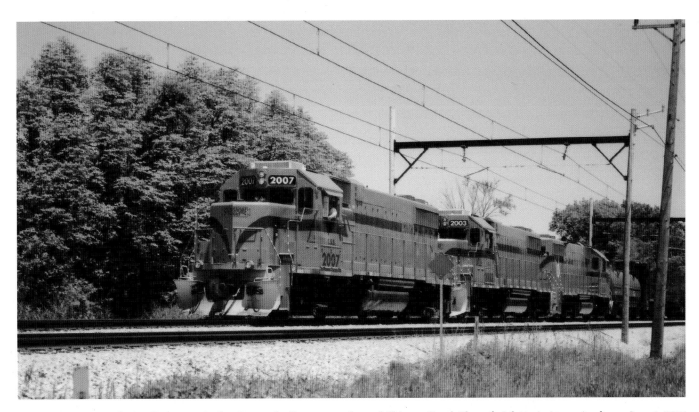

Midway between Miller and Portage–Ogden Dunes, Indiana, a westbound Chicago South Shore freight train is passing by on June 1, 2017 powered by type GP38-2 locomotives Nos. 2007, 2003, and 2006, built by the Electro-Motive Division of General Motors Corporation in 1981. The railroad operates freight service on 182 miles of track of which 27 miles are freight only, 75 miles are jointly used with the Northern Indiana Commuter Transportation District (NICTD), and 80 miles are jointly operated with other railroads. (*Kenneth C. Springirth photograph*)

On June 1, 2017, Northern Indiana Commuter Transportation District four-axle, 3,000-horsepower rebuilt GP40 diesel electric road switcher No. 1000 is at the Michigan City yard. This was originally locomotive type GP40 No. 405 built in June 1968 by the Electro-Motive Division of General Motors Corporation for the Detroit Toledo & Ironton Railroad. (*Kenneth C. Springirth photograph*)

Track work east of Carroll Avenue in Michigan City is an important part of meeting customer freight service requirements. In 2017, up to eighteen freight trains were operated by Chicago South Shore in a day on certain portions of the line between Michigan City and Chicago. (*Kenneth C. Springirth photograph*)

On April 2, 2017, the Michigan City yard is the location of Chicago South Shore locomotives. *From left to right*: two type GP38-2 locomotives with No. 2000 in the lead and to the right type SD38-2 No. 805 all built by the Electro-Motive Division of General Motors Corporation. The Michigan City yard includes the overnight storage and maintenance of the passenger cars, the diesel locomotive shops, and the operations center for the South Shore freight service. (*Kenneth C. Springirth photograph*)

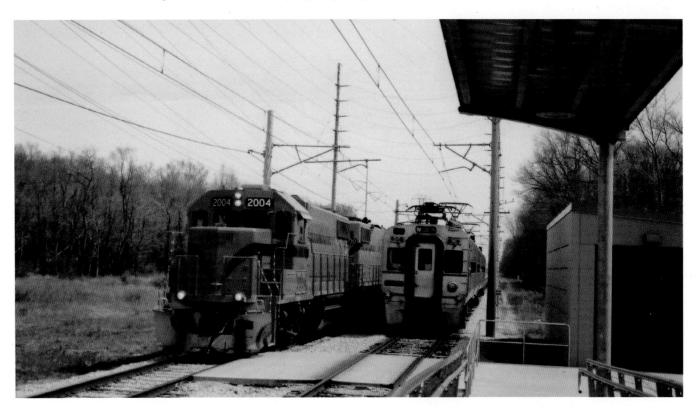

On April 10, 1977, Chicago South Shore type GP38-2 diesel locomotives led by No. 2004 (built by the Electro-Motive Division of General Motors Corporation) are waiting for the NICTD passenger train to clear Dune Park station. (*Kenneth C. Springirth photograph*)

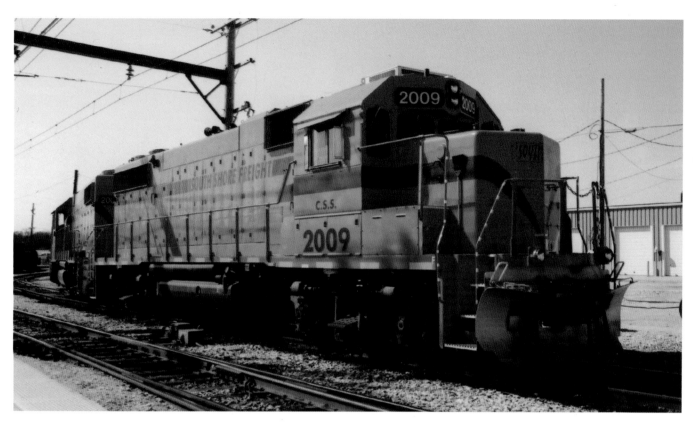

Type GP38-2 Chicago South Shore diesel locomotives Nos. 2009 and 2003 are at the Michigan City yard on April 8, 2017. (*Kenneth C. Springirth photograph*)

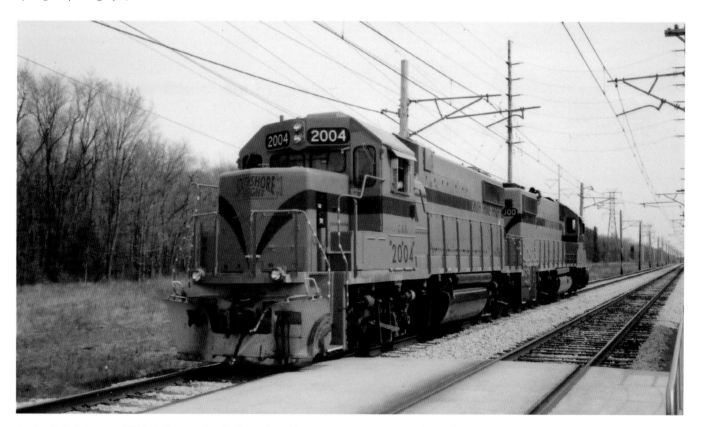

On April 10, 2017, type GP38-2 Chicago South Shore diesel locomotives Nos. 2004 and 2000 (built by the Electro-Motive Division of General Motors Corporation in 1981) are on the siding at Dune Park station waiting for the eastbound Northern Indiana Commuter Transportation District (NICTD) passenger train to arrive so that they can proceed westward to their freight assignment. (*Kenneth C. Springirth photograph*)

6

Northern Indiana Commuter Transportation District

In 1978, the limited financial support of passenger service that came through the Chicago area Regional Transit Authority (RTA) was augmented by federal operating assistance funds and grants through the Northern Indiana Commuter Transportation District (NICTD) from Indiana's Public Mass Transportation Fund. The extreme cold winter and fine blowing snow in January 1978 resulted in failure of traction motors, field coils, and motor generator sets, with only twelve operable cars, causing the railroad to shut down passenger service on January 13, 1978. In a week, some passenger service was restored. By April 1978, service was completely restored.

In 1978, the Indiana University's Institute of Urban Transportation made a cost benefit study of the South Shore corridor that found that keeping the South Shore rail service was the least costly and best option for the region. It recommended a capital improvement program for the railroad's passenger service. That was the foundation for a $67.5 million capital program developed by NICTD and funded by an 80 percent federal share plus state and local funding sources for new modern passenger cars for the South Shore line. Early in 1979, bids were taken, and in 1980, the contract was awarded to the Sumitomo Corporation of America and its car building partner Nippon-Sharyo USA for thirty-six cars that was increased to forty-four cars at a $47 million total cost. Each, of the forty-four motor cars was powered by four General Electric motors that were capable of driving the 57.5-ton cars at a balancing speed of 75 mph. In 1981, the first new car arrived for testing. The cold 1981–1982 winter resulted in numerous wire breaks and out of service cars because of burned out traction motors. Before the end of 1981, an agreement was reached whereby the railroad gave NICTD and the RTA in Chicago authority to set fares, determine train schedules, and approve budgets. In return, NICTD and RTA agreed to fully fund the railroad's passenger losses and provide a reasonable return on the investment. On January 25, 1982, the railroad adopted an emergency schedule using two diesel-powered push-pull train sets leased from the RTA plus whatever cars that were operable.

On November 22, 1982, six new cars began operating in regular service. This was the first time in fifty-three years

that passengers rode in new cars as the last new cars were in 1929. By the fall of 1983, all service was operated by the forty-four new cars. Improvements were also made in the railroads' power supply, and the Michigan City shop received new equipment to service the new cars. Passenger ridership grew from less than 1.5 million in 1978 to 2.5 million in 1983.

Venango River Corporation (VRC) purchased the railroad from the C&O in September 1984 for $31.7 million. NICTD, without an adequate local funding source, fell behind about $5.7 million in meeting its responsibility to cover the South Shore's passenger-service losses. With the railroad stating it would shut down passenger service or drastically reduce service, the State of Indiana made an emergency loan in March 1986 to NICTD to keep the passenger service operating. On April 28, 1987, VRC paid $81 million to acquire 631 miles of the Illinois Central Gulf Railroad (portion from Joliet, Illinois, to St. Louis and from Springfield, Illinois, to Kansas) and renamed it Chicago, Missouri & Western Railway (CM&W). VRC's South Shore line loaned CM&W $4 million and with South Shore freight service not as profitable as expected, the South Shore defaulted on its payments. The price paid for CM&W was too high for the revenues it generated, and the railroad filed for bankruptcy in April 1988. With continuing claims for payment and liability insurance in 1988, the South Shore received ICC approval to discontinue all passenger service by the end of 1988, but extended the date to mid-1989. Citicorp, the South Shore's principal creditor, took over the line. In April 1989, VRC filed for bankruptcy protection.

On January 1, 1990, the Anacostia & Pacific Company paid $34.6 million for the railroad, which became known as the Chicago South Shore & South Bend Railroad (South Shore), under which NICTD would eventually own all of the South Shore's Indiana facilities and trackage for both freight and passenger service. South Shore would retain freight only trackage and have exclusive freight rights on NICTD tracks. In Illinois, where the railroad operated over the Illinois Central Railroad (ICR) owned Kensington & Eastern (K&E) between the Indiana–Illinois state line and the junction with Metra (former ICR) suburban system at 115th Street, the South Shore acquired the K&E with NICTD having a permanent lease of that line.

With a growth in passenger ridership, Sumitomo Corporation of America and its car building partner Nippon-Sharyo USA built seventeen more cars for NICTD costing $26.5 million, which were placed in service in 1992 and 1993. Trackage was rerouted into the Michiana Regional Airport (west of South Bend, Indiana) on November 20, 1992. The airport was renamed South Bend Regional Airport on January 1, 2000. Ridership increased from 3,296,000 in 1995 to 4,245,900 in 2007; however, it declined to 3,503,700 in 2016. The April 1, 2017 NICTD schedule shows five trains in each direction daily between South Bend Airport and Chicago's Millennium station. Trains making all stops generally require about two hours and forty minutes. Monday through Friday express train No. 6 leaves South Bend Airport 6 a.m. Eastern Time (5 a.m. Chicago time) and arrives in Chicago one hour and fifty—five minutes later at 6:55 a.m. To reach downtown, the South Bend Transpo bus route 4 (Lincolnway West–Airport), depending on the time of day, takes twenty to twenty-six minutes between downtown South Bend and the airport. That bus route runs every thirty minutes Monday–Friday, with hourly evening service, hourly daytime Saturday service, and no Sunday service based on the April 3, 2017 schedule. The first Monday–Friday route 4 bus leaves South Street Station in downtown South Bend at 5:50 a.m. and arrives at the airport at 6:13 a.m., which is too late to make the express train to Chicago. Hence, a downtown South Bend to downtown Chicago trip by bus and train can be lengthy. In contrast, the October 29, 1967 CSS&SBR schedule showed eleven trains in each direction Monday through Friday between Chicago and South Bend, with Saturday, Sunday, and holidays, showing eight trains from South Bend to Chicago and seven trains from Chicago to South Bend, plus most of the trains were faster. For example, the Monday–Friday 5:18 p.m. express train left Chicago at 5:18 p.m. and arrived one hour and fifty-two

minutes later in downtown South Bend at 7:10 p.m. Chicago Time (8:10 p.m. Eastern Time). A local train left Chicago at 6 p.m. and arrived two hours and fifteen minutes later at South Bend at 8:15 p.m. Chicago Time (9:15 p.m. Eastern Time).

In 2017, the 90-mile NICTD electrically powered commuter line operates 14.4 miles from Millennium Station in downtown Chicago, Illinois, on the Metra predominately four-track main line to 115th Street and veers off on its own double track for 17 miles from 115th Street to Gary, Indiana. The next 59 miles (approximately) from Gary via Michigan City to South Bend Airport is mostly single track except for a 6.5-mile section of double track and three separate passing sidings that total 2.2 miles. In Michigan City, there are 1.9 miles of track on 10th and 11th Streets with trains operating alongside motor vehicle traffic. Within a 3-mile segment, there are thirty-nine at grade crossings, resulting in slow operating speeds through Michigan City. Most of NICTD track is shared with CSS freight service. The Federal Transit Administration (FTA) and NICTD have formulated a proposed project between milepost (MP) 58.8 in Gary and MP 32.2 in Michigan City that includes the construction 16.9 miles of second track and changes to the street running track in Michigan City by constructing new separated tracks south of 10th Street and along the north side of 11th Street. According to the *Environmental Assessment and Section 4(f) Evaluation NICTD Double Track Gary to Michigan City, IN* September 18, 2017, existing problems include "poor on time performance (81.9 percent compared to 90 percent acceptable standard), long travel time not competitive with automobiles, and slow operating speeds required in Michigan City." If the plan to double track the line between Gary and Michigan City is completed and provides faster service, this may attract more riders and hopefully more service. This is a very special railroad that has survived many challenges and has the potential for a great future.

On September 2, 2001, Northern Indiana Commuter Transportation District (NICTD) multiple unit coach No. 2 (one of forty-four, Nos. 1–44, built during 1982–1983 by Nippon-Sharyo USA) is the lead unit at the South Bend Airport awaiting departure time for the next trip to Chicago. The 85-foot-long car weighs 118,000 pounds, has a maximum speed of 79 mph, and seats ninety-three or ninety passengers when two wheelchair securing spaces are used. (*Kenneth C. Springirth photograph*)

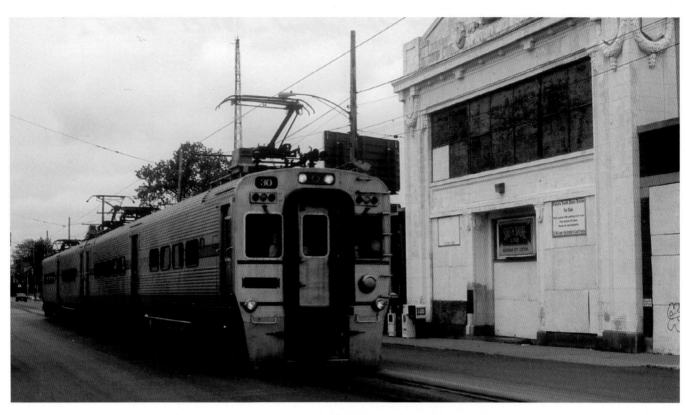

Eastbound Northern Indiana Commuter Transportation District (NICTD) train headed by coach No. 30 is making a passenger stop at the 11th Street station in Michigan City on May 27, 2008. The white façade station building opened on May 27, 1927 and was closed on November 11, 1987, when it was replaced by a nearby passenger shelter and parking area. (*Kenneth C. Springirth photograph*)

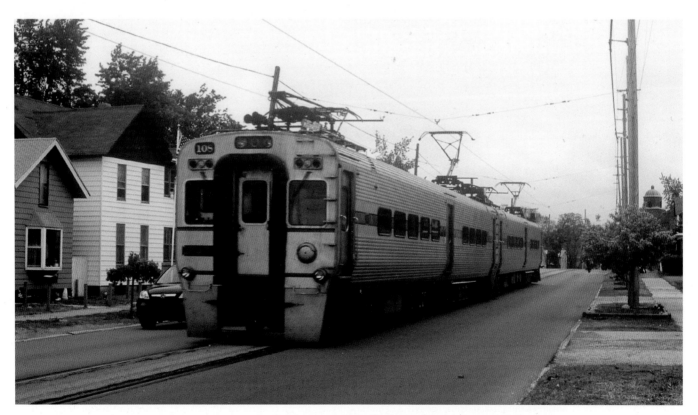

On May 27, 2008, NICTD multiple unit coach No. 108, built by Nippon-Sharyo USA in 2001, is part of a two-car train on 11th Street in Michigan City. Train speeds in Michigan City are 25 mph; however, because of street running track shared with motor vehicles, trains usually operate at about 10 mph, which results in a longer trip time. (*Kenneth C. Springirth photograph*)

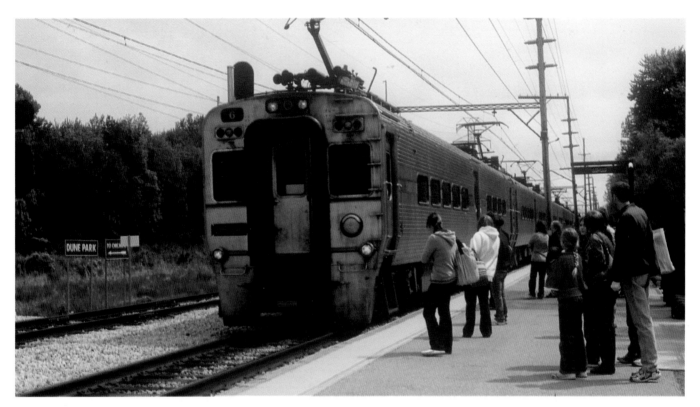

A number of riders at Dune Park station on May 27, 2008 are ready to board the arriving westbound NICTD train for Chicago, headed by coach No. 6 (one of thirty cars, Nos. 1–30, built by Nippon-Sharyo USA during 1982–1983). Dune Park station is located at Indiana State Route 49 and United States Route 12 in Westchester Township in Porter County, Indiana. (*Kenneth C. Springirth photograph*)

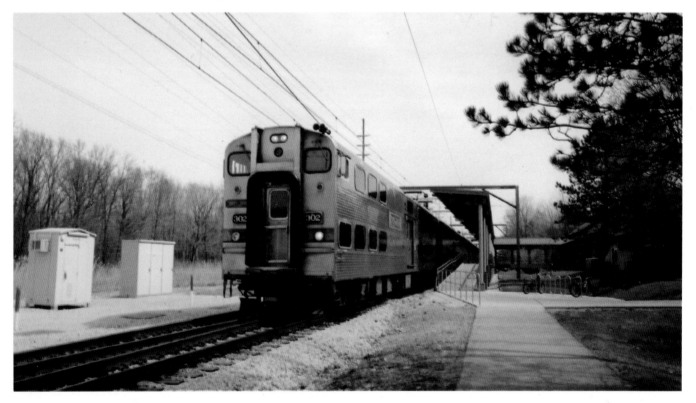

Westbound train No. 116 is at Dune Park station, the NICTD headquarters, for an on time 11:18 a.m. departure for Chicago on April 10, 2017. Leading the train was bi-level coach No. 302 (one of fourteen cars, Nos. 301–314, built by Nippon-Sharyo during 2008–2009). In 2015, weekday ridership at Dune Park station was 461 according to EAS 4(f) Evaluation NICTD Double Track NWI MP 58.8 to MP 32.2 September 18, 2017. (*Kenneth C. Springirth photograph*)

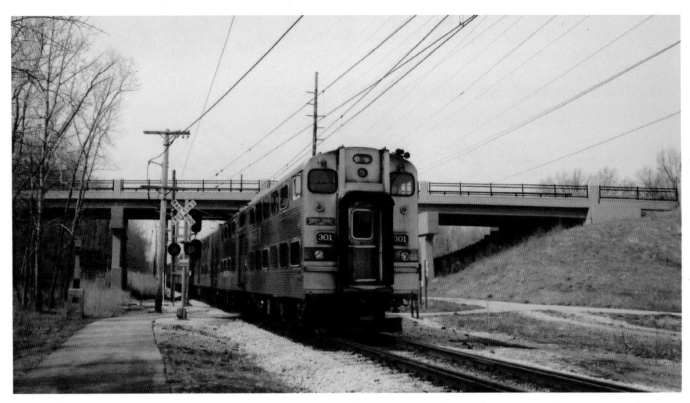

On April 10, 2017, train No. 116 has left Dune Park station with bi-level NICTD car No. 301 at the rear of the train passing under the Indiana State Route 49 bridge. Dune Park station was built in 1985 to replace the Tremont station, a location that was depopulated with the expansion of the Indiana Dunes National Lakeshore. (*Kenneth C. Springirth photograph*)

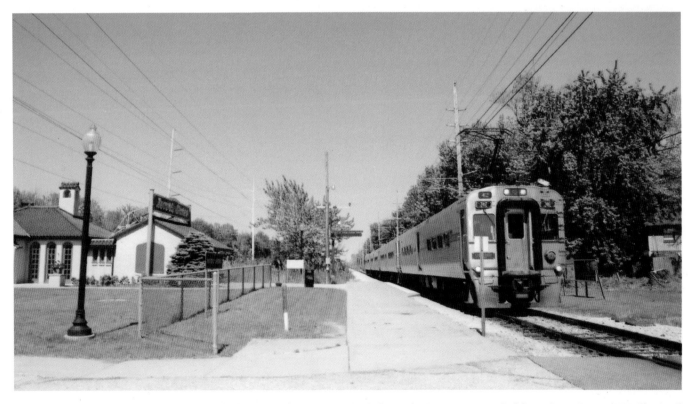

The picturesque Beverly Shores station is the location of a NICTD train with coach No. 42 at one end of the train on June 1, 2017. The April 1, 2017 NICTD timetable shows trains stopping at Beverly Shores on weekdays, nine westbound trains and thirteen eastbound trains, and weekends, eight westbound trains and nine eastbound trains. In 2015, weekday ridership at Beverly Shores station was forty-three according to EAS 4(f) Evaluation NICTD Double Track NWI MP 58.8 to MP 32.2 September 18, 2017. (*Kenneth C. Springirth photograph*)

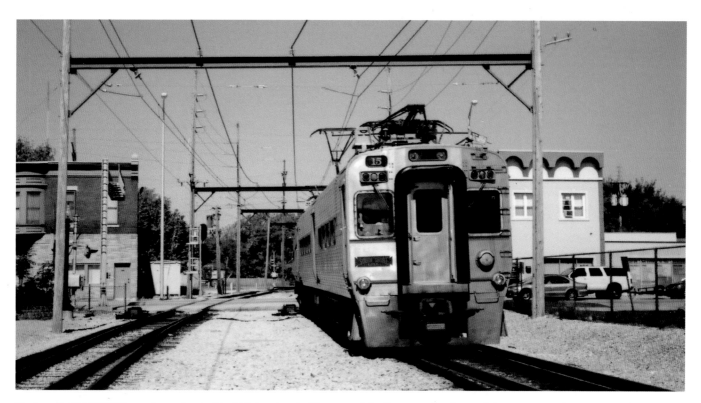

On June 1, 2017, NICTD westbound train No. 14 is leaving the Hammond, Indiana, station (4531 Hohman Avenue) at 9:40 a.m. heading for Chicago with the last coach No. 15 already west of the train platform. Hammond is the last westbound stop before trains cross into Illinois and the first stop in Indiana for eastbound trains. (*Kenneth C. Springirth photograph*)

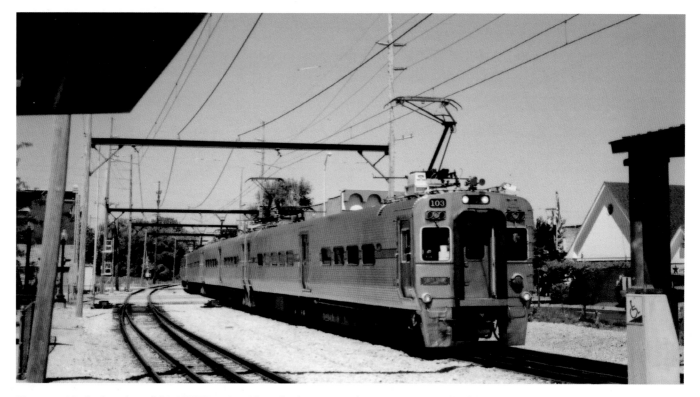

Hammond is the location of this NICTD train with multiple-unit coach No. 103 at one end of the train on June 1, 2017. Trains stopping at Hammond are eighteen westbound and seventeen eastbound on weekdays and nine eastbound and nine westbound on weekends according to the April 1, 2017 NICTD timetable. In 2015, weekday ridership at Hammond station was 1,190, making it the fourth busiest station after Millennium at 2,885; Van Buren at 1,935; and East Chicago at 1,818 according to EAS 4(f) Evaluation NICTD Double Track NWI MP 58.8 to MP 32.2 September 18, 2017. (*Kenneth C. Springirth photograph*)

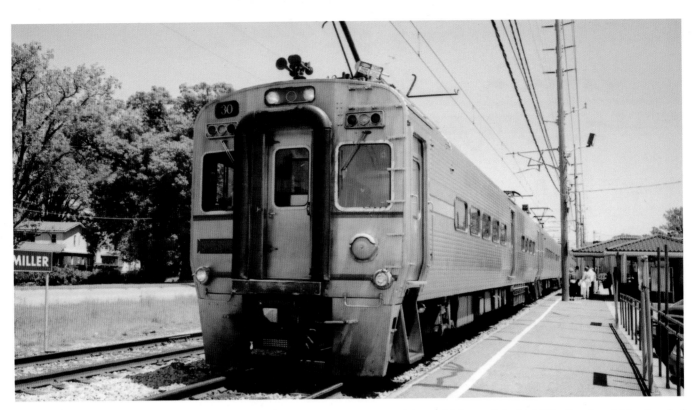

On June 1, 2017, NICTD train No. 18 is at Miller station (Lake Street and United States Highway 12 in the Miller Beach neighborhood of Gary in Lake County, Indiana) headed by coach No. 30 at the 1:09 p.m. on-time arrival for a westbound trip to Chicago. In 2015, weekday ridership at Miller station was 373 according to EAS 4(f) Evaluation NICTD Double Track NWI MP 58.8 to MP 32.2 September 18, 2017. (*Kenneth C. Springirth photograph*)

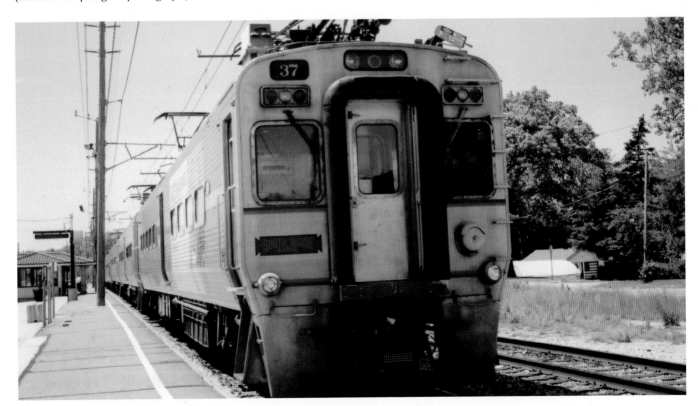

NICTD coach No. 37 is the last car of westbound train No. 18 at Miller station on June 1, 2017. According to the April 1, 2017 NICTD timetable, fourteen eastbound and twelve westbound trains stop at Miller on weekdays and nine eastbound and eight westbound trains stop at Miller on Saturday, Sundays, and holidays. (*Kenneth C. Springirth photograph*)

On a sunny June 1, 2017, eastbound NICTD train No. 9, with coach No. 45 at the head end, has arrived at 1:46 p.m. at the Portage–Ogden Dunes station, which has ground-level platforms and small passenger shelters. This station, built in 1998–1999 and replacing an earlier stop, is located on Hillcrest Road at United States Highway 12 in Porter County, Indiana, serving the city of Portage, Indiana, and the town of Ogden Dunes, Indiana. (*Kenneth C. Springirth photograph*)

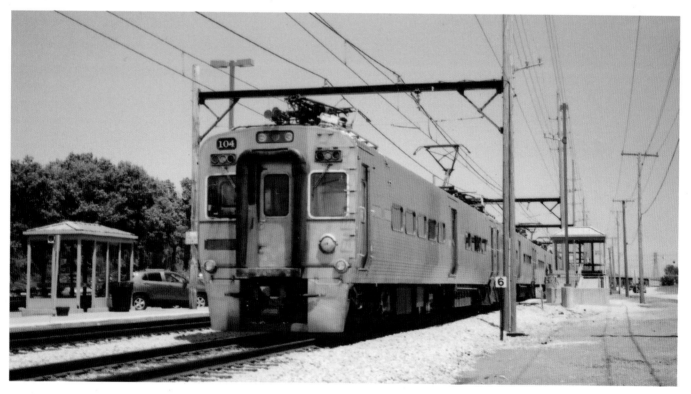

Coach No. 104 is at the rear of eastbound NICTD train No. 9 at Portage–Ogden Dunes in June 1, 2017. The April 1, 2017 NICTD timetable shows twelve westbound and thirteen eastbound trains on weekdays, with nine eastbound and eight westbound trains on Saturdays, Sundays, and holidays stopping at the Portage–Ogden Dunes station. In 2015, weekday ridership at Portage–Ogden Dunes station was 276 according to EAS 4(f) Evaluation NICTD Double Track NWI MP 58.8 to MP 32.2 September 18, 2017. (*Kenneth C. Springirth photograph*)

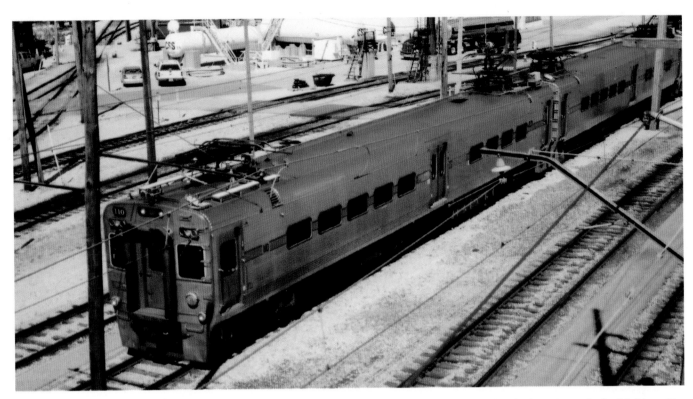

Looking east from the Roeske Avenue bridge on June 1, 2017, NICTD coach No. 110 is in the lineup of multiple-unit cars in the Michigan City yard. On these modern cars, it is nice to ride and see the traction orange stripe on the middle of the car sides that symbolizes this railroad's heritage. (*Kenneth C. Springirth photograph*)

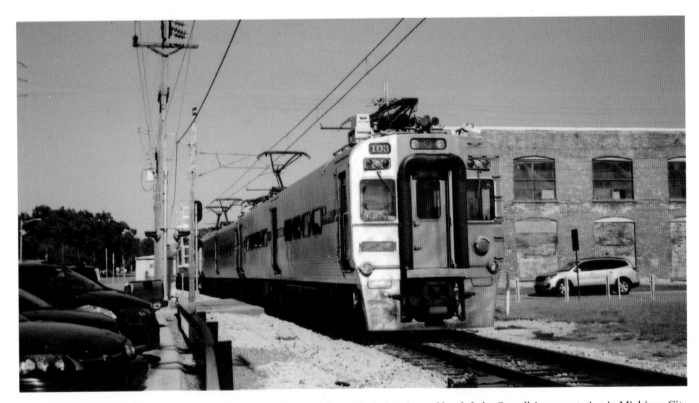

On June 2, 2017, westbound for Chicago, NICTD train No. 14 with car No. 103 at the end has left the Carroll Avenue station in Michigan City at 8:37 a.m. According to the April 1, 2017 timetable, there are five westbound trips from South Bend Airport to Chicago during weekdays. However, there are fifteen trains from Carroll Avenue westbound to Chicago, of which ten originate at Carroll Avenue. Eastbound, there are fourteen trips from Chicago to Carroll Avenue and five from Chicago to South Bend on weekdays. (*Kenneth C. Springirth photograph*)

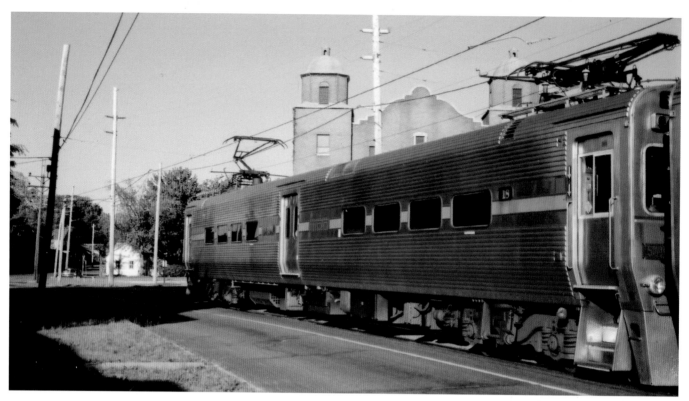

With the historic First Christian Church at 1102 Cedar Street in Michigan City constructed 1925 in the Spanish Mission Revival style in the background, eastbound NICTD train headed by multiple-unit coach No. 18 is on 11th Street, about to cross Cedar Street in the late afternoon of May 31, 2017. (*Kenneth C. Springirth photograph*)

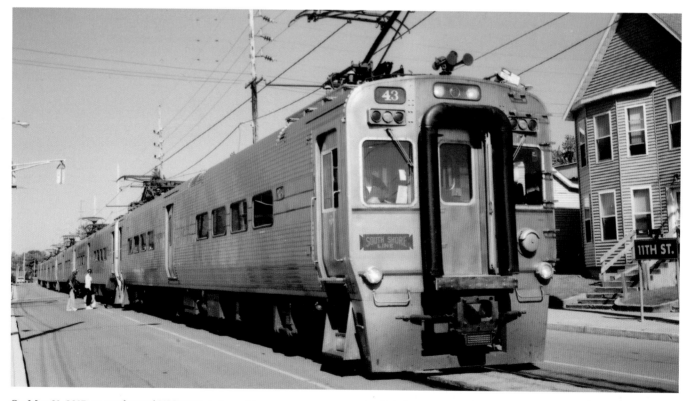

On May 31, 2017, an eastbound NICTD train is making a passenger stop at the 11th Street station (located at 114 East 11th Street) in Michigan City, with coach No. 43 at the end of the train. The April 1, 2017 NICTD timetable showed fourteen eastbound and eleven westbound trains on weekdays and nine eastbound and eight westbound trains on Saturday, Sunday and holidays stopping at the 11th Street station. (*Kenneth C. Springirth photograph*)

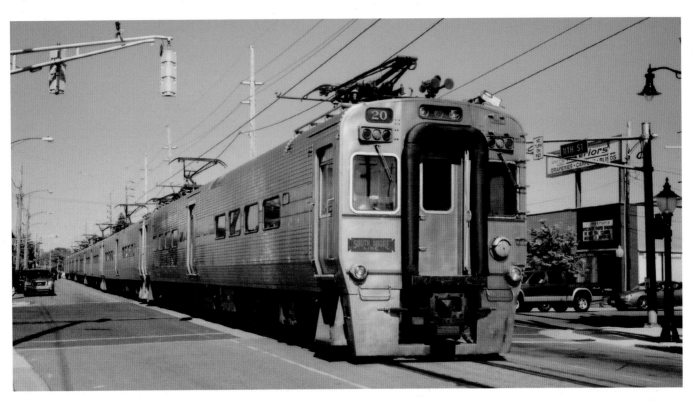

An eastbound NICTD train is on 11th Street crossing Franklin Street in downtown Michigan City on June 1, 2017, with coach No. 20 at the end of the train. On the front of the car, the design of the insignia "South Shore Line," consisting of a rectangle with two fish tails, is a reminder of this railroad's great heritage. (*Kenneth C. Springirth photograph*)

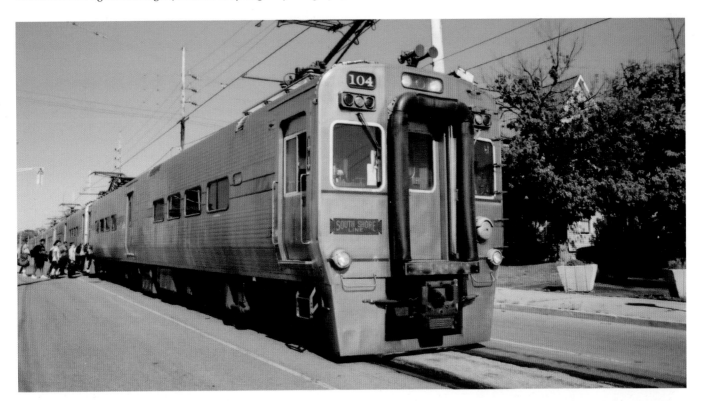

On June 1, 2017, a westbound train headed by coach No. 104 is at the 11th Street station in Michigan City. In 2015, weekday ridership at the 11th Street station was 113 according to EAS 4(f) Evaluation NICTD Double Track NWI MP 58.8 to MP 32.2, September 18, 2017. At a March 29, 2017 meeting at City Hall in Michigan City, the Michigan City Redevelopment Commission purchased the 11th Street station for $200,000 with future plans dependent on the proposed double-track project according to the March 31, 2017 *Michigan City Dispatch* newspaper. (*Kenneth C. Springirth photograph*)

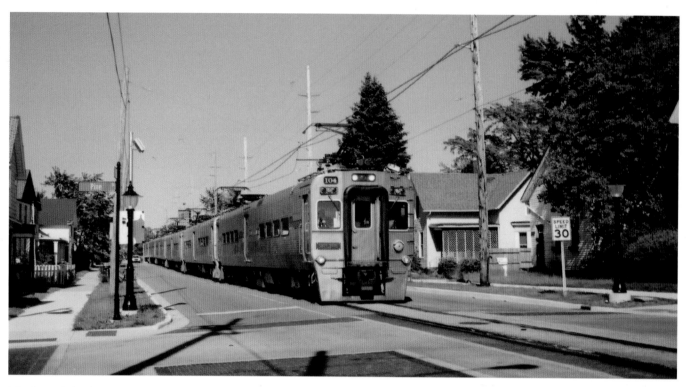

Westbound NICTD train headed by coach No. 104 is on 11th Street at Pine Street just a short distance from the downtown Michigan City station between Pine and Franklin Streets on June 1, 2017. It is slow going through Michigan City, where there are thirty-nine at-grade crossings between Sheridan Avenue and Carroll Avenue, with only seven having gates, bells, and flashing lights according to EAS 4(f) Evaluation NICTD Double Track NWI MP 58.8 to MP 32.2 September 18, 2017. (*Kenneth C. Springirth photograph*)

On April 8, 2017, NICTD train No. 608 headed by coach No. 15 is loading passengers for a 3:40 p.m. westbound departure at the Carroll Avenue station in Michigan City. In 2015, weekday ridership at the Carroll Avenue station was 226 according to EAS 4(f) Evaluation NICTD Double Track NWI MP 58.8 to MP 32.2 September 18, 2017. (*Kenneth C. Springirth photograph*)

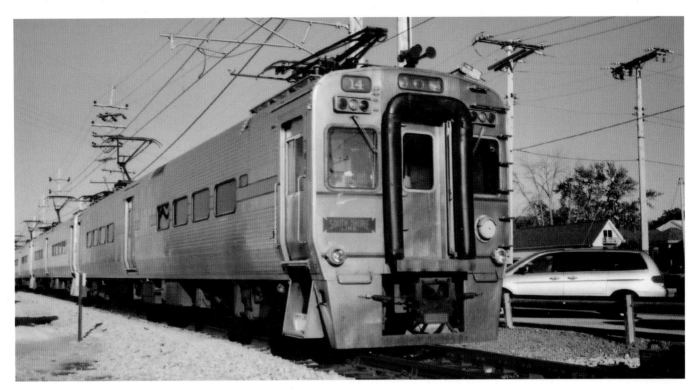

NICTD train No. 14 headed by coach No. 14 is on time at 8:37 a.m. at the Carroll Avenue station in Michigan City for a westbound trip to Chicago on June 2, 2017. The fleet of eighty-two rail cars, all built by Nippon-Sharyo USA, consists of forty-four single-level, self-propelled coaches (Nos. 1–44) built in 1982–1983; four single-level, self-propelled coaches (Nos. 45–48) built in 1992; ten single-level, unpowered trailers (Nos. 201–210) built in 1992; ten single-level, self-propelled coaches (Nos. 101–110) built in 2001; and fourteen bi-level, self-propelled coaches (Nos. 301–314) built in 2009. (*Kenneth C. Springirth photograph*)

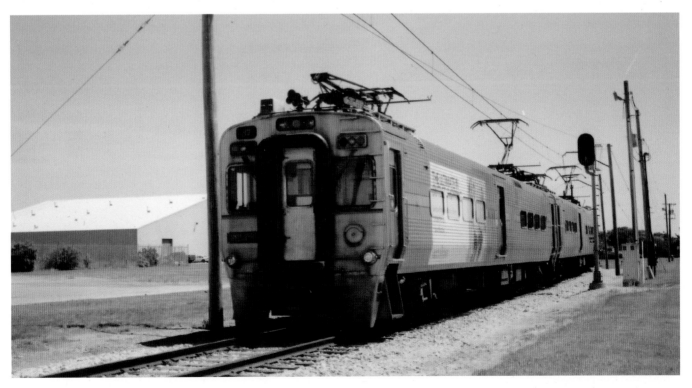

On June 2, 2017, NICTD train No. 7 headed by coach No. 37 is just a short distance from its 12:08 p.m. (Eastern Time) arrival time at the South Bend Airport. NICTD ridership increased from 3,296,000 in 1995 to 4,245,900 in 2007; however, it declined to 4,180,400 in 2008; 3,885,000 in 2009; 3,713,800 in 2010; 3,681,200 in 2011; 3,668,100 in 2012; 3,606,800 in 2013; and 3,503,700 in 2016. Passenger service needs to be speeded up so that it can be competitive with the automobile to attract more customers. (*Kenneth C. Springirth photograph*)

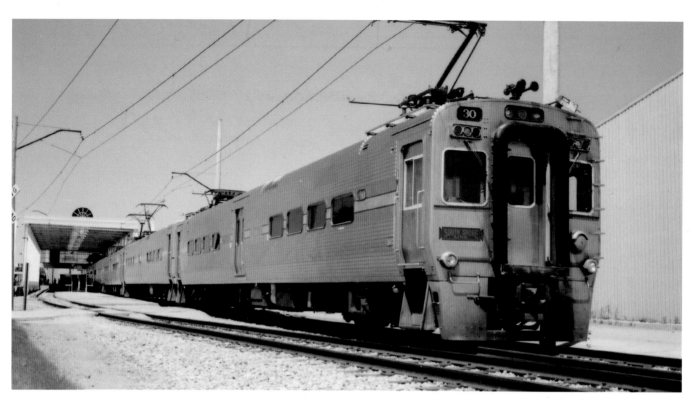

The South Bend Airport station is the location of NICTD train No. 18 headed by coach No. 30 waiting for its 12:49 p.m. departure time (Eastern Time) for Chicago on June 2, 2017. This station, about 3 miles north-west of downtown South Bend, replaced the former terminus near the Bendix plant on the west side of South Bend in November 1992, which had been in use since July 7, 1969 when passenger service into downtown South Bend ended. In 2015, weekday ridership at the South Bend Airport station was 194 according to EAS 4(f) Evaluation NICTD Double Track NWI MP 58.8 to MP 32.2 September 18, 2017. (*Kenneth C. Springirth photograph*)

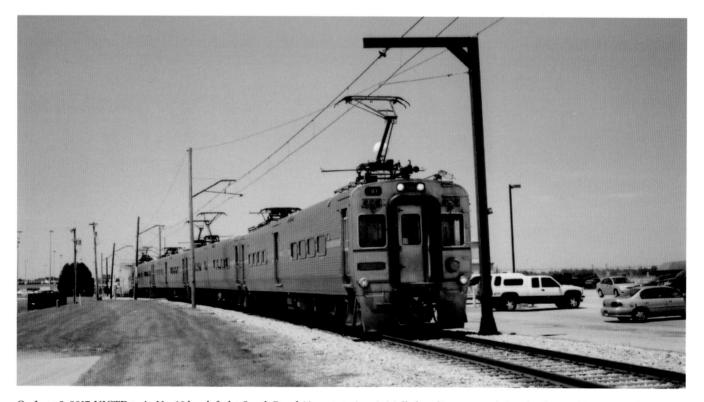

On June 2, 2017, NICTD train No. 18 has left the South Bend Airport station, initially heading east and shortly after making a turn that would ultimately head it west for Chicago. In 2017, NICTD and the SEPTA (Southeastern Pennsylvania Transportation Authority) Regional Rail Lines were the only two commuter rail systems in the United States that were completely electrified. (*Kenneth C. Springirth photograph*)